BERLIN

A Century of Change
Die Gesichter des Jahrhunderts

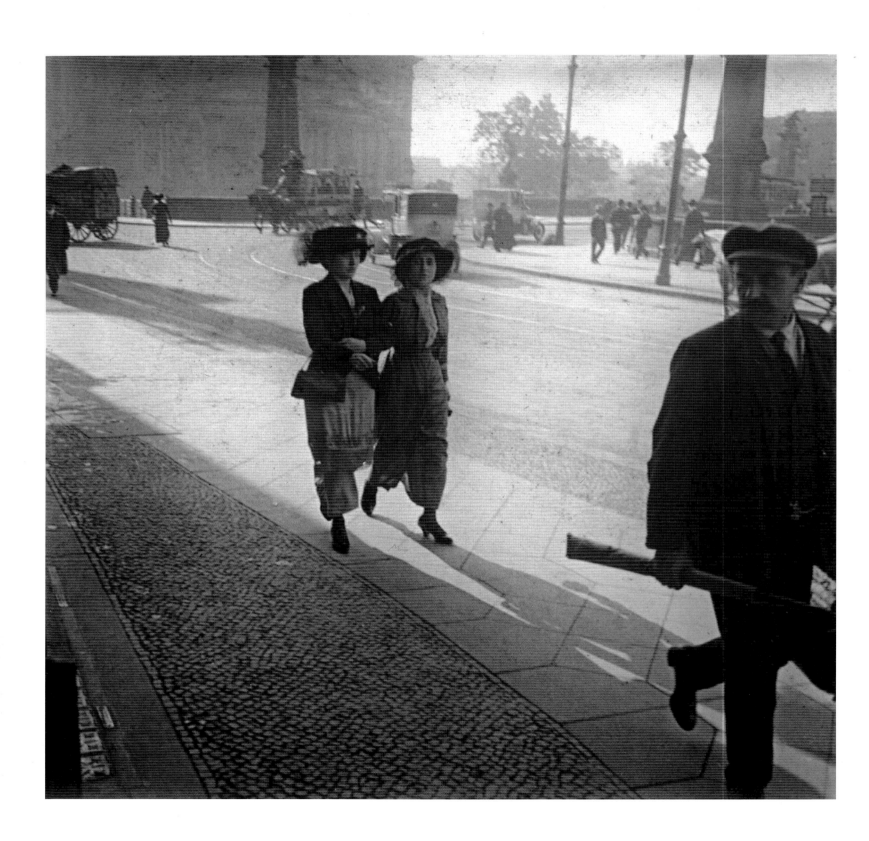

BERLIN

A Century of Change

Die Gesichter des Jahrhunderts

Prestel

Munich · London · New York

In association with
In Zusammenarbeit mit

AKG

Berlin · London · Paris

Frontispiece: The Lustgarten with the Altes Museum and Friedrichsbrücke in the background. Photo 1912/13.
Front jacket: The Goddess of Victory is transported back to the Brandenburg Gate after restoration. The complete Quadriga was designed in 1793 by Johann Gottfried Schadow. Photo 1958.
Back jacket: Top to bottom, left to right, see pp.: 15, 21, 14, 69, 75, 99, 96, 100.

Library of Congress card number: 00-101428

Prestel Publishing Ltd.
4 Bloomsbury Place
London
WC IA 2QA
Tel.: (020) 7323 5004
Fax: (020) 7636 8004

Prestel Publishing
175 Fifth Avenue
New York
NY 10010
Tel.: (212) 995 2720
Fax: (212) 995 2733

Prestel books are available worldwide. Please contact your nearest bookseller or any of the above addresses for information concerning your local distributor.

Concept by Julia Engelhardt
Picture research by David Pratt and Jürgen Raible
Captions by Alexander Kluy (German) and
Julia Hardiman (English)
Chronology by Julia Hardiman
Editing (German) by Katrin Wiethege

Editorial direction by Philippa Hurd

Designed by Maja Thorn, Berlin

Colour separations by LVD, Berlin
Printed and bound by Freiburger Graphische Betriebe, Freiburg i.Br.

Printed in Germany

ISBN 3-7913-2299-0

© Prestel Verlag, München · London · New York, 2000

© für die Abbildungen bei AKG London, Archiv für Kunst und Geschichte, Berlin, und den Photographen

© für die abgebildeten Werke bei den Künstlern, ihren Erben oder Rechtsnachfolgern, mit Ausnahme von: Ludwig Gies, Thomas Theodor Heine und Käthe Kollwitz bei VG Bild-Kunst, Bonn, 2000.

Frontispiz: Der Lustgarten mit dem Alten Museum und der Friedrichsbrücke im Hintergrund, 1912/13.
Auf dem Umschlag vorn: Die restaurierte Siegesgöttin während des Transports zum Brandenburger Tor, 1958. Die Quadriga entwarf Johann Gottfried Schadow 1793.
Auf dem Umschlag hinten: von oben nach unten, von links nach rechts: siehe S. 15, 21, 14, 69, 75, 99, 96, 100.

Die Deutsche Bibliothek – CIP-Einheitsaufnahme
Ein Titeldatensatz für diese Publikation ist bei der Deutschen Bibliothek erhältlich.

Prestel Verlag
Mandlstraße 26
D-80802 München
Tel.: (089) 381709-0
Fax: (089) 381709-35
E-Mail: info@prestel.de

Buchkonzept: Julia Engelhardt
Bildrecherche: David Pratt und Jürgen Raible
Deutsche Bildunterschriften: Alexander Kluy
Englische Bildunterschriften: Julia Hardiman
Chronologie: Julia Hardiman
Übersetzung aus dem Englischen: Alexander Kluy

Projektleitung: Philippa Hurd

Deutsches Lektorat: Katrin Wiethege

Gestaltung: Maja Thorn

Lithografie: LVD, Berlin
Druck und Bindung: Freiburger Graphische Betriebe, Freiburg i.Br.

Printed in Germany

ISBN 3-7913-2299-0

CONTENTS INHALT

7 Foreword
 Vorwort
 Julia Engelhardt

9 Berlin—A Century of Change
 Berlin – Ein Jahrhundert des Wandels
 Neal Ascherson

20 Chapter 1 1900–1918 Unter den Linden
 Kapitel 1 1900–1918 Unter den Linden

38 Chapter 2 1919–1933 The New Reality
 Kapitel 2 1919–1930 Die neue Realität

56 Chapter 3 1933–1945 The Centre of Power
 Kapitel 3 1933–1945 Das Zentrum der Macht

74 Chapter 4 1945–1989 The Divided City
 Kapitel 4 1945–1989 Die geteilte Stadt

96 Chapter 5 1989–2000 The New Capital
 Kapitel 5 1989–2000 Die neue Hauptstadt

114 Chronology of Events
 Chronologie der Ereignisse

120 Picture Credits
 Bildnachweis

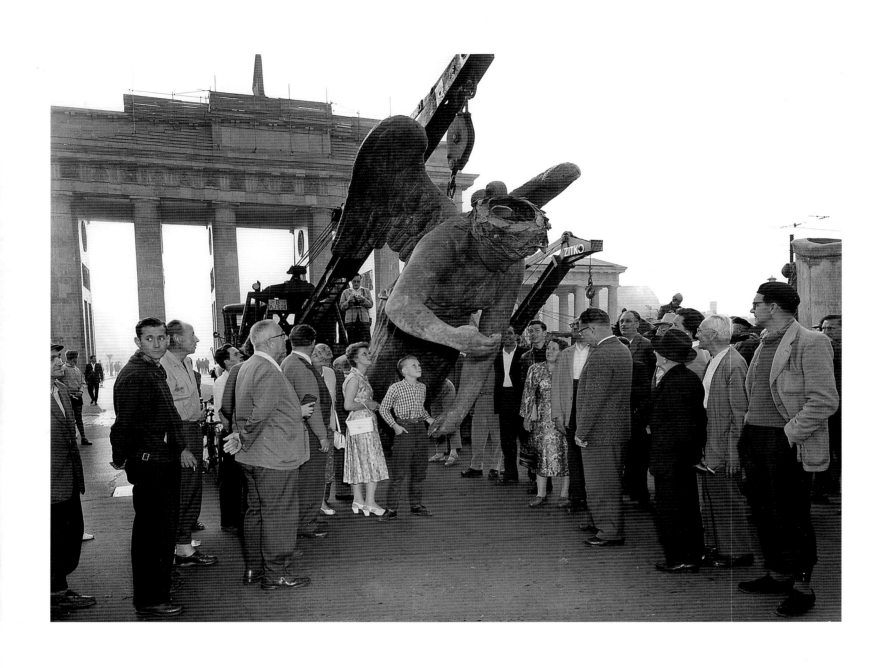

The Goddess of Victory is transported
back to the Brandenburg Gate.
Photo 1. August 1958.

Die Siegesgöttin der Quadriga wird zum
Brandenburger Tor transportiert,
1. August 1958.

FOREWORD
VORWORT

Julia Engelhardt

Berlin is in the headlines again. After many decades of turbulence, the city is able to make a fresh start as the new capital of a unified Germany.

Berlin is the only genuine metropolis in Germany. As such, it has undergone more radical political and social changes than any other European capital. This is reflected in one of the themes of the book: change and re-invention. This change can be seen in the face of the city itself, in new building styles which frequently symbolize a positive vision for the future.

A theme which also emerges is the indomitable survival instinct Berliners have shown over the last century. Periods of physical and financial hardship for the majority of citizens have been more frequent than in other European cities, the worst being at the end of the Second World War, when the city lay in ruins and it was extremely difficult to survive at all among the rubble and the rats. There followed the psychological hardship of the division of the city. Not only were families separated, but the Western part of the city became an island surrounded by East Germany. During the many years of the Cold War, this island had the unenviable status of being the prime flashpoint of confrontation between East and West.

Another side to this survival instinct is the sheer capacity and will that Berliners possess to have a good time, to indulge themselves. Not the rich and famous posing in fashionable cafes, nightclubs, and at important social events – people found in any city; but ordinary Berliners who, in good times or bad, seem to be able to create or enjoy small, simple pleasures: getting together for a drink, or coffee and cake, playing skittles or skat, going for a swim or on a boat trip on the lakes, going to see a show, or joining the crowds to watch the fireworks on New Year's Eve.

The history and culture of Berlin is so rich and complex that it is difficult to compress visually into these pages. Therefore, we have arranged the book into themed spreads which reflect those aspects of life and history in Berlin that we see as most important. The perspective chosen is that of the people, not of their rulers. The narrative is roughly led by dates, so the five chapters cover specific years. We only touch briefly on the cultural life of the city – visual art, music, literature, theatre, and film. This subject would make a book in itself. However, we hope to have created a cocktail that will give readers a flavour of the rich mix of old and new, ordinary and extraordinary, that is this lively and fascinating city.

Berlin steht wieder in den Schlagzeilen. Nach vielen turbulenten Jahrzehnten kann die Stadt einen Neubeginn als deutsche Hauptstadt machen.

Berlin ist im Grunde die einzige echte deutsche Metropole. Diese Stadt war tiefgreifenderen politischen und gesellschaftlichen Umwälzungen unterworfen als jede andere europäische Hauptstadt. Dies zeigt sich im Grundmotiv ›Veränderung und Neubeginn‹ dieses Buches. Die Konstante des Wandels ist im Erscheinungsbild Berlins unübersehbar, in den neuen Baustilen, in denen häufig einer Zukunftshoffnung Ausdruck verliehen wird.

Ein großes Thema ist der durch nichts zu brechende Überlebenswille der Berliner. Sie waren viel häufiger Zeiten von Hunger und Not ausgesetzt als Menschen in anderen europäischen Großstädten. Am schlimmsten war das Ende des Zweiten Weltkriegs. Die Stadt war ein Trümmerfeld und das Überleben zwischen den Schuttbergen kaum möglich. Es folgte die traumatische Teilung Berlins. Familien wurden auseinandergerissen, und der Westteil der Stadt war auf einmal eine Exklave. Während des Kalten Krieges war diese Insel in der wenig beneidenswerten Lage, im Mittelpunkt der Auseinandersetzung zwischen Ost und West zu stehen.

Eine andere Seite dieses Überlebenswillens ist die unerschütterliche Fähigkeit und Energie der Berliner, sich zu amüsieren. Es sind nicht die Prominenten, die in modischen Cafés, Nachtclubs und bei wichtigen gesellschaftlichen Anlässen posieren; es sind vielmehr die einfachen Menschen, die es verstehen, in guten und in schlechten Zeiten große und kleine Freuden zu genießen: die Verabredung auf ein Bier oder zu Kaffee und Kuchen, Kegeln oder Skatspielen, Schwimmengehen oder eine Bootsfahrt auf den Seen, der Besuch eines Musicals oder das Feuerwerk in der Silvesternacht.

Berlins Geschichte und Kultur sind so komplex und vielfältig, daß sie kaum in einem Buch erfaßt werden können. Aus diesem Grunde wurden Schwerpunktthemen ausgewählt, die das Leben und die Geschichte der Menschen zeigen. Unsere Perspektive ist diejenige der Bürger, nicht der Regierenden. Fünf Kapitel gliedern das Jahrhundert, in denen in vertrauten, spannenden und teils neuartig überraschenden Bildern Geschichte erzählt und festgehalten wird. Das kulturelle Leben der Stadt – Kunst, Musik, Literatur, Theater und Film – wird hier am Rande berührt; es ist so vielfältig, daß es den Rahmen dieses Buches sprengen würde. Wir hoffen, ein Panoptikum zusammengestellt zu haben, eine faszinierende Mischung aus Altem und Neuem, aus Alltäglichem und Außergewöhnlichem – denn genau das ist Berlin.

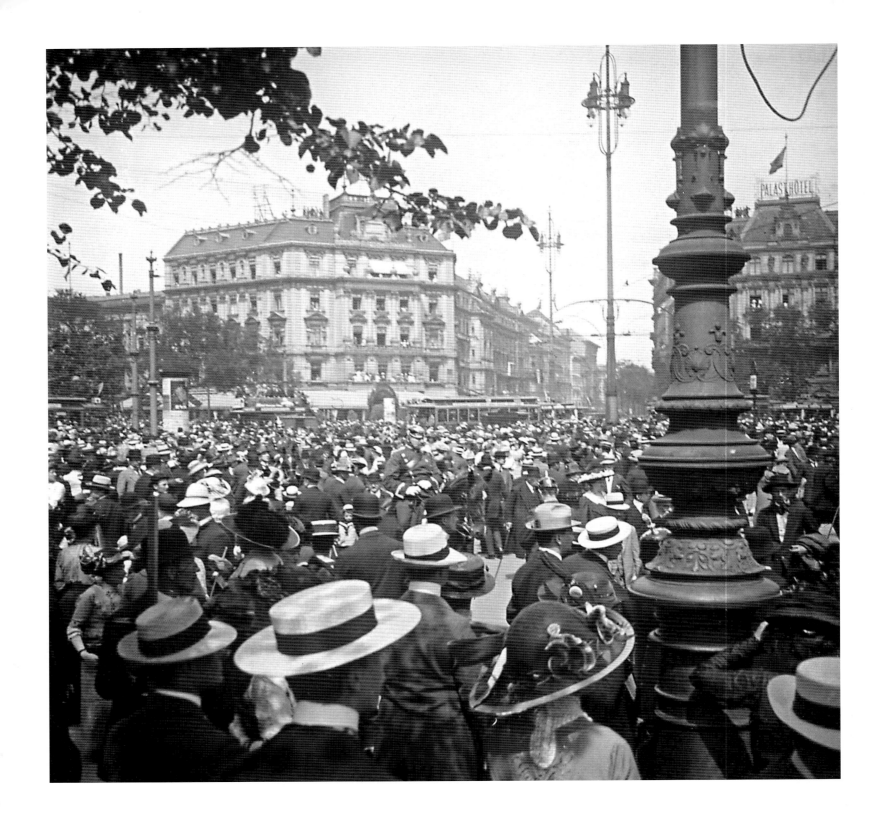

Crowds on Potsdamer Platz celebrate the
marriage of the Kaiser's daughter Victoria Luise
of Prussia. Photo May 24, 1913.

Gedränge auf dem Potsdamer Platz am Tag
der Hochzeit Viktoria Luises von Preußen, der
Tochter des Deutschen Kaisers Wilhelm II.,
24. Mai 1913.

BERLIN—A CENTURY OF CHANGE
BERLIN – EIN JAHRHUNDERT DES WANDELS

Neal Ascherson

In Berlin, history doesn't walk. It leaps. It does not tread along in a measured way, as one epoch steadily turns into the next. Instead, huddled periods of stillness are broken by a sudden, gigantic bound into the future, by a yell that startles the world.

When I first lived in the city, it was still. The Wall was up; the Cold War was frozen hard. Coming up from Bonn by rail overnight, the train would reach the Berlin border post at Griebnitzsee at about dawn. Then a thick silence would fall. I would lie dozing in my bunk, listening. Sometimes I would hear the sound of jackboots softly crunching the snow on the platform. Then more silence; a distant murmur of Saxon accents, a door slamming somewhere. Dreams, as I drifted off to sleep again: visions of my botanist ancestor, old Professor Ascherson, who used to take his students through these very pine forests on summer nature rambles that ended with free beer all round at the local station buffet. In the dream, set in about 1910, the bearded Professor and his straw-hatted disciples seemed to float through the fences of barbed wire, past the concrete watch-towers, across the deadly ploughed strip of sand and into the conifer-shadows of the Mark Brandenburg, as if all these places were in the same country. A nostalgic fantasy!

And it was still, too, on the other side of West Berlin, at the Lehrter Bahnhof. This was the last station in the West, where the wooden S-Bahn carriages waited before they

In Berlin vollzieht sich Geschichte nicht in einzelnen Schritten. Sie macht Sprünge. Sie bewegt sich nicht linear, so daß eine Epoche allmählich in die nächste übergeht. Statt dessen werden zusammengedrängte Perioden von großer Ruhe durch einen unerwarteten, riesenhaften Sprung in die Zukunft beendet, durch einen Schrei, der die Welt in Erstaunen versetzt.

Als ich das erste Mal in Berlin lebte, war es ruhig. Die Mauer stand; es herrschte Kalter Krieg. Ich hatte in Bonn den Nachtzug genommen; der Zug sollte den Berliner Grenzübergang Griebnitzsee im Morgengrauen erreichen. Dann senkte sich dichte Stille herab. Ich lag auf meinem Bett im Liegewagen und döste. Dann und wann hörte ich das leise Geräusch von Stiefeln im Schnee, der auf dem Bahnsteig lag. Dann wieder Stille; von ferne ein sächsisch gefärbtes Gemurmel, irgendwo wurde eine Tür zugeschlagen. Ich träumte, während ich in den Schlaf hinüberglitt: Ich sah einen meiner Vorfahren, den alten Botanik-Professor Ascherson, vor mir, der sommers mit seinen Studenten durch ebendiese Fichtenwälder zu streifen pflegte. Seine Wanderungen endeten stets mit einer Lokalrunde in der nächstgelegenen Bahnhofsgaststätte. Im Traum, der ungefähr 1910 spielte, schienen der bärtige Professor und seine strohhutbewehrten Schüler durch die mit Stacheldrahtzaun befestigten Grenzen, über die Wachtürme aus Beton, über den sandigen Todesstreifen und in die Schatten der Kiefern der Mark Brandenburg zu schwe-

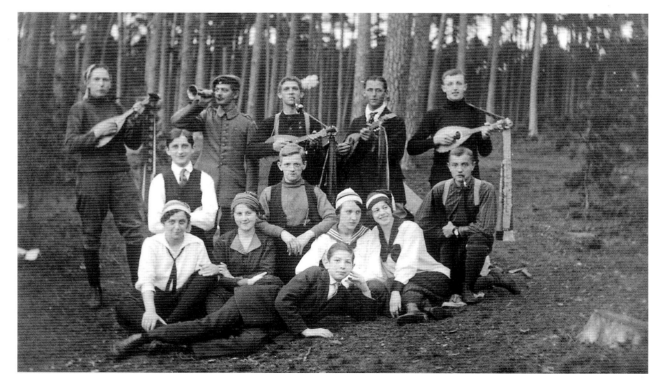

Young Berliners on an excursion to Gorinsee. Photo October 3, 1915.

Eine Gruppe junger Berliner während einer Wanderung zum Gorinsee, 3. Oktober 1915.

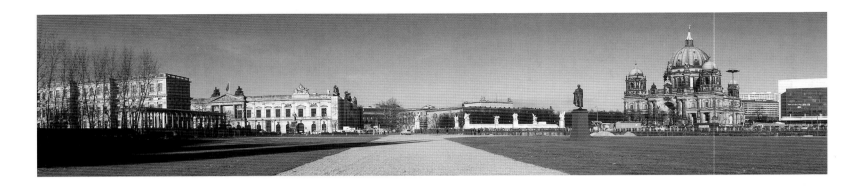

rumbled across the Spree Bridge into East Berlin, past the scarred shell of the old Reichstag, over the Wall until it stopped—all change!—at Friedrichstraße. There, if you glanced upwards, you could see the silhouettes of soldiers with Kalashnikovs, pacing in the rafters like rooks in the high boughs of a tree. It was quiet; it was spectral; it felt as if it had been like this for ever.

But I misunderstood the quality of all that stillness. Berlin was not in a coma: it was crouching, motionless, with every muscle tensed, preparing for the next bound into the future. Now I visit those two places and it is my memory of them which has become nostalgic fantasy. At Griebnitzsee, the express trains hurtle through without stopping, and the small cars throng back and forth to the Mark. The "forest" around that once forbidden and heavily guarded platform turns out to be just an insignificant copse in the suburbs of Potsdam.

And at what used to be the Lehrter Bahnhof, you can catch the Berlin giant in mid-bound. The Wall has gone, but so has the Spree itself, diverted by cofferdams while a hole the size of a small airfield is excavated. This is the biggest building-site in Europe. You can try to count cranes, and when I last tried I got up to about ninety. Where Hitler's bunker lay, a plantation of glass and steel and marble towers soars up towards the sky, as a whole new Government and commercial quarter is constructed for "Berlin—Capital of Germany," or one day perhaps, "Berlin—Hauptstadt Europas." The Reichstag is rebuilt and busy, loud with parliamentary debates and crowned with a new glass cupola designed by British architect Sir Norman Foster. And the Lehrter Bahnhof itself is turning into a superstation, the nerve-junction of European transport, a colossal multilevel palace of transit where the north–south main line from the Baltic to the Balkans will cross the east–west main line from Paris to Moscow and Vladivostok.

Two Berlin traits endure, however. One is the taste for gigantism in architecture and planning, for overthrowing the existing city and designing another on a scale which reduces

ben, als ob all diese Orte im selben Land lägen. Eine nostalgische Vorstellung!

Und auch auf der anderen Seite West-Berlins, am Lehrter Bahnhof, war es ruhig. Hier hielten die hölzernen S-Bahnen zum letzten Mal im Westen, bevor sie über die Spree nach Ost-Berlin rumpelten, vorbei an den wundgeschlagenen Mauern des Reichstagsgebäudes, über die Mauer, bis sie – »Alle aussteigen!« – am Bahnhof Friedrichstraße hielten. Dort konnte man die Silhouetten von Soldaten mit Kalaschnikows im Gebälk des Bahnhofs wie Krähen in einer Baumkrone auf und ab patrouillieren sehen. Es war still; es war geisterhaft; man meinte, es sei schon immer so gewesen.

Aber ich faßte die Eigenheit dieser Stille falsch auf. Berlin lag nicht im Koma; die Stadt hatte sich geduckt, war bewegungslos, doch jeder Muskel war angespannt und bereitete sich auf den nächsten Sprung in die Zukunft vor. Heute sehe ich diese beiden Orte wieder, und meine Erinnerung an sie ist zur Nostalgie geworden. An Griebnitzsee sausen die Schnellzüge vorbei, ohne zu halten, und ein Strom von Kleinwagen pendelt durch die Mark. Der »Wald« rings um den einst verbotenen und schwer bewachten Bahnsteig entpuppt sich als unbedeutendes Gehölz in einem Vorort Potsdams.

Und dort, wo einst der Lehrter Bahnhof war, läßt sich der Berliner Gigant schon in Umrissen erkennen. Die Mauer ist verschwunden, ebenso wie die Spree, die mittels Fangdämmen umgeleitet wird; und eine Baugrube mit den Ausmaßen eines kleinen Flugfelds wird ausgehoben. Es ist die größte Baustelle in Europa. Man ist versucht, die Kräne zu zählen, und als ich dies das letzte Mal tat, kam ich auf rund neunzig. Wo sich der Führerbunker befand, ragt eine Ansammlung von Glas und Stahl und Marmortürmen in den Himmel, denn ein völlig neues Regierungs- und Geschäftsviertel entsteht hier für »Berlin – Hauptstadt Deutschlands« oder vielleicht eines Tages für »Berlin – Hauptstadt Europas«. Der Reichstag wurde umgebaut und ist geschäftig und erfüllt von Parlamentsdebatten. Er ist nun von einer neuen Glaskuppel überkrönt, die der englische Architekt Sir Norman Foster entwarf. Und der Lehrter Bahnhof selbst wird zu

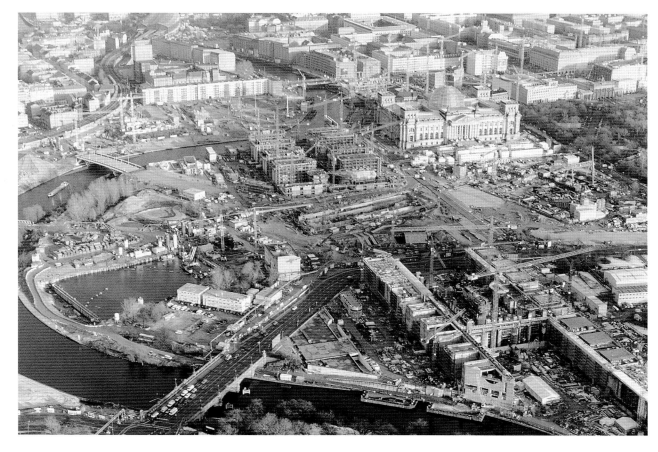

The Spree canal winds its way through the giant building site and past the offices of the new federal government. In the background is the Reichstag building. Photo 1998/99.

Der Spreebogen mit der riesigen Baustelle für das Bundeskanzleramt und die neuen Regierungsbauten sowie dem Reichstagsgebäude, 1998/99.

human beings to ants. This was the style of the later Kaisers, during the Empire which lasted from 1871 to 1918. Adolf Hitler was the same; in this book, you can see maquettes of the monstrous new Berlin which Albert Speer would have built if Hitler had won the war: his triumphal-arch design would have made the Arc de Triomphe look like a keyhole. After the war, the new Communist rulers in the East succumbed to the same instinct, and constructed on the ruins the huge Stalinallee boulevards in the Soviet 1930s wedding-cake style. (The finishing was atrocious, and pedestrians on these windswept pavements have been dodging falling bits of marble ever since). And now comes yet another central Berlin, rising out of that big hole in the Prussian sand which was the nerve-centre of the Kaiserreich, the Third Reich, and then an empty no-man's-land beside the Wall, where rabbits nibbled and guard dogs howled. Here, too, that old megalomania is reappearing, but this time that contempt for human scale is expressed in a mad jungle of discordant styles: some beautiful buildings, some hideous like the new Dresdner Bank bunker, but all monstrous in size. How strange it is that Fritz Lang's "Metropolis", his terrifying vision of the urban future,

einem Super-Bahnhof, zum Nervenzentrum des europäischen Transportwesens, zu einem kolossalen vielgeschossigen Palast des Verkehrs, in dem die Hauptverkehrsverbindung zwischen dem Baltikum und den Balkanstaaten auf die Ost-West-Zugverbindung zwischen Paris und Moskau und Wladiwostok treffen wird.

Zwei Eigenheiten Berlins haben die Zeiten unverändert überdauert. Die eine ist die Vorliebe für architektonischen und städtebaulichen Gigantismus, für ein Ignorieren der bestehenden Stadt und das Entwerfen einer neuen, deren Maßstab die Bewohner auf die Größe von Ameisen schrumpfen läßt. Dies war der Fall in der Kaiserzeit, die von 1871 bis 1918 dauerte. Unter Adolf Hitler war es ebenso; in diesem Buch können Sie Modelle des monströsen neuen Berlin sehen, die Albert Speer realisiert hätte, wenn Hitler den Krieg gewonnen hätte (sein Entwurf für einen Triumphbogen hätte den Arc de Triomphe wie ein Schlüsselloch erscheinen lassen). Nach dem Krieg gaben die neuen kommunistischen Machthaber im Osten dem gleichen Impuls nach und errichteten auf Ruinen die gewaltigen Bauten entlang der breiten Stalinallee im Moskauer Zuckerbäckerstil der dreißiger Jahre

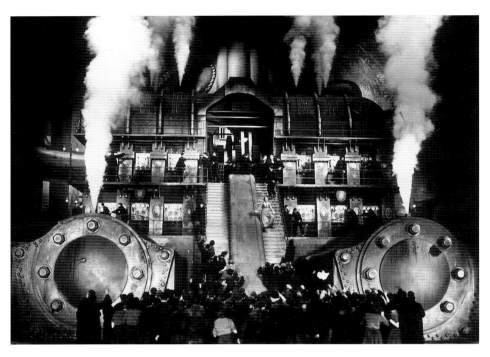

Fritz Lang's "Metropolis".
Film still 1926.

Fritz Langs »Metropolis«.

is now becoming reality, albeit two Berlins later on from the one he worked in!

And the other trait? It is this habit of leaping, this way in which something like a major urban earthquake happens in every generation and renders Berlin unrecognizable. Two centuries ago, this was a dear little neoclassical borough among

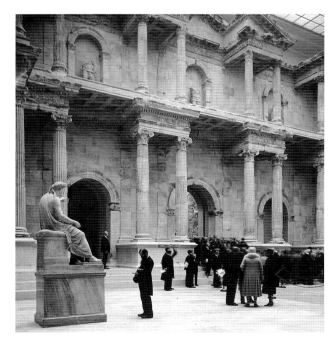

Visitors to the Pergamon
Museum in Berlin.
Photo c. 1925.

Besuchergruppe vor dem
Markttor von Milet im
Pergamon-Museum, um 1925.

(die Ausführung war miserabel, und auf den Bürgersteigen, über die der Wind fegt, müssen Fußgänger immer noch herabfallendem Mauerputz ausweichen). Und nun entsteht wieder ein neues Zentral-Berlin, das aus der riesigen Baugrube im märkischen Sand emporwächst, einst der Mittelpunkt des Kaiserreiches, des Dritten Reiches und später ein verlassenes Niemandsland neben der Mauer, in dem Hasen hoppelten und Wachhunde heulten. Hier erscheint die alte Megalomanie von neuem, aber diesmal schlägt sich die Verachtung einer den menschlichen Proportionen angemessenen Maßstäblichkeit in einem verrückten Mischmasch unvereinbarer Stile nieder: Einige Neubauten sind sehr schön, andere gräßlich, wie zum Beispiel das neue Gebäude der Dresdner Bank, aber alle sind in ihrer Größe ins Monströse übersteigert (wie seltsam, daß Fritz Langs »Metropolis«, seine erschreckende Vision der zukünftigen Stadt, nunmehr Wirklichkeit wird, wenn auch zwei Stadt-Generationen später!).

Und was ist die andere Eigenheit? Es ist jenes Springen, die Art und Weise, in der sich innerhalb jeder Generation so etwas wie ein größeres Erdbeben in der Stadt ereignet und Berlin bis zur Unkenntlichkeit verändert. Vor zweihundert Jahren war diese Stadt ein liebenswertes kleines klassizistisches Städtchen, zwischen Seen gelegen, in Ehrfurcht vor den preußischen Königen im nahen Potsdam. Im 19. Jahrhundert verdoppelte sich Berlins Bevölkerungszahl und nahm bald noch einmal um einhundert Prozent zu, und es wurde zu einer ziemlich anderen Stadt, wie man dies im ersten Kapitel des vorliegenden Buches sehen kann: zu einem Ort mit gewaltigen, pompösen Palästen, Kathedralen und Warenhäusern (und jenen Kirchen aus rotem Backstein, von denen Christopher Isherwood schrieb, sie seien alle aus einer einzigen, Millionen Tonnen schweren Karotte geschnitzt). Die Straßen verstopften Pferdebusse und Straßenbahnen; die Bürgersteige bevölkerten Männer und Frauen mit Hüten. Innerhalb weniger Jahrzehnte hatte sich Berlin in eine kaiserliche Hauptstadt verwandelt, besaß weltberühmte Orchester und Museen und war von einem Industriegürtel aus Maschinenfabriken und Kraftwerken umgeben.

Der Erste Weltkrieg kam, das Kaiserreich löste sich auf, Revolution und Gegenrevolution loderten durch die Stadt. Die Weimarer Republik wurde gegründet und von einer enormen Inflation heimgesucht; sie hielt ein Ordnungssystem aufrecht, das erst mit der Depression und den politischen Verwerfungen endete, durch die 1933 Hitler zum Reichskanzler ernannt wurde. Berliner kämpften in den Straßen, Kommunisten gegen Nazis. Halunken in braunen Hemden hielten Paraden mit Fackeln und Hakenkreuzen ab und waren im November 1938 für die »Reichskristallnacht«, das Judenpogrom, verantwortlich. Fast alle Synagogen, jüdischen Friedhöfe und Geschäftshäuser wurden zerstört. Aber der Hintergrund, vor dem sich all diese dramatischen Vorgänge

lakes, a town in awe of the Prussian kings at nearby Potsdam. Then in the nineteenth century Berlin's population doubled and soon doubled again, and it became a quite different city, the city you can see in the first chapter of this book, a place of vast, pompous palaces, cathedrals, and department stores (and those red-brick churches which Christopher Isherwood said were carved from a single million-ton carrot). The streets were congested with horse-buses and electric trams; the pavements crowded with men and women in hats. In a few decades, Berlin had transformed itself into an imperial capital complete with world-famous orchestras and museums, and surrounded by an industrial belt of engineering factories and power stations.

World War I came, the Empire fell, revolution and counter-revolution flared up across the city. The Weimar Republic arose, grappled with hyper-inflation, and restored a sort of order which lasted until the Depression and the political convulsions that ended in 1933 with Hitler's appointment as Chancellor. Berliners fought in the streets, Communists against Nazis. Brown-shirted thugs paraded their torches and swastikas and in November 1938 led the *Reichskristallnacht* pogrom against the Berlin Jews. Almost all synagogues, Jewish graveyards, office blocks and shops were devastated. But the backdrop, the cityscape against which all these dramas were acted out, did not change much between about 1910 and 1939.

Then came the next leap. Bombing, above all British night raids in the last years of World War II, reduced much of central Berlin to rubble or gutted shells of buildings. In May 1945, Soviet and Polish armies fought their way into the heart of the city from the east, pulverizing the old cultural core of Berlin and the government quarter around Unter den Linden and Potsdamer Platz. The city was partitioned into four Allied sectors, then, in 1961, divided in two by the Wall which also cut West Berlin off from the surrounding Brandenburg countryside. Rebuilding began, rapidly in the West, much more slowly in the East. Two incompatible styles of public building added a visual dimension to the political divide.

At each transformation, those who knew the previous Berlin and returned to its successor found themselves lost, bereaved. I saw some of that with my own eyes. Once in the 1960s I found myself on a bus full of ancient survivors of the pre-Hitler film industry, returning for the first time from Hampstead or California. The old Ufa studios at Babelsberg were out of bounds on the wrong side of the East German wire. Instead the bus drove through the industrial suburb of Siemensstadt, where many of the sets and locations had been built, and en route its occupants became more and more dazed with shock and loss. Nothing they remembered remained; everything had been bombed, cleared, redeveloped.

vollzogen, die Stadtlandschaft, änderte sich zwischen 1910 und 1939 nur gering.

Dann folgte der nächste Sprung. Durch die Bombardements, vor allem die der britischen Luftwaffe in den letzten Kriegsjahren, wurde Berlins Mitte in Schutt und Asche gelegt. Im Mai 1945 kämpften sich russische und polnische Truppen von Osten bis ins Zentrum der Stadt, und dabei wurde dem alten kulturellen Mittelpunkt Berlins und dem Regierungsviertel rings um den Boulevard Unter den Linden und dem Potsdamer Platz der Todesstoß versetzt. Die Stadt wurde in vier alliierte Sektoren aufgeteilt und im Jahr 1961 schließlich durch die Mauer zweigeteilt, was West-Berlin von seinem Umland abtrennte. Im Westen begann der Wiederaufbau schnell, viel langsamer dagegen im Osten. Zwei völlig unterschiedliche Entwurfsstile für öffentliche Gebäude signalisierten deutlich die Trennung in zwei politisch unterschiedliche Systeme.

Bei jeder Verwandlung fühlten sich jene, die das frühere Berlin erlebt hatten und später wiederkamen, verloren und hilflos. Ich erlebte dies selbst. In den sechziger Jahren war ich mit einer Busladung einstiger Mitarbeiter der deutschen Filmindustrie zu Zeiten der Weimarer Republik unterwegs, die zum ersten Mal, aus Hampstead, England oder Kalifornien kommend, wieder Deutschland besuchten. Wir konnten die alten Ufa-Studios in Potsdam-Babelsberg auf der falschen Seite der Grenze nicht besichtigen. Stattdessen fuhr der Bus durch Siemensstadt, einen von Industrie geprägten Stadtteil, in dem Filmarchitekten und Filmausstatter vieles für ihre Filme hatten bauen lassen, und während der Fahrt wuchs bei den Mitreisenden der Schock und das Gefühl, etwas verloren zu haben. Nichts, woran sie sich erinnerten, gab es noch; alles war zerstört, abgerissen, neu bebaut worden. Bei einer anderen Gelegenheit fuhr ich eine jüdische Dame aus London zu den Straßen in Ost-Berlin, in denen sie aufgewachsen war. Sie sagte nur »Halten Sie hier!« oder »Jetzt etwas langsamer und dann links bis zum Platz fahren — wenn es ihn noch gibt.« Dann stieg sie aus, ging schnell und fast blindlings einige Schritte kurz in die eine Richtung und dann in die andere, schüttelte den Kopf und stieg wieder ein. Am Ende war sie verstummt, aber in ihren Augen sah ich eine wachsende Panik. Hatte sie gehofft, schreckliche Erinnerungen dadurch zu bannen, daß sie an deren Ursprungsort zurückkehrte? Aber diesen gab es nicht mehr: Nur der Prellstein in einem Ödland stand noch, der einst den Eingang eines Hauses angezeigt hatte, ein Straßenschild mit einem vertrauten Namen in Frakturschrift oder ein Hoftor, hinter dem das Unkraut wucherte.

Ich wußte, daß mir dasselbe passieren würde. Mein Berlin war die geteilte Stadt, und ich konnte mir kein anderes vorstellen. Die Mauer war alt; die auseinandergerissenen Familien hatten sich fast aus den Augen verloren. Straßen en-

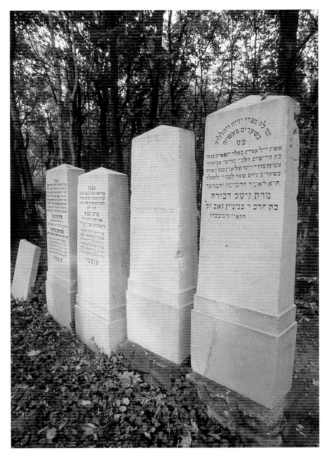

Jewish cemetery in Prenzlauer Berg. Photo 1990.

Grabsteine auf dem Jüdischen Friedhof in der Schönhauser Allee 23–25 in Berlin-Prenzlauer Berg. 1990.

On another occasion I drove a Jewish woman from London back to the eastern Berlin streets she had fled from as a child. All she said was "Stop here!" or "Slow down a bit, and turn left into the square—if there still is a square." She would get out of the car, walk swiftly and almost blindly this way and that for a few moments, shake her head and return to the car. Finally she was silent, but I saw the gathering terror in her face. Had she hoped to bring dreadful memories to heel, by confronting their source? But there was no source left: only a kerb across a wasteland which had once marked the front of a house, a street sign with a familiar name in black Gothic letters, or a gateway opening into weeds.

I knew my own time would come. My Berlin had been the divided one, and I could not imagine it any different. The Wall was old; the sundered families had nearly forgotten one another. Roads ended in cracked tarmac, a rusty fence, a brightly coloured thicket of flowering weeds. Broken bridges, rusty rail lines leading nowhere. The suave glitter of the Kurfürstendamm in West Berlin; the ultra-smart bars and bookshops around it. The gloom of East Berlin, with its long-snouted buses, pot-holed streets, and red-and-white

deten in rissigem Asphalt vor einem rostigen Zaun, an einem bunt blühenden Busch Unkraut. Verrottete Brücken, rostige Bahngeleise führten ins nichts. Das angenehme Glitzern des Kurfürstendamms in West-Berlin, die ultra-smarten Bars und Buchhandlungen in seiner Nähe. Die Düsternis Ost-Berlins mit seinen langschnäuzigen Bussen, mit seinen mit Schlaglöchern übersäten Straßen und rot-weißen Transparenten: »Jede gute Tat/hilft Dir und Deinem Staat«. Dann kam plötzlich 1989; die Mauer fiel, die Stadt war wieder eins oder, besser gesagt, die zwei Stadthälften waren zueinander hin geöffnet worden. Und das Immobilienfieber setzte ein, nachdem man das riesige Niemandsland in der Stadtmitte rings um das Brandenburger Tor Bauunternehmern, Architekten und Spekulanten aus allen Herren Ländern präsentiert hatte. Der nächste Sprung steht bevor, und auch mein Berlin gibt es nicht mehr.

Etwas, das sich nicht verändert hat, sind die Bürgersteige. Berlin hat die breitesten, großzügigsten Trottoirs der Welt, und ihr Muster, eine komplizierte Kombination von Platten und rechteckigen Basaltsteinen, ist eine Besonderheit dieser Stadt. Diese Bürgersteige bilden den bescheidenen, unaufdringlichen Hintergrund fast aller Aufnahmen in diesem Buch. Betrachtet man die Photographien ganz genau, so bemerkt man diesen merkwürdigen Granitteppich unter den Füßen der Menschen, der Frauen mit den großen Hüten, der Arbeitssuchenden, der Marschierenden, und dann und wann wurde er aufgerissen, um Barrikaden zu errichten.

Es mag sein, daß zarte Signale aus der Vergangenheit aus diesen alten Steinen die Berliner noch immer erreichen. So gingen beispielsweise billige Prostituierte auf den Trottoirs der Prenzlauer Allee auf und ab, bevor die Nazis sie nach 1933 von den Straßen verjagten. Viel Zeit verging, siebenundfünfzig Jahre, um genau zu sein, in denen die öffentliche Prostitution unter Nationalsozialisten und Kommunisten verboten war. Aber 1990 lösten sich die Deutsche Demokratische Republik und alle ihre Gesetze in nichts auf, und binnen kurzem waren die jungen Frauen mit den langen Stiefeln und den Miniröcken wieder entlang der Prenzlauer Allee zu sehen. Wer hat dafür eine Erklärung? Die Änderungen in Berlin sind verblüffend genug, aber einige abseitige Kontinuitäten noch erstaunlicher als andere.

Den Unterschied zwischen dem Bürgersteig einst und heute machen natürlich die Menschen aus. Ihre Kleidung hat sich verändert, und auf den Photographien jüngeren Datums, in erster Linie auf den Nachkriegsaufnahmen, sind sie weniger geworden. Manchmal bilden sie eine richtige Menge, so sieht man zum Beispiel ein Meer von Menschen bei der Rede des Regierenden Bürgermeisters Ernst Reuter während der Berlin-Blockade 1948 (siehe Seite 80). Aber die überfüllten, pulsierenden Straßen des Berlins der zwanziger und dreißiger Jahre, wie man dies noch heute in London oder Paris erlebt,

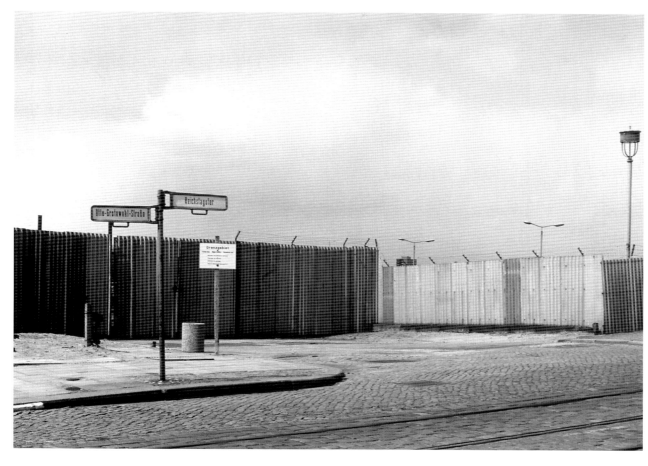

banners: "Each Good Deed You Do/ Helps Your State And You." Then suddenly it was 1989; the Wall gave way, the city was united or, more accurately, the two cities were opened to one another. And the real-estate rush began, as the enormous no-man's-land at the centre of Berlin around the Brandenburg Gate was thrown open to the contractors, architects, and speculators of the world. The next leap is underway and my Berlin, too, has ceased to exist.

One thing that doesn't change is the pavement. Berlin has the broadest, most generous pavements in the world, and their design—an elaborate tapestry of slabs and basalt cubes—is special to the city. These pavements are the humble, unobtrusive stage-set for almost all the photographs in this book. If you peer closely at the pictures, you can glimpse this curious granite kilim underfoot, minced on by women in big hats, slouched on by unemployed workers, stamped on by marching battalions, every now and then levered up to make barricades.

It may be that tiny signals from the past still reach Berliners from these old stones. For instance, the cheaper prostitutes used to walk the pavement of the Prenzlauer Allee

haben sich geleert. Die breiten Trottoirs glichen in den sechziger Jahren ausgetrockneten Ozeanen. Die Passanten durchquerten allein den weiten Raum. und nur bei seltenen Anlässen politischen Straßentheaters sah man drei Wasserwerfer der Polizei nebeneinander postiert oder zwanzig Studenten. die sich untergehakt hatten und »Ho! Ho! Ho Tschi Minh!« skandierten. Zum Teil war dies der Abnahme der Berliner Bevölkerung zuzuschreiben. Die westdeutsche Mittelklasse konnte sich nicht mit der Vorstellung anfreunden, auf einer »Insel der Demokratie« in einem sozialistischen Meer zu leben und zu arbeiten; im Ostteil dagegen war die Zerstörung von Wohngebieten einige Jahrzehnte nach Kriegsende noch immer nicht behoben. Die verbliebene städtische Bevölkerung in West-Berlin war großenteils überaltert, die Industriearbeiter in Ost-Berlin dagegen fuhren nach Schichtende einfach gleich nach Hause, denn es gab keine Geschäfte oder Cafés. die sie zum Bleiben lockten.

Bis jetzt haben die Wiedervereinigung der Stadt und ihr ehrgeiziger Status als deutsche Hauptstadt nur wenig dazu beigetragen, die Trottoirs zu füllen. Zugegeben, es gibt einen großen Wandel der innerstädtischen Ausrichtung; der

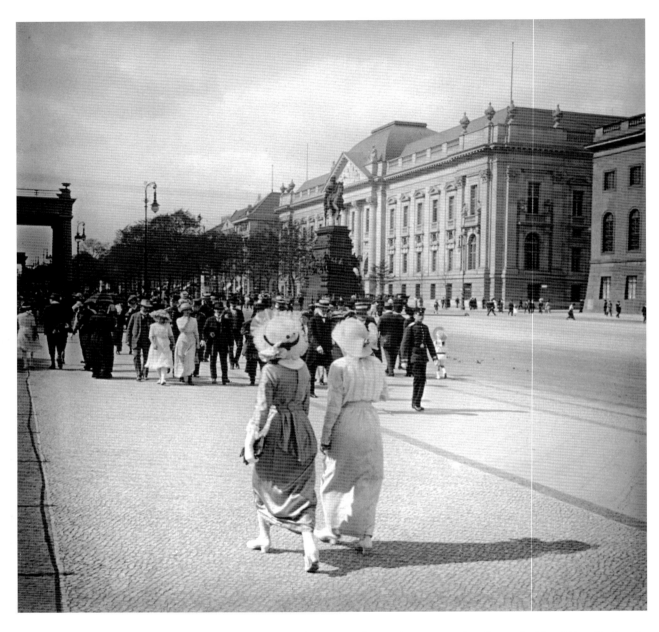

Unter den Linden.
Photo 1913.

Unter den Linden. 1913.

before the Nazis drove them off the streets in 1933. A long time passed, fifty-seven years to be exact, during which Nazis and then Communists made streetwalking illegal. But in 1990 the German Democratic Republic and all its laws blew away in the wind, and within weeks here were the young women in long boots and miniskirts on the pavement of the Prenzlauer Allee once more. Who can explain that? Berlin changes are startling enough, but some of the dark continuities are more disturbing still.

The difference between the pavements then and now is, or course, the people. Their dress has changed, and in the

Kurfürstendamm, einst das glitzernde Herz West-Berlins, ist schäbig geworden. Das angesagte Viertel, wo die Jungen gesehen werden wollen und Unternehmer Geschäfte und Restaurants eröffnen, bilden die schönen, restaurierten kleinen Straßen und Gassen rund um die Sophienstraße und den Hackeschen Markt. Die Menschen und das Geld sind zum Kern der Stadt des 19. Jahrhunderts zurückgekehrt. Aber der Menschentrubel weist keine Ähnlichkeit mehr auf mit dem Treiben auf den Straßen zu Beginn des 20. Jahrhunderts. Die Zahl der Immigranten ist beträchtlich: Die Mehrzahl der 40 000 Bauarbeiter in der innerstädtischen »Riesenbaugrube«

recent pictures—the postwar ones, above all—they have become fewer again. Sometimes there is a proper crowd: for instance, that human ocean on page 80, listening to Mayor Ernst Reuter at the time of the 1948 blocade. But the packed, jostling streets of Berlin in the 1920s and 1930s, something which you can still experience in London or Paris, have emptied. Those spacious pavements were deserted oceans in the 1960s. Pedestrians sailed alone across their blank expanse, and only on rare occasions of political street-theatre did they accommodate three police water-cannon abreast or twenty students with linked arms roaring: "Ho, Ho, Ho Chi Minh!" In part this was because the population had defected. The Western middle class did not fancy the idea of living and doing business in an "island of democracy" in a Communist sea, while in the East the damage to residential areas was not made good for decades after 1945. In part, though, it was because the remaining West Berliners were often elderly while the East Berlin factory workers, with almost no shops or cafés to attract them, simply went home on the streetcar after their shift.

So far, the unification of Berlin and its soaring status as the German capital have not noticeably filled the pavements. Admittedly, there is a big change in urban focus; the Kurfürstendamm district, once the glitzy nucleus of West Berlin, is turning shabby at last. The cool places now, where the young want to be seen and the enterprising want to open shops and restaurants, are in what used to be East Berlin, in the pretty, renovated little streets and lanes around Sophienstraße and the Hackescher Markt. The crowds and the money have gravitated back to the nineteenth-century nucleus of the town. But as crowds go, they do not begin to compare with the early twentieth-century street life in this book. There has been impressive immigration: most of the 40,000 construction workers in the city-centre "Big Hole" are foreign, while the city contains 137,000 Turks, 72,000 people from the former Yugoslavia, 30,000 Poles, and large, new Russian and Russian–Jewish colonies. But it was always true that most Berliners were born somewhere else. What nobody could have predicted was that a reunified Berlin would actually lose population.

It seems a mystery. After all, something like 100,000 government officials and their families are moving in from Bonn. But the newcomers don't choose to live in the capital itself. Instead, the poor, underpopulated state of Brandenburg which surrounds Berlin, mostly sandy moor and pine forest, has gone into a mighty real-estate boom as speculators build suburbs of cheap owner–occupier housing in the little villages around the city limits. It's the urban planner's nightmare: a population which uses the city's facilities—parking, public transport, water, power—but pays its taxes to another authority somewhere else.

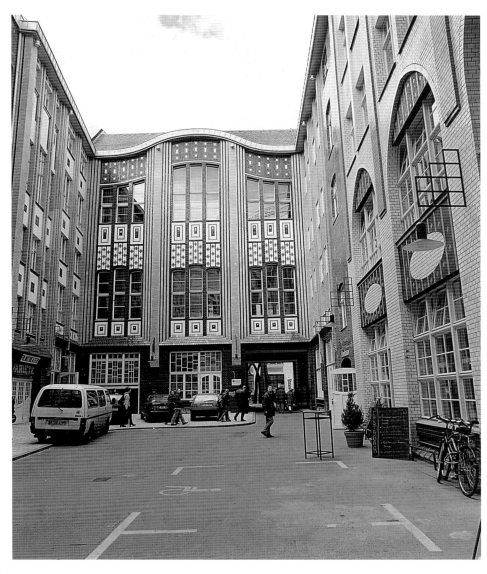

kommt aus dem Ausland; zugleich leben in Berlin 137 000 Türken, 72 000 Menschen aus Ex-Jugoslawien, 30 000 Polen, und es gibt große, noch junge russische und russisch-jüdische Kolonien. Aber es war schon immer richtig, daß die meisten Berliner woanders geboren wurden. Was niemand vorhersehen konnte, war der Bevölkerungsschwund des wiedervereinten Berlin.

Es mutet mysteriös an. Schließlich ziehen etwa 100 000 Regierungsbeamte mit ihren Familien von Bonn hierher. Aber die Neuankömmlinge wählen sich nicht die Stadt zum Lebensmittelpunkt. Statt dessen hat sich im armen Brandenburg mit seiner geringen Bevölkerungsdichte, das Berlin umgibt und zumeist aus Sandgebieten und Fichtenwäldern be-

The restored courtyards of the Hackesche Höfe in central Berlin now house cafés, cinemas, cabarets, shops, and art galleries. A hundred years ago they were home to artisans and their workshops. Photo 1997.

In den restaurierten Innenhöfen der Hackeschen Höfe in Berlin-Mitte befinden sich Cafés, Kinos, Cabarets, Läden und Kunstgalerien. Hundert Jahre zuvor waren hier Handwerksbetriebe untergebracht. 1997.

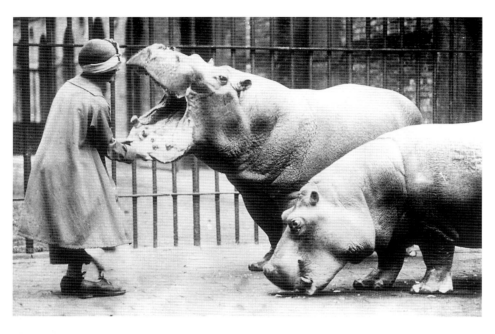

Feeding the hippos at the Zoo, Photo c. 1922.

Fütterung der Nilpferde im Zoologischen Garten, um 1922.

In light of this new trend, it is a good time to recall the intense dramas of twentieth-century Berlin: revolution, war, genocidal crime, total destruction, partition, siege, moments of liberation. Berliners were caught up in these dramas. But they were spectators as well as actors, with a tradition that is sharp-tongued and sceptical. The rhymes about Hitler and Goebbels that children sang in the backyard, between air raids, are shockingly funny and filthy. All the revolutions in Berlin streets were done by wild-eyed loonies from distant provinces, it seemed to Berlin folk, and that went for Adolf too.

When Berliners feel homesick, it is rarely for the Schinkel palaces and the Victory Columns. More often it is for the scent of summer mud at the Havel lakes; for the sour taste of Brause lemonade; for foaming, acid Berliner Weiße with a shot of raspberry or woodruff syrup; for the glow of the shoe-shops on Tauentzienstraße on winter evenings; for a plate of "Green Eel" at the Hotel Berlin; for an evening newspaper story on the sex life of the late Knautschke, the bull hippopotamus at the Zoo. History has occasionally made the Berliners look noble. More frequently, maniacal regimes have made them look foolish. All they really want is for their great city to get comfortable and give up this bad habit of leaping into new futures. On the evidence of these photographs, that seems unlikely.

steht, ein wahrer Immobilienboom vollzogen. Spekulanten stampfen in den kleinen Dörfern rings um die Hauptstadt Neubauviertel aus dem Boden, in denen man Häuser entweder kaufen oder mieten kann. Es ist der Alptraum eines jeden Stadtplaners: Menschen nehmen alle städtischen Einrichtungen – Parkplätze, den öffentlichen Personennahverkehr, Wasser und Energie – in Anspruch, zahlen aber ihre Steuern in einer anderen Kommune.

Angesichts dieser neuen Entwicklung ist es durchaus angeraten, sich die heftigen dramatischen Ereignisse Berlins im 20. Jahrhundert ins Gedächtnis zu rufen: Revolution, Krieg, Völkermord, totale Zerstörung, Teilung, Isolierung, Momente der Befreiung. Die Berliner waren in diesen dramatischen Vorgängen gefesselt. Aber sie waren zugleich Zuschauer und Akteure mit einer traditionell scharfzüngigen und skeptischen Grundhaltung. Die Spottlieder über Hitler und Goebbels, die Kinder in den Hinterhöfen zwischen zwei Luftangriffen sangen, sind fürchterlich lustig und anzüglich. Alle Revolutionen auf den Straßen der Stadt führten Verrückte mit weit aufgerissenen Augen an, die aus entfernten Landstrichen stammten, so kam es jedenfalls den Berlinern vor, und das galt auch für Hitler.

Verspüren Berliner Heimweh, dann weniger nach den Schinkel-Bauten und der Siegessäule als nach dem Geruch des Sommers an den Havelseen, nach dem säuerlichen Geschmack der Faßbrause, nach der schäumenden scharfen Berliner Weiße mit einem Schuß Himbeer oder Waldmeister, nach den Lichtern der Schuhgeschäfte auf der Tauentzienstraße im Winter, nach einem Teller Aal grün im Hotel Berlin, nach einem Artikel in der Abendausgabe einer Lokalzeitung über das Sexualleben des inzwischen verstorbenen Nilpferdbullen Knautschke im Zoologischen Garten. Die Geschichte ließ gelegentlich die Berliner vornehmer erscheinen. Häufiger allerdings machten despotische Regimes die Bürger der Stadt zu Narren. Alles, was sie sich von ihrer großen Stadt erwarten, ist, gemütlich zu sein und künftig die schlechte Gewohnheit sein zu lassen, sprunghafte Entwicklungen zu vollführen. Angesichts der Photographien im vorliegenden Band erscheint dies jedoch nicht sehr wahrscheinlich.

Pfaueninsel. Summer on the Havel lakes.
Photo 1913.

Auf der Pfaueninsel, Sommer 1913.

1900–1918
UNTER DEN LINDEN
UNTER DEN LINDEN

In the early years of the twentieth century, Berlin was still a nineteenth-century capital. Alongside the neo-classical architecture and the calm leafy avenues of a European metropolis, these photographs reveal the shadows of a revolution, which will continue to be perceptible for a hundred years. They show the public reclaiming the streets which are filled with new forms of transport, street-traders, and curious flâneurs, in order to define the metropolis for their own use and not just for the display of official power—a tension which will recur throughout the city's later history. At the beginning of the twentieth century, this popular ownership is still precarious, however, as we see in the photographs where the streets are deserted, and the planned city regains control.

The crowded interiors of factory and home too display archaeological traces, with medieval squalor and neo-classical architecture forming incongruous settings for the new working practices of industrialization. Leisure pursuits show a preoccupation with new-fangled machinery, and while the theatre still revisits old themes, the life of the modern city itself becomes an object of fascination in entertainments such as "Berlin bei Nacht", and "Metropol".

Zu Anfang des 20. Jahrhunderts war Berlin noch eine Stadt des 19. Jahrhunderts. Jenseits der neoklassizistischen Architektur und den ruhigen baumbestandenen Boulevards einer europäischen Metropole vermitteln die Aufnahmen bereits die Vorahnung einer Revolution, die die nächsten einhundert Jahre bestimmen wird. Menschen, neue Transportmittel ebenso wie Straßenhändler und neugierige Flaneure füllen die Straßen, die die neu entstandene Großstadt in ihrem Sinne prägen und dies nicht ausschließlich der Zurschaustellung offizieller Macht überlassen; dieses Spannungsverhältnis durchzieht die Geschichte Berlins vom Kaiserreich bis in die Gegenwart. Im frühen 20. Jahrhundert ist der Anspruch der einfachen Bürger auf den öffentlichen Raum allerdings noch nicht gesichert, wie wir an jenen Photographien sehen, die leergefegte Straßen zeigen und auf denen die Stadtplanung die Oberhand gewonnen hat.

Die Innenansichten von Fabriken und überfüllten Wohnungen zeigen, daß die mangelnden hygienischen Verhältnisse einerseits und die neoklassizistische Architektur andererseits für die neuen Produktionsmethoden des Industriezeitalters einen unvereinbaren Rahmen bilden.

Während das Theater in diesen Jahren auf traditionelle Stoffe zurückgreift, wird das moderne Großstadtleben selbst faszinierendes Thema von Unterhaltungsrevuen wie »Berlin bei Nacht« und »Metropol«.

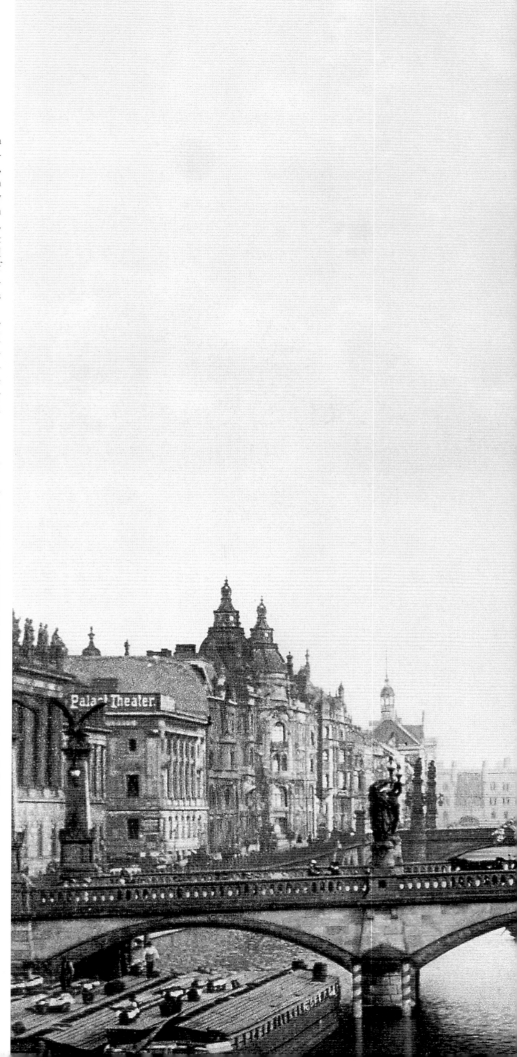

View of the cathedral and Friedrichsbrücke from the Spree canal. The cathedral was built between 1983 and 1905 after designs by Julius Raschdorff and was the state church of the Hohenzollern dynasty. Photochrome c. 1905.

Blick von der Spree auf den zwischen 1893 und 1905 nach Entwürfen von Julius Raschdorff erbauten Dom und die Friedrichsbrücke. Der Berliner Dom war die Hofkirche der Hohenzollern, um 1905.

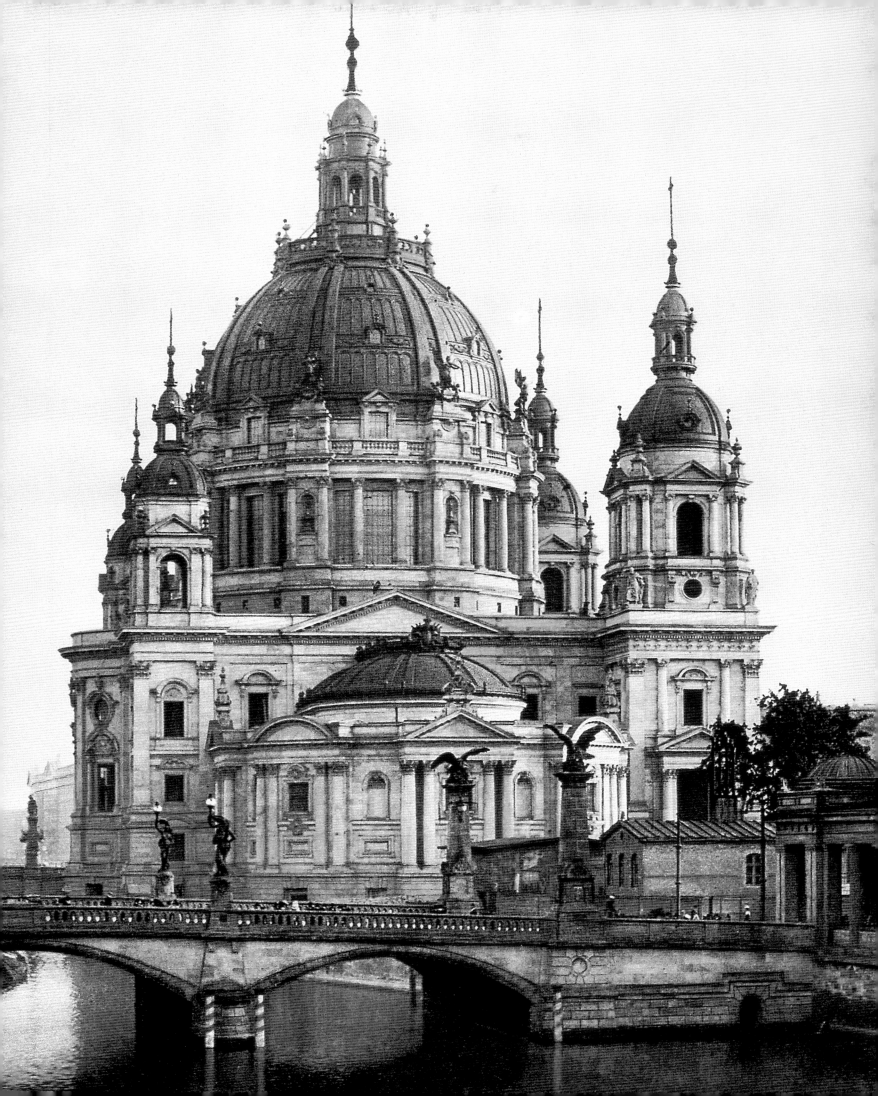

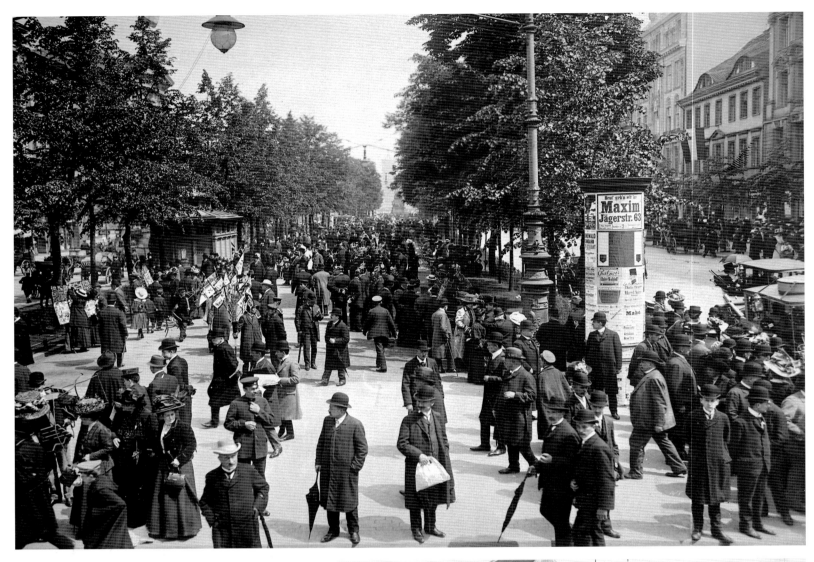

The hustle and bustle on the Lindenpromenade reflects the fact that by 1910 Berlin had become the social and economic centre of the German Reich. Photo 1910.

Der Trubel auf der Lindenpromenade belegt, daß sich Berlin bis zum Jahr 1910 zum geschäftigen und wirtschaftlichen Mittelpunkt des Deutschen Reichs entwickelt hatte, 1910.

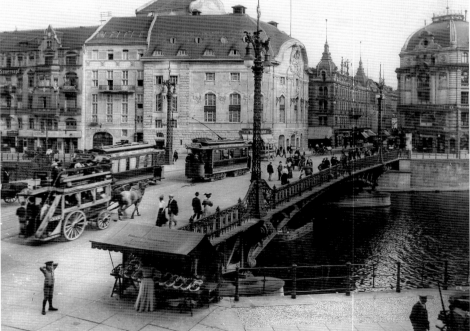

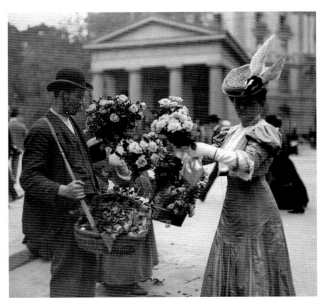

An itinerant flowerseller finds a customer on Potsdamer Platz. Karl Friedrich Schinkel's neo-classical guardhouse provides a backdrop. Photo 1910.

Ein fliegender Blumenhändler am Potsdamer Platz, im Hintergrund die von Karl Friedrich Schinkel entworfenen Torhäuser. 1910.

Trams and horse-drawn vehicles compete for passengers on Friedrichstraße and the Weidendammer Brücke. Photo 1906.

Straßen- und Pferdebahnverkehr auf der Friedrichstraße und der Weidendammer Brücke. 1906.

Passengers arriving at the Stettiner Bahnhof look on as their cases are unloaded from a hackney cab. Photo c. 1910.

Reisende treffen mit einer Kraftdroschke am Eingang des Stettiner Bahnhofs ein, um 1910.

A birds-eye view of street life at the junction of Leipziger Straße and Friedrichstraße. Photo c. 1910.

Straßenszene an der Kreuzung von Leipziger Straße und Friedrichstraße, um 1910.

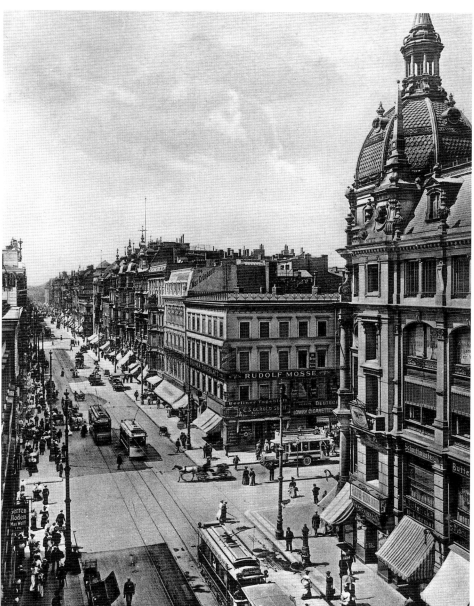

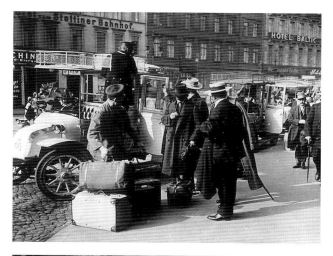

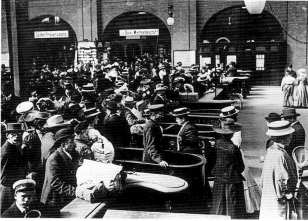

Crowds push through the platform barriers at the Stettiner Bahnhof. Berlin had never had a central station but the district stations became local landmarks during the nineteenth century. Photo c. 1908.

Gedränge an der Bahnsteigsperre im Stettiner Bahnhof, um 1908. 1876 wurde ein neues Empfangsgebäude für diesen Bahnhof errichtet; nach der Zerstörung im Zweiten Weltkrieg wurde er teilweise wiederaufgebaut und in Nordbahnhof umbenannt.

Horse-drawn vehicles cross electric tramlines at the corner of Französische Straße and Friedrichstraße. The famous arcade, the Kaisergalerie, is visible in the back left of the picture. Photo c. 1908.

Die Friedrichstraße/Französische Straße, um 1908. Links hinten die Kaisergalerie, eine der berühmten Passagen des 19. Jahrhunderts.

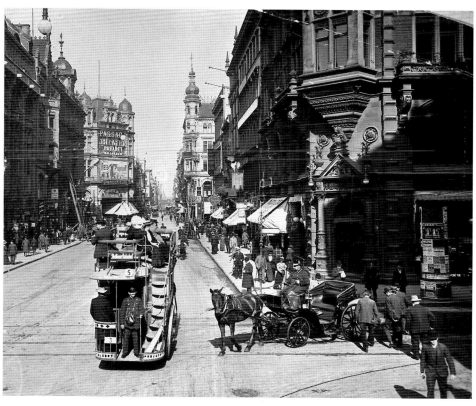

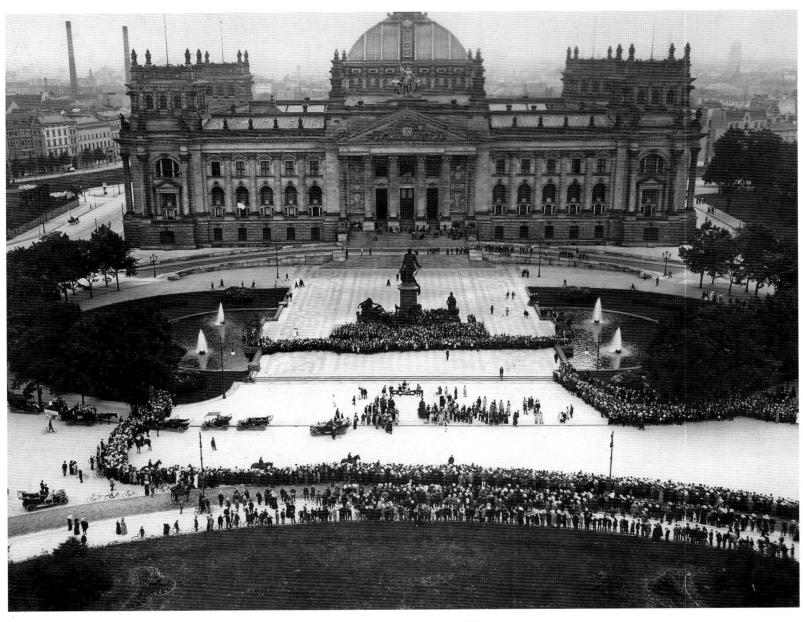

Dwarfed by the monumental edifice of the
Reichstag, Bismarck's memorial still towers
above the crowds who have gathered to watch
the finish of the Potsdam–Berlin relay race.
Photo February 16, 1912.

Blick von der Siegessäule auf das Reichstags-
gebäude und das Bismarck-Denkmal. Dieses
Foto entstand am 16. Februar 1912 anläßlich
des Stafettenlaufs Potsdam-Berlin, dessen Ziel
das Bismarck-Denkmal war.

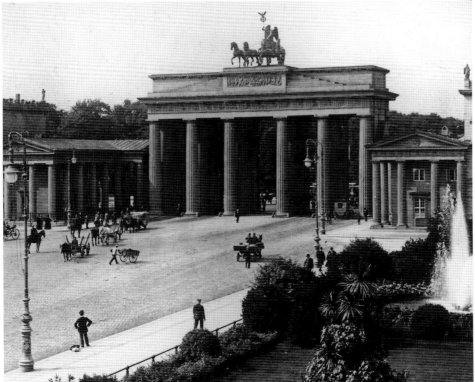

The Brandenburg Gate, perennial symbol of
Berlin, was built by C. G. Langhans between
1788 and 1791. Seen here from the east, with
the Pariser Platz in the foreground, it is crowned
by J. G. Schadow's Quadriga. Photo 1902.

Der Pariser Platz mit dem Brandenburger Tor,
1902. Das Brandenburger Tor, 1788 bis 1791
von Carl Gotthardt Langhans erbaut und als
Stadttor Teil der Akzisemauer, wurde zwei Jahre
nach seiner Fertigstellung durch Johann Gott-
fried Schadows Quadriga ergänzt.

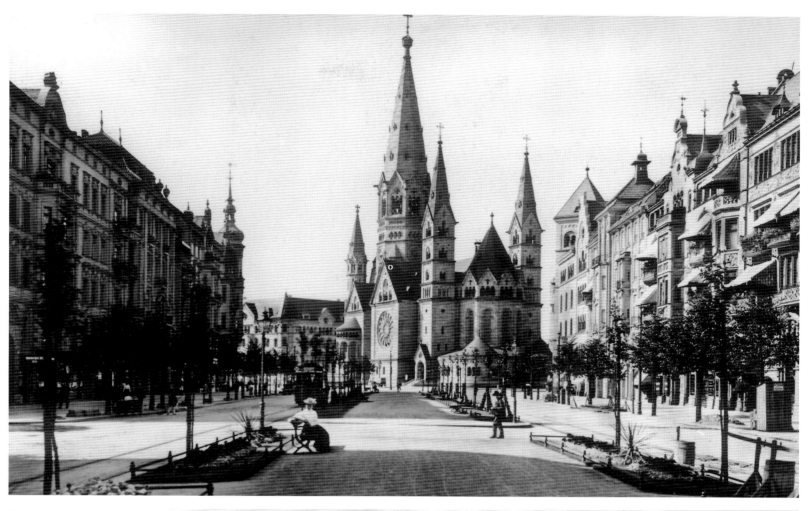

The neogothic spires of the Kaiser-Wilhelm-Gedächtniskirche soar skywards from the Tauentzienstraße. Designed by Franz Schwechten and built between 1891 and 1895, the church was named after the Kaiser's grandfather: a controversial choice, but in keeping with the nationalistic spirit of the age. Photo 1905.

Blick von der Tauentzienstraße auf die Kaiser-Wilhelm-Gedächtniskirche, die von Franz Schwechten entworfen und zwischen 1891 und 1895 errichtet wurde. Die Namensgebung der Kirche zu Ehren Wilhelms I. war heftig umstritten.

The Hotels Bellevue and Palast, both designed in the late nineteenth century by Ludwig Heim, overlook the spacious north side of the Potsdamer Platz where it leads into the Königgrätzer Straße. Photo c. 1900.

Die Nordseite des Potsdamer Platzes mit dem Hotel Bellevue (1887 bis 1888 von Ludwig Heim erbaut), der Königgrätzer Straße und dem Palasthotel (1892 bis 1893 ebenfalls nach Entwürfen Ludwig Heims errichtet), um 1900.

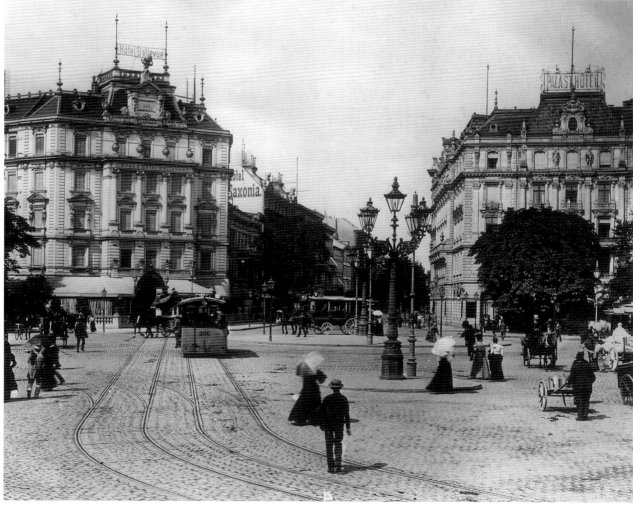

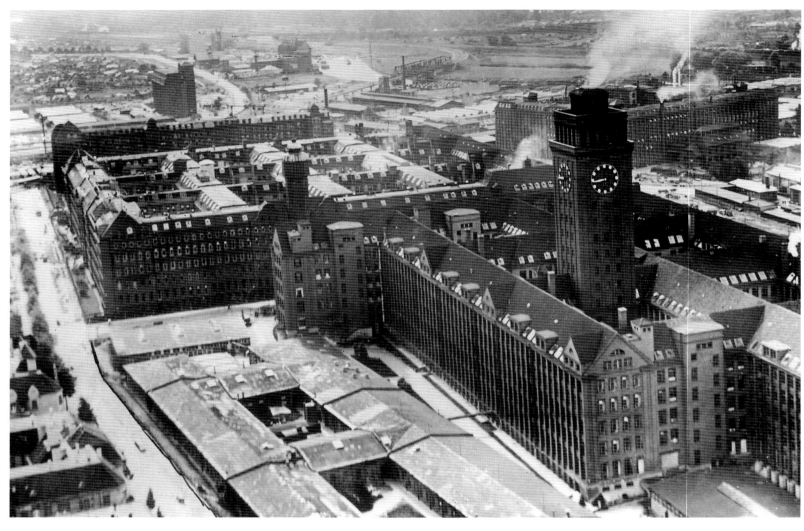

Siemens was one of the giants of German industry who were attracted to Berlin in the second half of the nineteenth century. Pictured here are the main office and factory buildings at the centre of Siemensstadt, the suburb named after the company. Photo c. 1914.

Hauptgebäude und Werksanlagen der Siemens AG in dem nach dieser Firma benannten Stadtviertel Siemensstadt zwischen der Spree und dem Hohenzollernkanal in Berlin-Spandau, um 1914.

The manufacture of steel nibs and stitching cards were among the activities of women factory workers. Stereoscopic photo c. 1905.

Stahlfederfabrikation und Kartennähen waren Tätigkeiten der in den Fabriken beschäftigten Frauen. Diese Aufnahme von 1905 war Teil einer stereoskopischen Aufnahme der Neuen Photographischen Gesellschaft Berlin-Steglitz.

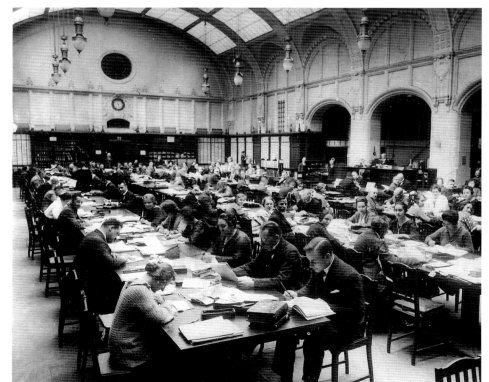

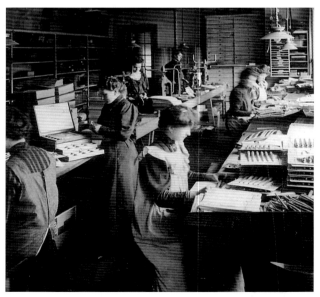

Interior of the patent office constructed in 1877 on the Gitschiner Straße in the district of Kreuzberg. Photo 1914.

Innenansicht der Auslegehalle des 1877 in der Gitschiner Straße in Berlin-Kreuzberg errichteten Patentamtes, 1914.

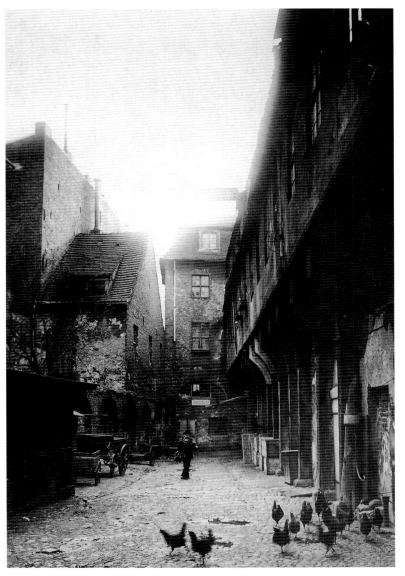

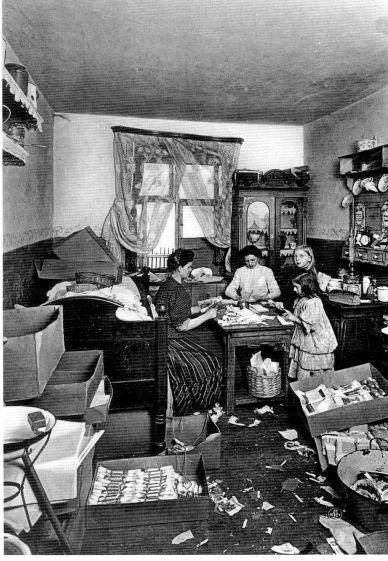

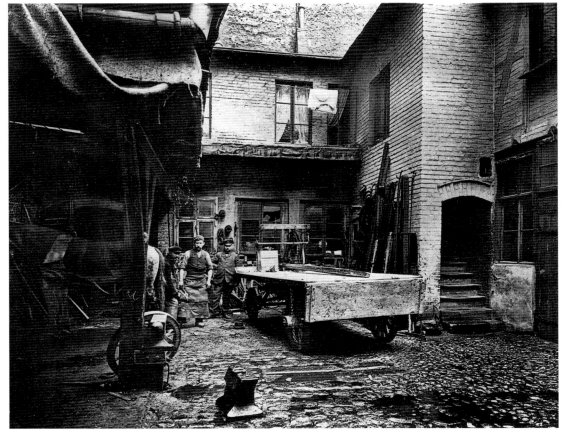

A view of the courtyard "Am Krögel" on the Fischerinsel in the Mitte district. A former trading area on the Spree canal, "Am Krögel" was one of Berlin's oldest residential districts. Photo 1910.

Blick in den großen Krögelhof auf der Fischerinsel in Berlin-Mitte. Das Wohnquartier Am Krögel, der ehemalige Stapelplatz an der Spree, zählte zu den ältesten Wohnbezirken in Berlin; Krieg und Nachkrieg führten zu einer vollständig neuen Bebauung dieses Quartiers.

The women of the family make festive crackers at their home in Manteuffelstraße. For many at that time, a cottage industry was the only way to make ends meet. Photo 1910.

In Heimarbeit fertigt eine Familie in ihrer Wohnung in der Manteuffelstraße 64 in Berlin-Lichterfelde Knallbonbons an, um 1910.

Living quarters at Möckernstraße in southwest Berlin. The courtyards were traditionally used for trading purposes by artisans and craftsmen. Photo 1904.

Wohngebäude in der Möckernstraße 115 im südwestlichen Berlin, 1904. Die Innenhöfe wurden traditionell zu gewerblichen Zwecken von Handwerkern und Gewerbetreibenden genutzt.

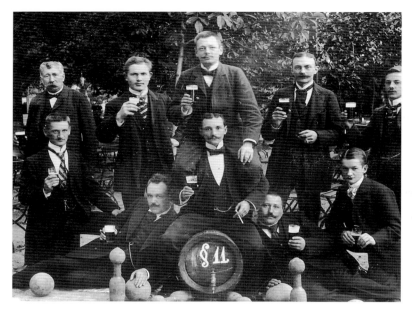

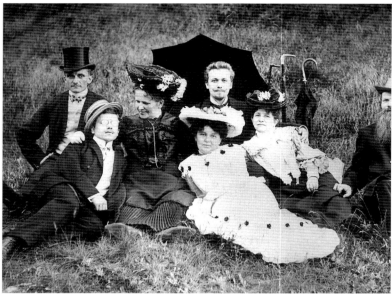

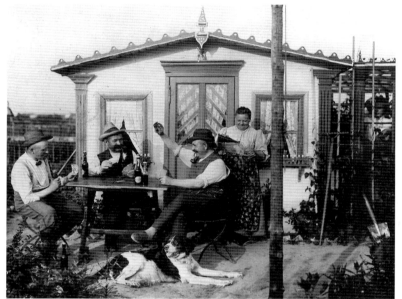

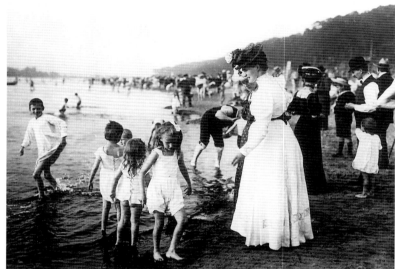

The members of a Berlin skittle club raise their glasses for the camera on a group excursion. Photo September 21, 1902.

Gruppenbild eines Berliner Kegelclubs bei einem Ausflug am 21. September 1902.

Simple pleasures: men on an allotment enjoy a round of skat in front of the summerhouse. Photo 1906.

Kleinbürgerliche Freuden: eine Skatrunde vor einer Schrebergartenlaube, 1906.

A favourite pastime in Imperial Berlin was a trip to the countryside. The city's green environs provided the perfect destination. Photo 1903.

Eine in der Kaiserzeit beliebte Freizeitgestaltung war der Ausflug ins Grüne. Die Aufnahme dieser Gesellschaft stammt von 1903.

Children enjoy paddling in the waters of the Wannsee. Berliners wanting a taste of the beach flocked to its shores in the summer months. Photo 1907.

Strandleben im Strandbad Wannsee, das ein sehr beliebtes Ausflugsziel der Berliner war und ist, um 1907.

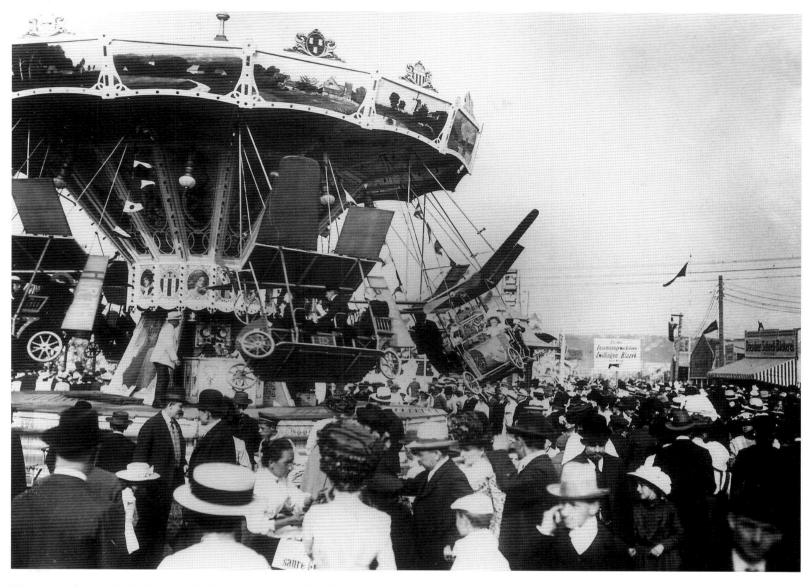

Three years after the Wright brothers flew from Berlin's Tempelhof field, would-be aviators enjoy a ride on the "Airplane Carousel" at a packed fun fair. Photo 1912.

Das »Aeroplan-Karrussell« auf einem Berliner Rummelplatz, 1912. Drei Jahre zuvor hatten die Gebrüder Wright auf dem Flugfeld Tempelhof ihr Können vorgeführt.

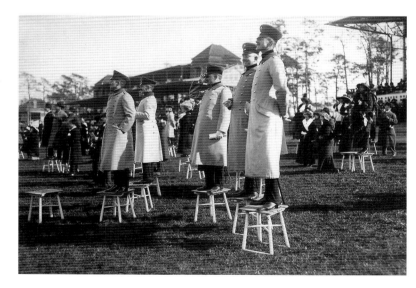

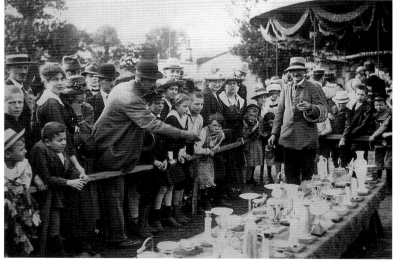

Identically clad officers strain to catch the action at the opening horserace of the season. The Grunewald racecourse in Berlin was laid out in 1906/07 according to designs by Carl March. Photo April 9, 1912.

Zuschauer beim Eröffnungsrennen der Rennsaison am 9. April 1912 auf der Rennbahn Berlin-Grunewald. Diese war 1906/07 nach Entwürfen von Carl March angelegt worden.

Hoopla at a Berlin funfair. Photo c. 1920.

»Ringewerfen« auf einem Berliner Rummelplatz, um 1920.

The works of playwright Frank Wedekind were among those championed by Reinhardt at the Deutsches Theater. Thought to be taken at the Berlin premiere, this scene is from Wedekind's Spring Awakening. Photo November 20, 1906.

Szenenbild aus der Uraufführung von Frank Wedekinds »Frühlings Erwachen« am 20. November 1906 in den Kammerspielen des Deutschen Theaters.

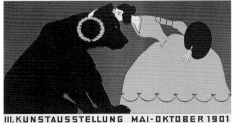

The artist Thomas Theodor Heine domesticates the mighty Berlin Bear in this poster advertising the 3rd Art Exhibition of the Berlin Secessionists. The group was formed in 1898 as a protest against the restrictive official line on art and numbered Max Liebermann, Walter Leistikow, and Paul Cassirer among its founder members. Colour lithograph, 1901.

Plakat für die III. Kunstausstellung der Berliner Secession von Thomas Theodor Heine, die als Künstlervereinigung gegen die offizielle Kunstpolitik Wilhelms II. von Max Liebermann, Walter Leistikow und Paul Cassirer im Mai 1898 gegründet worden war. Ihr gehörten die Maler an, die die künstlerische Moderne entscheidend prägten.

Theatre director Max Reinhardt, shown here at the time of his appointment to the directorship of the Deutsches Theater. He held this position between 1905 and 1920, and returned to it in 1924 for a further 9 years. Photo 1905.

Der Regisseur Max Reinhardt (Baden bei Wien 1873 – New York 1943), 1905. Während seiner Ägide als Direktor des Deutschen Theaters von 1905 bis 1920 und von 1924 bis 1933 entwickelte er eine revolutionäre impressionistisch-magische Theatersprache.

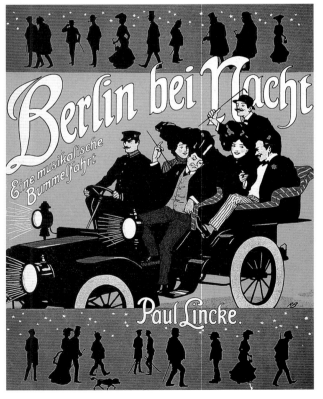

This operetta by the popular composer, Paul Lincke, invites its audience to enjoy a lighthearted musical journey through the city. Score cover 1907.

»Berlin bei Nacht. Eine musikalische Bummelfahrt« (1907), hier das Titelblatt des Notendrucks, war eine Operette des beliebten Operettenkomponisten Paul Lincke. Die deutsche Hauptstadt war damals neben Wien das Zentrum dieser unterhaltsamen Singspielform.

Wagner's operas were firm favourites with the Wilhelmine middle-classes. Hoffmann's Wotan supports Brünnhilde (Melanie Kurt) in this scene from "The Valkyrie", probably from a production in the Königliches Opernhaus. Photo c. 1915.

Wagners Opern waren beim Bürgertum der Kaiserzeit sehr beliebt. Szenenbild aus Richard Wagners »Walküre« mit Melanie Kurt als Brünnhilde. Diese Aufführung fand vermutlich im Königlichen Opernhaus statt, um 1915.

Wedekind's works provided the inspiration for G. W. Pabst's later film "Pandora's Box". The film created a scandal when it was released in Berlin in 1928/29. This publicity shot shows Louise Brooks in the title role.

Standfoto aus dem Film »Die Büchse der Pandora« (Deutschland 1928/29). Louise Brooks war die Hauptdarstellerin in diesem Skandalfilm, der nach Motiven aus Stücken Frank Wedekinds entstand.

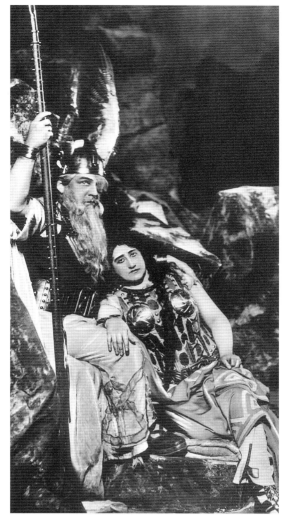

Although by this time electric trams were sweeping through the streets of Berlin, the cover of Albert Boehme's musical "Im Berliner Nachtomnibus" depicts the old-time horse-drawn bus. Score cover c. 1910.

Obwohl im Ersten Weltkrieg bereits elektrische Straßenbahnen durch Berlin fuhren, zeigt das Titelblatt des Notendrucks »Im Berliner Nachtomnibus« einen von Pferden gezogenen Omnibus, um 1910.

"Hurra, wir leben noch!" [Hurrah, we're still alive] was to become a stock phrase for Berliners who prided themselves on a nightlife that continued long after Paris and London had gone to bed. It was originally the title of a revue at the Berlin Metropol. Score cover, 1910.

Zunächst Titel einer Revue, sollte der Ausruf »Hurra, wir leben noch!« zum geflügelten Wort der Berliner im Lauf der folgenden Jahrzehnte werden. Titelblatt des Notendrucks, 1910.

Tilla Durieux was one of the most renowned actresses of her time. Here she plays Queen Jocasta in Sophocles' tragedy "Oedipus Rex", directed by Max Reinhardt at the Deutsches Theater. Photo postcard c. 1910.

Tilla Durieux war eine der bedeutendsten Schauspielerinnen ihrer Zeit. Hier sieht man sie als Königin Jokaste in der Tragödie »König Ödipus« von Sophokles, die Max Reinhardt im Deutschen Theater inszenierte, um 1910.

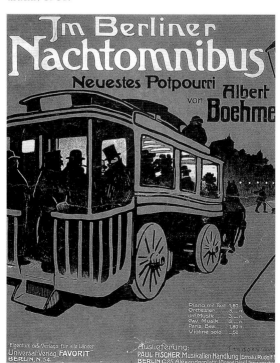

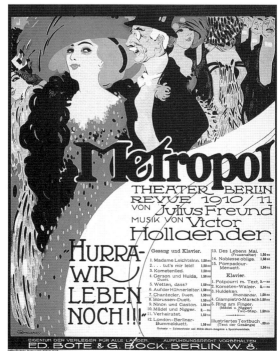

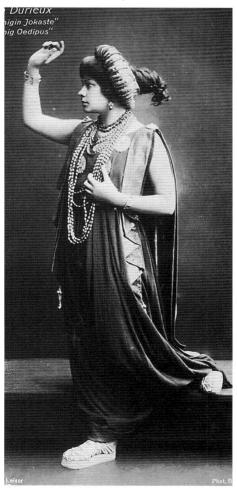

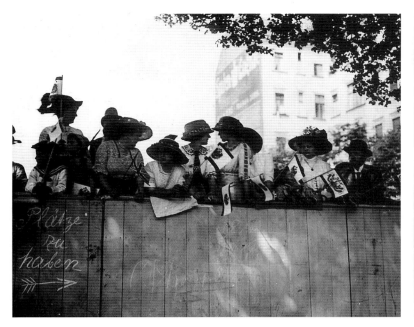

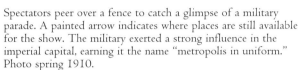

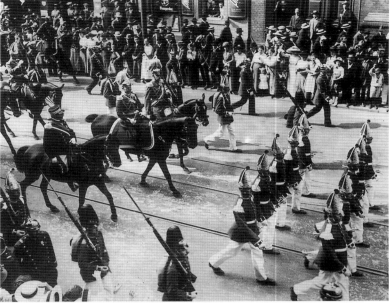

Spectators peer over a fence to catch a glimpse of a military parade. A painted arrow indicates where places are still available for the show. The military exerted a strong influence in the imperial capital, earning it the name "metropolis in uniform." Photo spring 1910.

Zuschauer auf einem Bauzaun während einer Militärparade, Frühjahr 1910. Die Hauptstadt des Kaiserreichs war stark vom Militär geprägt, man sprach sogar von einer »Metropole in Gardeuniform«.

Kaiser Wilhelm II returns from a parade on the Tempelhof field. The style adopted by the imperial court recalled the past days of Prussian might. Photo September 2, 1913.

Kaiser Wilhelm II. bei der Rückkehr von einer Parade auf dem Tempelhofer Feld, 2. September 1913. Der kaiserliche Hof pflegte einen hochartifiziellen imperialen Ausstattungsstil, der Bezug auf die preußische Vergangenheit nahm.

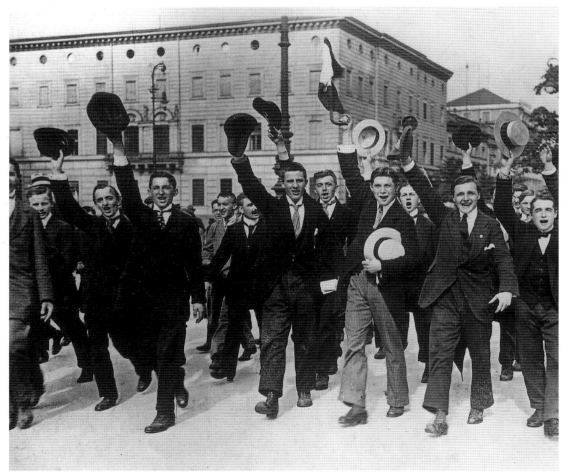

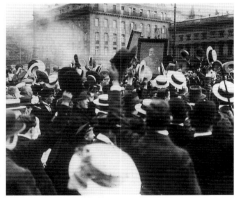

Euphoric Berliners on Pariser Platz hold aloft a picture of Emperor Franz Joseph of Austria, Germany's ally, whose ultimatum to Serbia triggered the start of the war. Photo August 1, 1914.

1. August 1914: Der Ausbruch des Ersten Weltkriegs wird von Berlinern, die ein Bild des mit dem Deutschen Reich verbündeten österreichischen Kaisers Franz Joseph tragen, auf dem Pariser Platz euphorisch gefeiert.

Patriotic young Germans add their jubilant voices to the hundreds of others on Pariser Platz at the outbreak of war. Photo August 1, 1914.

Patriotische Jugendliche auf dem Pariser Platz, 1. August 1914. Der Ausbruch des Krieges beendete die lange Phase eines sich immer stärker verdichtenden politischen Schwebezustands in Europa.

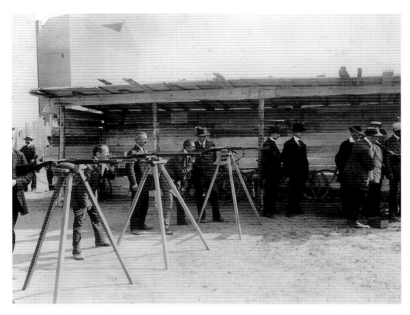

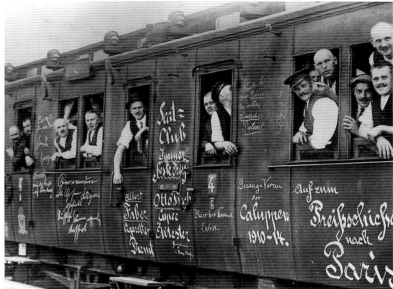

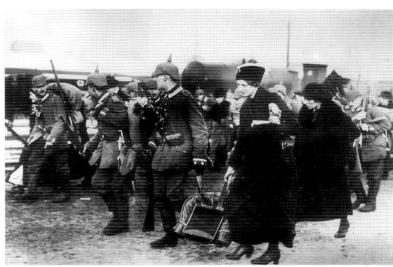

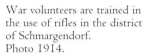

War volunteers are trained in the use of rifles in the district of Schmargendorf. Photo 1914.

Kriegsfreiwillige werden in Berlin-Schmargendorf am Gewehr ausgebildet, 1914.

"Off to the Paris Prize Shooting Contest" reads the graffiti. There was a spirit of optimism and confidence amongst the departing troops that the war would soon be over—and won. Photo August 28, 1914.

Ein Truppentransportzug am 28. August 1914 in einem Berliner Bahnhof. Noch waren die Soldaten zuversichtlich, daß der Krieg bald siegreich beendet sein würde.

Winter 1914: more soldiers leave for the front. Here, women accompany their husbands to the troop trains. Photo 1914.

Winter 1914. Frauen begleiten ihre zum Militär eingezogenen Ehemänner zu den Zügen.

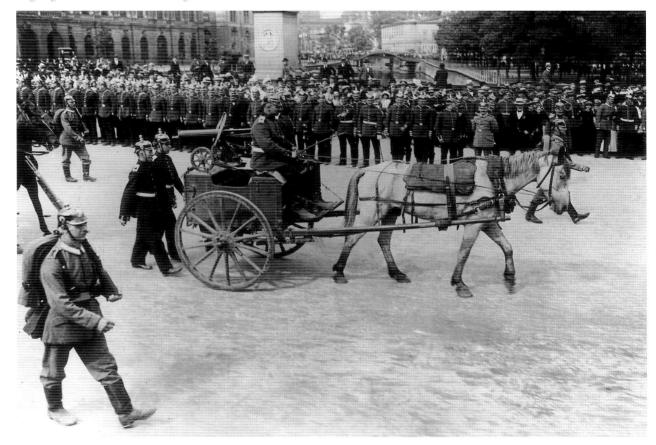

After just one month of fighting, German troops ceremoniously present spoils of war. Here a Russian cart and machine gun are paraded near the Schlossbrücke. Photo September 2, 1914.

Bei einer feierlichen Truppenparade am 2. September 1914 werden erbeutete Kriegstrophäen und Spolien vorgeführt, so ein auf einem Pferdekarren montiertes Maschinengewehr der russischen Armee.

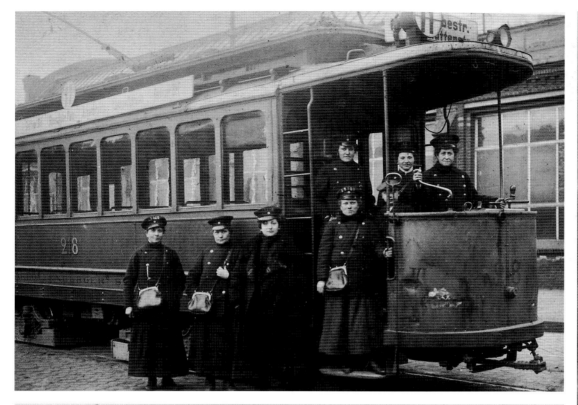

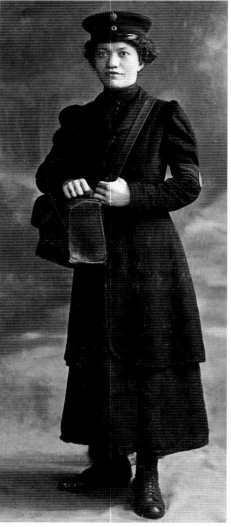

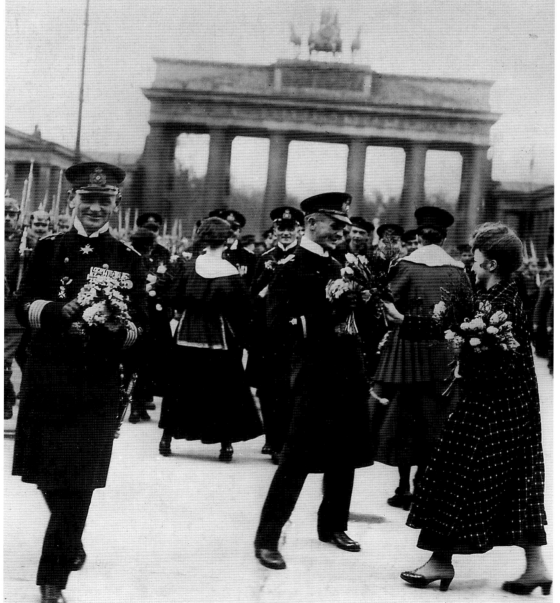

Women conductors and driver on a Char-
lottenburg tram during World War I.
Photo 1917.

Schaffnerinnen und Fahrerin einer Straßenbahn
im Kriegseinsatz auf der Berlin-Charlottenburger
Straßenbahn, 1917.

A Berlin postwoman poses for the camera.
Photo 1917.

Leichtere Tätigkeiten in Fabriken, im Transport-
wesen oder in anderen Bereichen des öffentlichen
Dienstes, wie z. B. der Post, waren typische
Arbeitsfelder von Frauen während der Kriegs-
jahre, 1917.

The successes of the auxiliary cruiser "Wolf" in
mining and anti-trade shipping campaigns fuelled
the ongoing belief in a German victory even as
late as 1918. Women welcome back the ship's
officers and sailors with flowers in front of the
Brandenburg Gate. Photo March 25, 1918.

Noch Anfang 1918 herrscht in Deutschland
Siegeszuversicht. Am 25. März 1918 begrüßen
Damen die Offiziere und Mannschaften des
Hilfskreuzers »Wolf« am Brandenburger Tor.
Die »Wolf« hatte seit Ende 1916 erfolgreich am
Minen- und Handelskrieg im Atlantik teilge-
nommen.

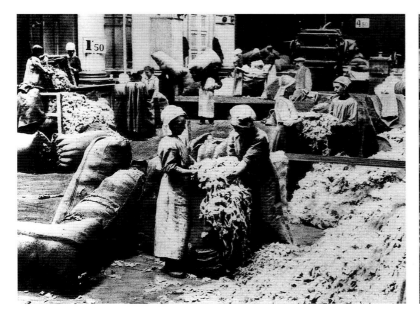

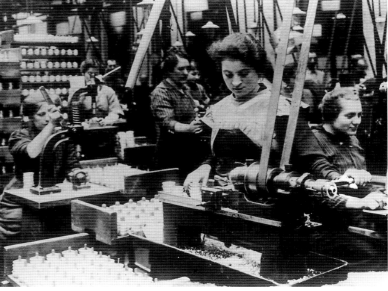

Wool is sorted according to quality. Such "light" work was typical of the jobs undertaken by women at the start of the war. Photo 1917.

Die Kriegswirtschaft war wesentlich auf Frauenarbeit angewiesen. Hier sortieren Frauen Wolle nach verschiedenen Qualitäten, 1917.

As more men went away to war, women were assigned to increasingly technical tasks in industry, such as here the production and mounting of fuses. Photo c. 1917.

Im Lauf des Ersten Weltkriegs werden Frauen verstärkt in der Rüstungsindustrie eingesetzt, 1917: Frauen bei der Herstellung und Montage von Zündern.

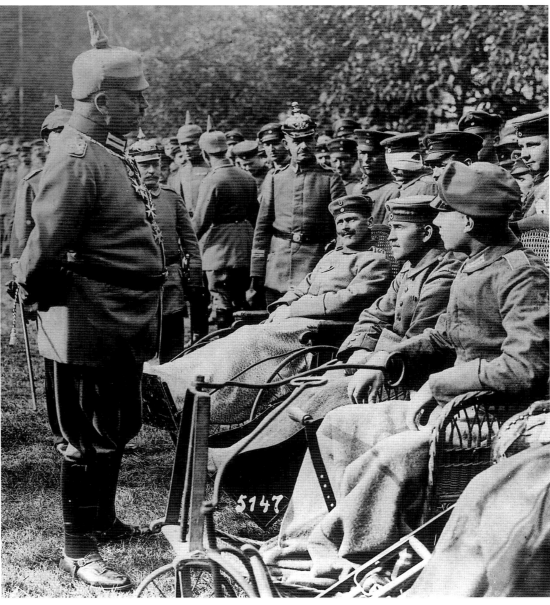

Field Marshal von Hindenburg greets warwounded veterans on his 70th birthday. Photo October 2, 1917.

Generalfeldmarschall Paul von Hindenburg begeht seinen 70. Geburtstag am 2. Oktober 1917 mit einem Empfang von Kriegsverletzten und -versehrten.

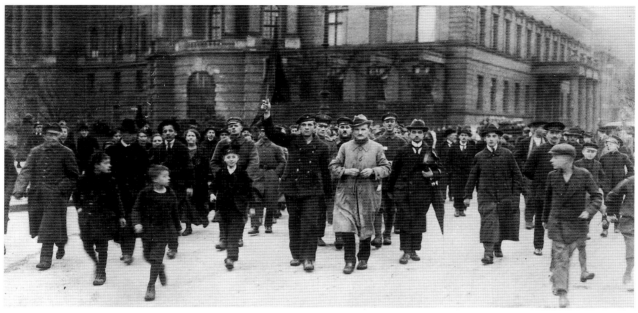

Revolution followed capitulation in Germany's capital and troops were quick to join the strikers. Demonstration on Unter den Linden. Photo November 9, 1918.

Nach der Kapitulation Deutschlands im November 1918 brach die November-revolution aus. Am 9. November 1918 schließen sich Truppenteile den Streikenden an.

A soldier buys food supplies which another soldier is reduced to selling. Photo November 1918.

November 1918: Ein Soldat kauft Ersatzlebensmittel ein.

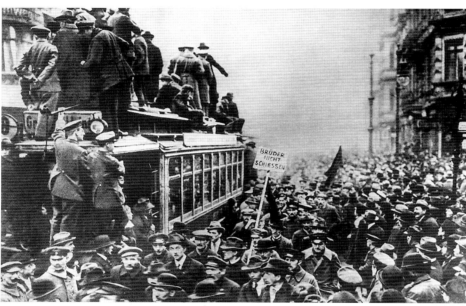

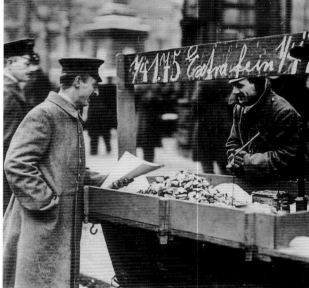

Demonstration and counter-demonstration in the Zimmerstraße. A placard pleads: "Don't shoot your brothers." Photo November 1918.

Demonstration und Gegendemonstration in der Zimmerstraße, 1918. Unübersehbar ist der Wunsch, daß kein Blut vergossen werden soll.

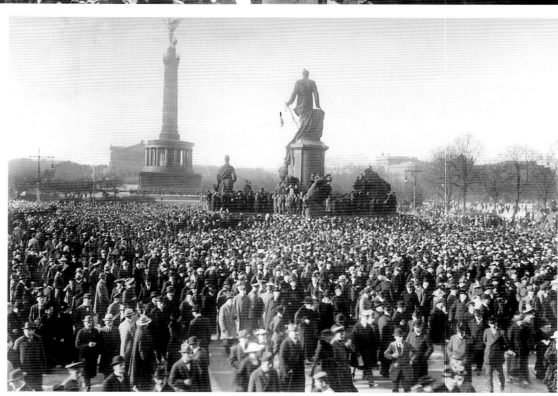

Thousands rally on Königsplatz in front of the Reichstag. The Siegessäule [victory column] and Bismarck Memorial, isolated symbols of imperial Berlin, tower over the revolutionary masses. Photo November 10, 1918.

Auf dem Königsplatz vor dem Reichstagsgebäude findet am 10. November 1918 eine Massenkundgebung statt; im Hintergrund die Siegessäule (1939 in den Tiergarten versetzt) und die Krolloper (im Zweiten Weltkrieg zerstört).

Soldiers who had left an imperial city returned to a precarious republic. They are greeted by Friedrich Ebert as they pass through the Brandenburg Gate. In the following year the Social Democrat Ebert was elected the first President of the Weimar Republic. Photo August 1918.

Friedrich Ebert, der Vorsitzende des Rats des Volksbeauftragten, begrüßt heimkehrende Truppen, die durch das Brandenburger Tor einziehen. Im folgenden Jahr wird der Sozialdemokrat Ebert zum ersten Staatspräsidenten der Weimarer Republik gewählt, August 1918.

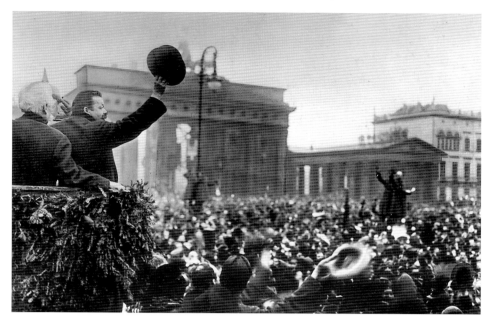

Released French prisoners of war fraternize with German soldiers on Potsdamer Platz at the end of the war. Photo November 1918.

November 1918: Deutsche Soldaten verbrüdern sich wenige Tage nach Ende des Krieges mit freigelassenen französischen Kriegsgefangenen auf dem Potsdamer Platz.

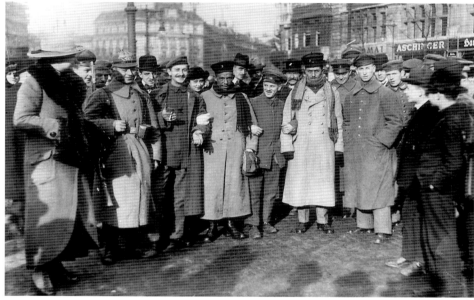

The 37th cavalry division, pictured here on Pariser Platz, returns home to Berlin. Photo December 17, 1918.

Heimkehr der Truppen: die 37ste Kavalleriedivision auf dem Pariser Platz, 17. Dezember, 1918.

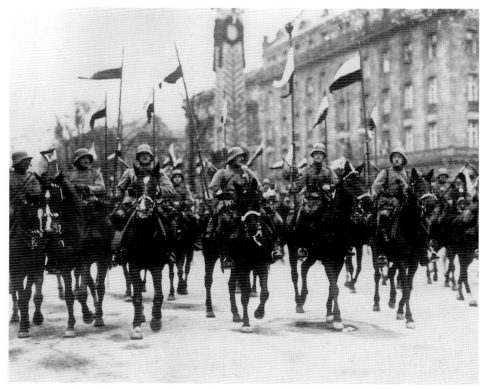

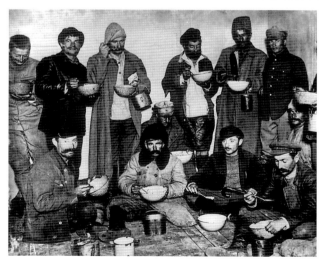

Prisoners of war from all over Germany return home from captivity in Siberia. They are cared for by the POW medical service as they travel through Berlin. Photo c. 1919.

Rückkehr deutscher Kriegsgefangener aus Sibirien. Während der Durchreise werden Heimkehrer durch die Kriegsgefangenenfürsorge in der Hauptstadt verpflegt, um 1919.

1919–1933
THE NEW REALITY
DIE NEUE REALITÄT

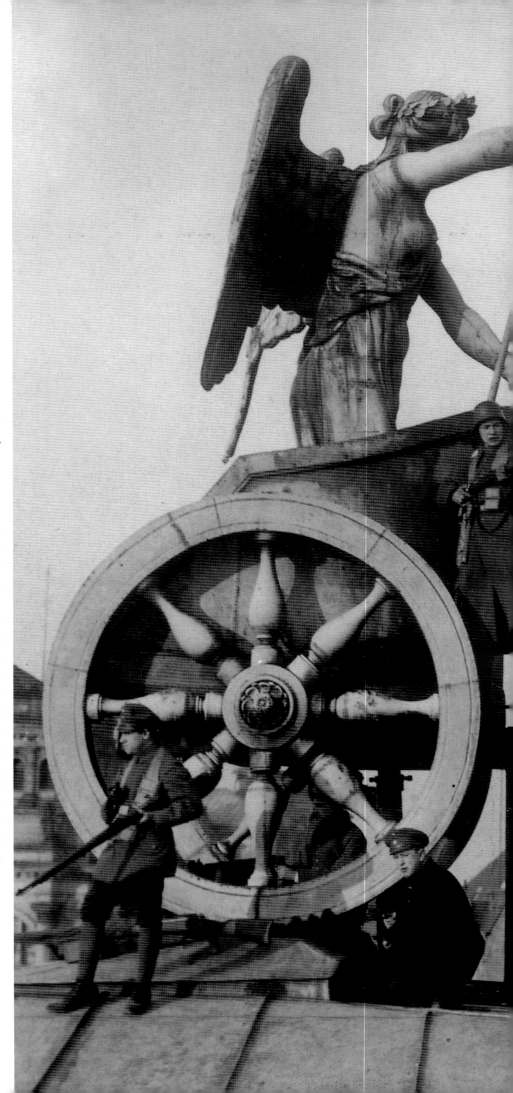

During the period 1919 to 1933 Berlin reinforced its reputation as a cultural centre. Its social and economic conditions were specific to a country suffering the costs of war reparations; yet the cultural life of Berlin attracted and nourished immigrants, artists, and writers from many other countries, who in turn contributed to the city's legendary image.

If pre-war Berlin had defined the modern life of the crowd against an anachronistic backdrop, post-war Weimar Berlin sought to explore the identity of the individual lost in the crowd. The streets were both battleground and marketplace, where the price of commodities, both human and inanimate, were re-evaluated daily. Ways of spending time—like spending money—took on a new scale and significance. Children and the unemployed queued in lines seemingly without end; other groups passed the hours playing cards, or in waiting rooms and cafés. Group sports encouraged the cult of the body which was perhaps reflected and satirized by the sexually adventurous cabaret shows of the period. A new architecture attempted to shape modern city-dwellers through clean, functional spaces epitomized by the work of Bruno Taut, Mendelsohn, and Fahrenkamp. This period also offered dystopian realities in Expressionism, Dada, and Brecht.

In den Jahren zwischen 1919 und 1933 verstärkte sich Berlins Ruf, Zentrum der Künste zu sein. Die sozialen und ökonomischen Rahmenbedingungen wurden von den zu zahlenden Kriegsreparationen bestimmt; das kulturelle Leben der Hauptstadt zog aber Einwanderer aus vielen Ländern an, die ihrerseits am legendären Ruf der Stadt mitwirkten.

Wenn das Vorkriegs-Berlin dem modernen Leben der Menschen einen anachronistisch anmutenden Hintergrund gegeben hatte, so war man im Berlin der zwanziger Jahre bestrebt, die Individualität des Menschen als Einzelperson in der Masse auszuloten. Die Straßen waren zugleich Kampf- und Umschlagplatz, auf dem der Preis von Waren, seien sie nun Mensch oder Ding, täglich von neuem festgesetzt wurde. Die Freizeitvergnügungen gewannen wie das Vergnügen am Konsum an Bedeutung. Kinder und Arbeitslose standen in scheinbar endlosen Warteschlangen an; andere überbrückten die freie Zeit mit Kartenspiel oder mit dem Warten in Cafés. Gemeinschaftlich betriebener Sport rückte den Körperkult in den Mittelpunkt, der in den erotisch gewagten Cabaret-Darstellungen jener Zeit aufgenommen und satirisch überspitzt vorgeführt wurde. Eine neue Architektur versuchte, den modernen Stadtbewohner durch die Art des Gebäudeentwurfs zu verändern: Klare funktionelle Raumanordnungen fanden ihren exemplarischen Ausdruck in den Bauten Bruno Tauts, Erich Mendelsohns und Erich Fahrenkamps. Die Kultur dieser Epoche erstreckte sich von den negativen Utopien des Expressionismus über Dada bis zum Theater Brechts.

One arm raised, the goddess on the Quadriga seems to shield her eyes from the violent scenes in the city below. The removal of police chief Eichhorn on January 4, 1919 triggers the Spartacus Uprising, which was finally crushed on January 15. Government troops stand guard on the Brandenburg Gate.
Photo January 1919.

Die Absetzung des Berliner Polizeipräsidenten Eichhorn am 4. Januar 1919 löst den Spartakusaufstand aus, der erst am 15. Januar niedergeschlagen wird. Regierungstreue Truppen halten die Quadriga auf dem Brandenburger Tor besetzt.

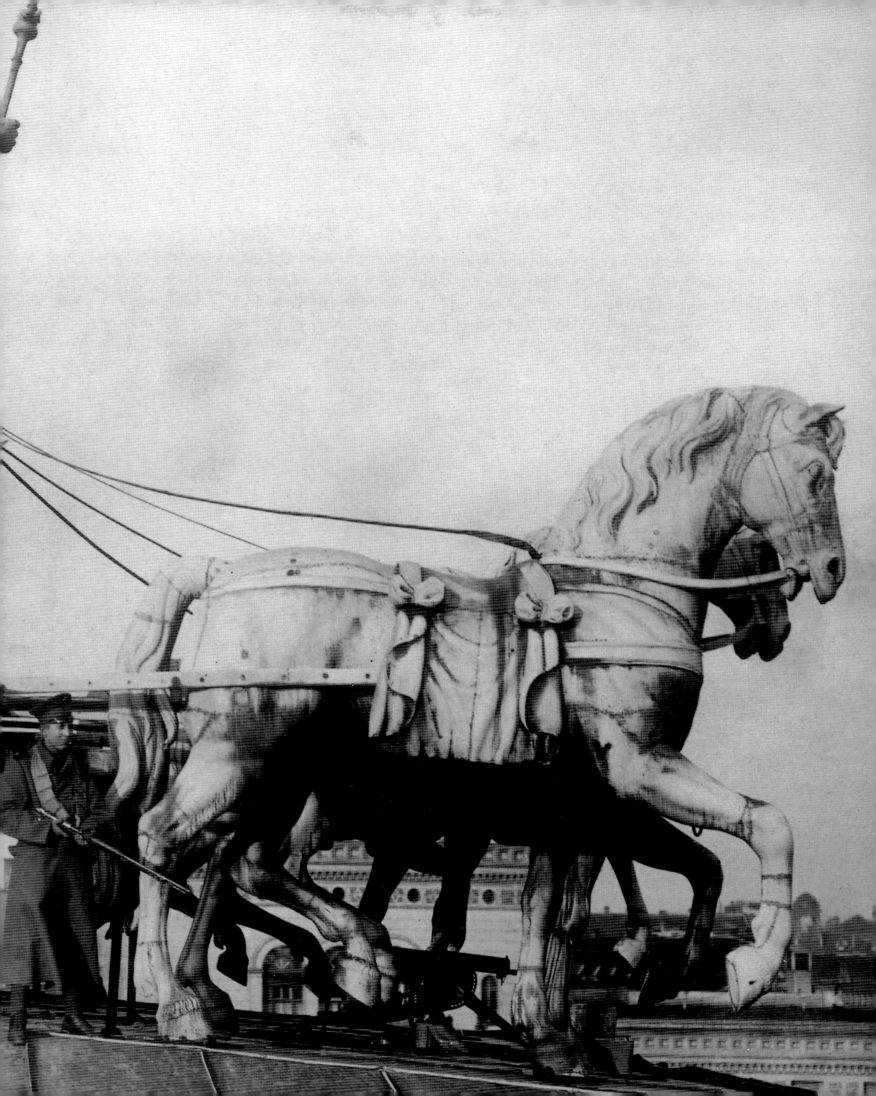

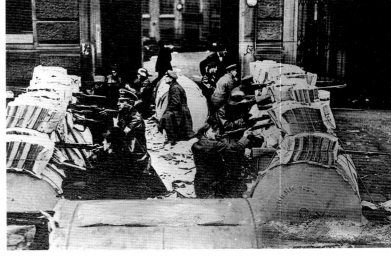

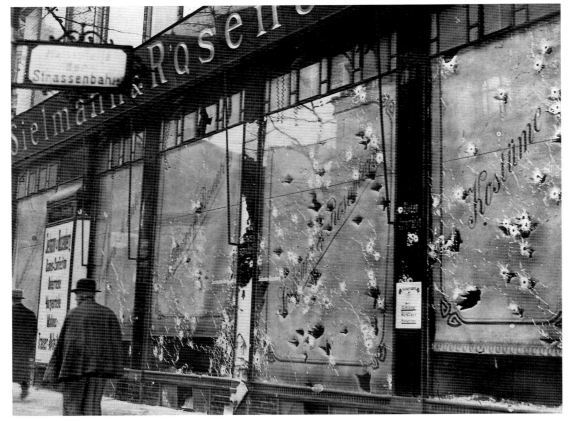

A government soldier keeps watch beneath the Brandenburg Gate during the Spartacus Uprising. Photo January 1919.

Spartakusaufstand: Ein Soldat der Regierungstruppen neben einer Kanone unter dem Brandenburger Tor. Januar 1919.

Bundles and rolls of paper reinforce the barricades during fierce street fighting in the newspaper district. Photo January 1919.

Im Berliner Zeitungsviertel rund um die Leipziger Straße werden während des Aufstands erbitterte Straßenkämpfe geführt.

Bullet holes in the windows of a shop in the Lindenstraße at the end of the Spartacus Uprising testify to the bloody battles. Photo January 1919.

Das Ende des Spartakusaufstandes: zerschossene Schaufenster eines Geschäfts in der Lindenstraße in Berlin-Mitte. Januar 1919.

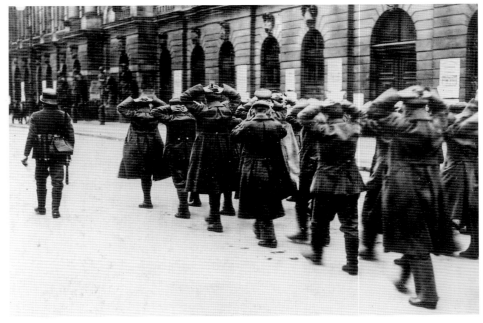

Soldiers of the Republican movement who joined the Spartacists are led away by government troops. Photo January 1919.

Soldaten, die sich den Spartakisten angeschlossen hatten, werden von Regierungstruppen nach ihrer Festnahme abgeführt.

Artillery was soon rolling through the streets in the bid to take the capital. Photo March 1920.

Während des Kapp-Putsches sieht man in den Berliner Innenstadtbezirken schwerbewaffnete Truppen, März 1920. Nach vier Tagen bricht der Putsch durch einen Generalstreik der Gewerkschaften zusammen.

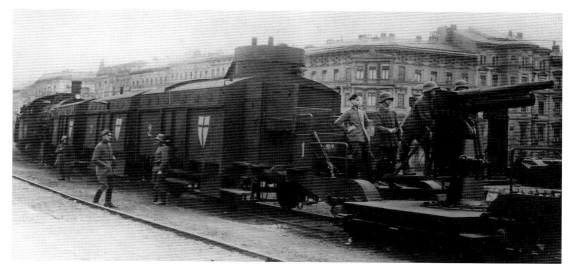

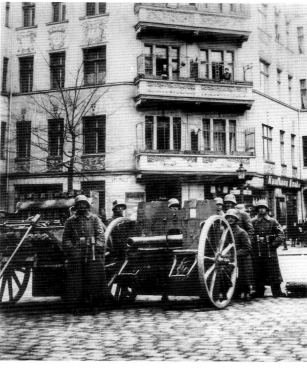

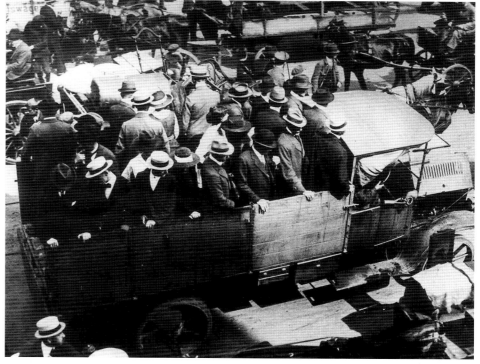

Right-wing politicians led by Wolfgang Kapp join troops under General von Lüttwitz in an abortive coup, the so-called "Kapp Putsch." Rebel artillery post on the corner of Weise-straße in Neukölln. Photo March 1920.

Mitte März 1920: Kapp-Putsch, Rechtskonservative Politiker unter Führung von Wolfgang Kapp versuchen mit Unterstützung von General von Lüttwitz und dessen Truppen, die Macht an sich zu reißen. Aufständische Artilleristen in der Weisestraße in Berlin-Neukölln.

A general strike ultimately brought down the Kapp putschists. In the chaos, passengers on Potsdamer Platz return to old-fashioned forms of public transport to get around. Photo March 1920.

Lastwagen, Pferde und Pferdegespanne ersetzen während des gegen den Kapp-Putsch gerichteten Generalstreiks auf dem Potsdamer Platz den Bus- und Straßenbahnverkehr.

Berliners are forced to fetch water from a street pump during the general strike. Photo March 1910.

Infolge des Generalstreiks müssen die Berliner ihr Wasser an öffentlichen Pumpen schöpfen.

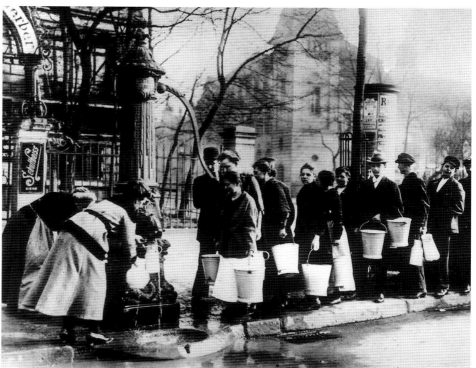

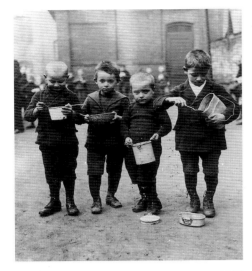

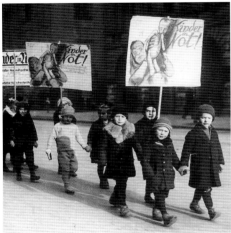

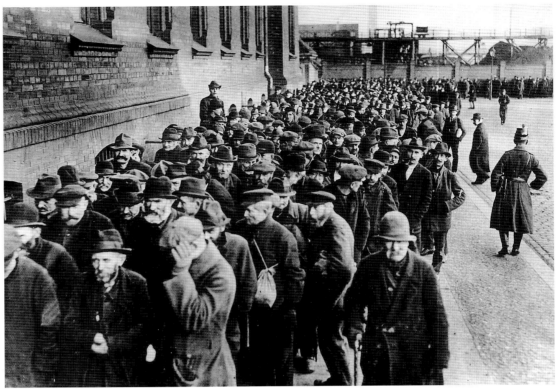

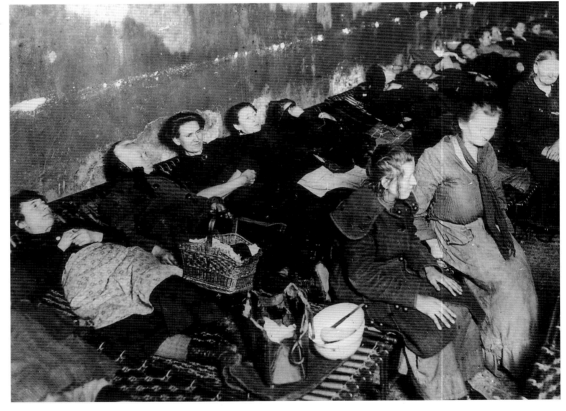

Poverty and hardship were everywhere in the years following the end of the war. Malnourished children receive food from a soup kitchen. Photo c. 1920.

Not und Elend in der jungen Demokratie: Essensausgabe an unterernährte Berliner Kinder, um 1920.

The haunting graphic art of Käthe Kollwitz is paraded on placards by children marching for German Children's Aid. A public meeting was held in aid of suffering children in front of the Klosterstraße church. Photo November 1920.

Werbezug von Kindern für eine Kundgebung der »Deutschen Kinderhilfe« und der »Volksversammlung für das notleidende Kind« vor der Parochialkirche in der Klosterstraße. Die Motive der Plakate stammen von Käthe Kollwitz, November 1920.

Hundreds of homeless Berliners queue outside a state hostel in Fröbelstrasse in Prenzlauer Berg. Photo c. 1920.

Warteschlange vor dem Einlaß des Städtischen Obdachlosenasyls in der Fröbelstraße im Bezirk Prenzlauer Berg, um 1920.

Women lie in rows in the bleak dormitory of a state hostel for the homeless. Photo 1920.

Der Schlafsaal für Frauen im Städtischen Obdachlosenasyl in der Fröbelstraße, um 1920.

Ever-increasing poverty means many Berliners can no longer afford to keep their pets and must queue to have them put to sleep. Photo c. 1922.

Eine Warteschlange vor einem Berliner Tierheim. Hundebesitzer stehen an, um ihre Tiere einschläfern zu lassen, um 1922. Die Armut ist zu groß, als daß man sich die steigende Hundesteuer leisten kann.

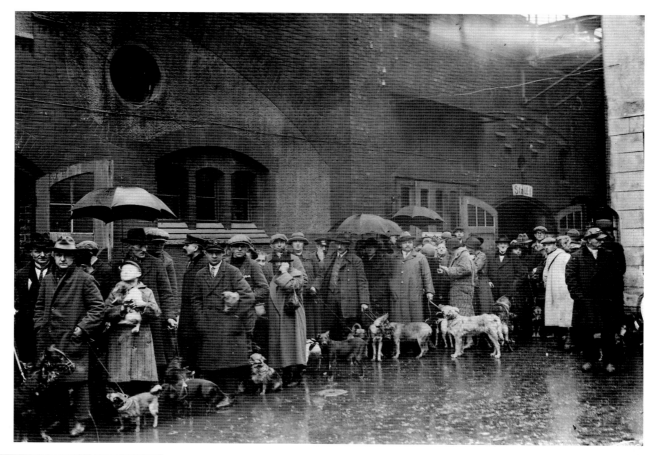

A baker adds up the day's takings at the height of inflation. Photo 1923.

Abrechnung der Tageseinnahmen eines Bäckermeisters, 1923. Die Inflation befindet sich auf einem Höhepunkt.

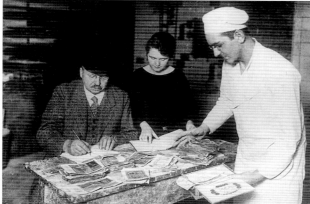

Berliners queue with cases to collect their money from the central bank. Photo 1923.

Schlange vor der Zentrale der Reichsbank, 1923. Die Leute stehen mit Koffern an, um ihr Geld abzuheben.

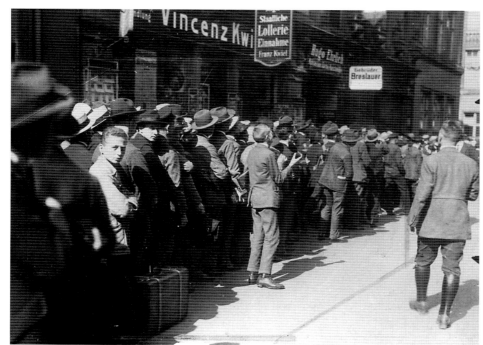

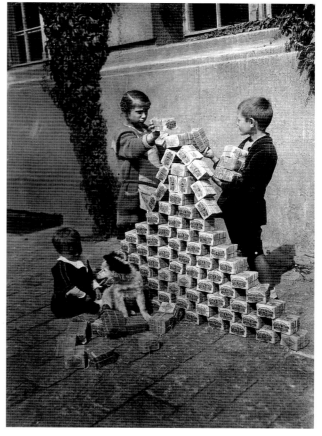

After the introduction of the "Rentenmark" to reduce inflation, the worthless old notes are fit only for child's play. Photo 1924.

Nach der Geldumstellung 1924 dienen alte gebündelte Geldscheine Kindern als Spielzeug.

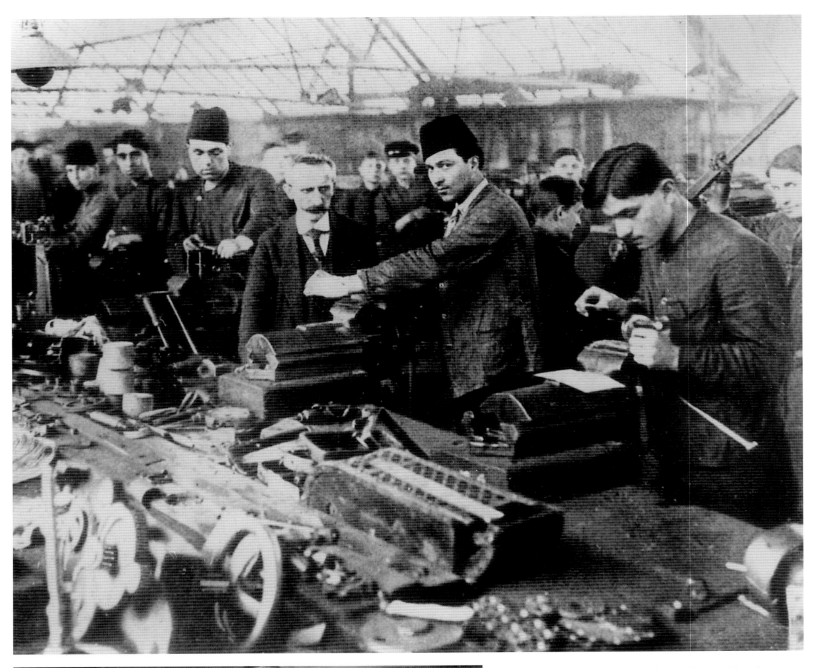

Turkish workers at the AEG transformer plant in Oberschöne-
weide near Berlin. Photo May 1917.

Türkische Arbeiter in den AEG-Transformatorenwerken in
Oberschöneweide bei Berlin, Mai 1917.

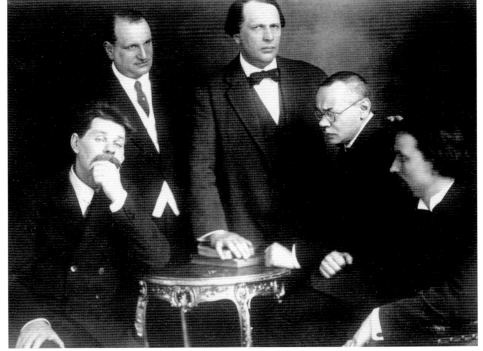

There was a large Russian émigré community in Berlin in the
1920s which numbered many intellectuals, artists, and writers
among those who had fled the Bolsheviks. This remarkable image
captures, from left to right, the writers Maxim Gorky, Amali
Rode, Alexei Tolstoy, Alexei Remisov, and Albert Pinkevitsch.
Photo 1922.

In den zwanziger Jahren ist die russische Kolonie in Berlin groß.
Zu den Emigranten, die während der Oktoberrevolution vor den
Bolschewisten ins Ausland geflohen waren, gehörten auch viele
Intellektuelle, Künstler und Schriftsteller. Dieses Gruppenbild
aus dem Jahr 1922 zeigt von links nach rechts die Schriftsteller
Maxim Gorki, Amali Rode, Alexej Tolstoi, Alexej Remisow und
Albert Pinkewitsch.

Exterior view of the Fasanen-
straße synagogue in
Charlottenburg, built by
Ehrenfried Hessel in 1911–12.
Photo 1930.

Außenansicht der Synagoge in
der Fasanenstraße in Berlin-
Charlottenburg, die in den
Jahren 1911/12 von Ehren-
fried Hessel erbaut wurde,
1930.

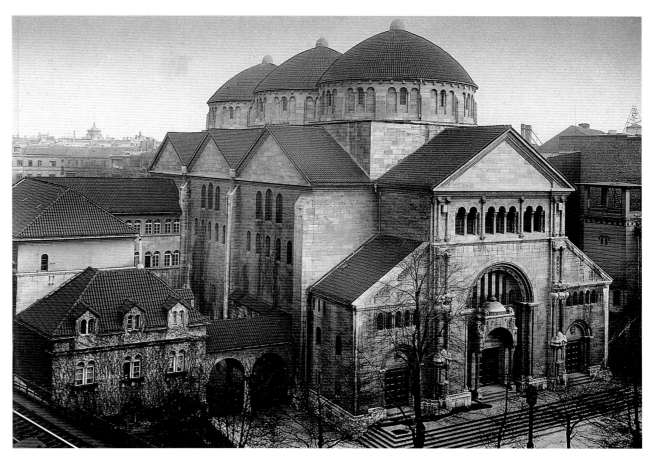

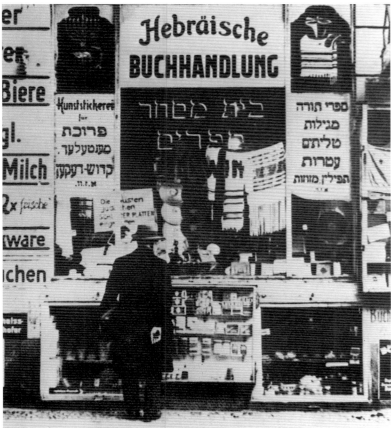

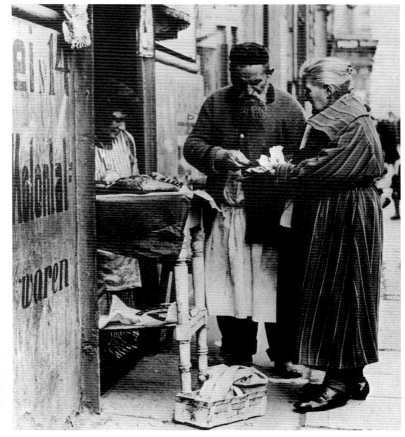

A Jewish bookshop in the Grenadierstraße testifies to the thriving
Jewish culture during the Weimar Republic. Photo 1920s.

Jüdische Buchhandlung in der Grenadierstraße, der heutigen Alm-
stadtstraße, in der Spandauer Vorstadt nördlich vom Alexander-
platz, zwanziger Jahre. Jüdisches Leben und jüdische Kultur kon-
zentrieren sich im Berlin der Weimarer Republik besonders auf
dieses Viertel.

Daily life outside a Jewish food shop in Berlin's Grenadierstraße.
Photo c. 1920.

Jüdisches Kellergeschäft in der Grenadierstraße, der heutigen
Almstadtstraße, in der Spandauer Vorstadt, um 1920.

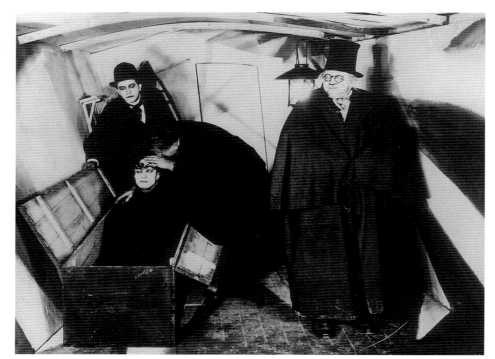

"The Cabinet of Doctor Caligari" is today the most famous Expressionist film, although it had a run of only 4 weeks in Berlin. Contorted sets and strange, cloaked figures evoke a city in a state of dark unrest. Conrad Veidt and Werner Krauss star under the directorship of Robert Wiene in 1919.

»Das Kabinett des Doktor Caligari« (1919; Regie: Robert Wiene) mit Conrad Veidt und Werner Krauss in den Hauptrollen ist der bedeutendste expressionistische Film und eines der Meisterwerke der Ufa (Universum Film Aktiengesellschaft) in Potsdam-Babelsberg.

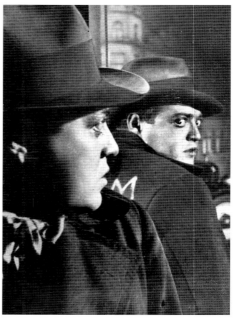

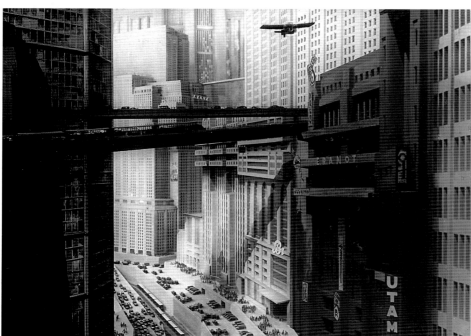

The movie "M" was directed by Fritz Lang in 1931 and scripted by Thea von Harbou. Another dark film of the Weimar years, it starred Peter Lorre as a psychopathic sex offender. Two years after the film was produced Lang and Lorre fled to Hollywood while Thea von Harbou stayed to write screenplays for the Nazis.

»M – Eine Stadt sucht ihren Mörder« (1931; Regie: Fritz Lang; Buch: Thea von Harbou). Peter Lorre spielt darin einen psychopathischen Triebtäter; zwei Jahre später flohen Lang und Lorre nach Hollywood, während Thea von Harbou Filmskripte für die Nazis schrieb.

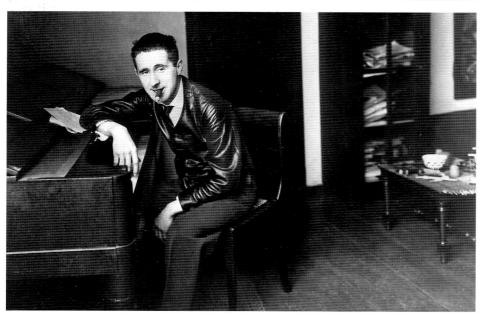

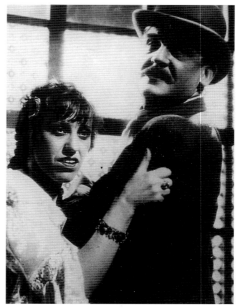

Interior of the busy Romanisches Café, a favourite meeting-place for writers and artists until it was destroyed in World War II. Photo c. 1930.

Innenansicht des vollbesetzten Romanischen Cafés, ein sehr beliebter Treffpunkt von Künstlern und Schriftstellern, um 1930. Im Zweiten Weltkrieg wurde es zerstört.

Opening of the 1st International Dada Fair in Dr. Burchard's Berlin bookshop. George Grosz, John Heartfield and Hannah Höch were among the artists represented. Photo July 5, 1920.

Eröffnung der »1. Internationalen Dada-Messe« in der Berliner Buchhandlung Dr. Burchard am 5. Juli 1920. Die bildende Kunst bricht nach dem Ersten Weltkrieg radikal mit allen akademischen und bürgerlichen Konventionen.

left-hand page / linke Seite:

Fritz Lang's film "Metropolis" raised the stakes for future films with its use of American-style scenery and gargantuan futuristic machinery. Film still 1926.

Standfoto aus »Metropolis« (1926) von Fritz Lang. Dieser Film setzte in seiner Ausstattung Maßstäbe. Amerikanisierung und technoide Tendenzen finden darin ihren ins Gigantische übersteigerten Ausdruck.

Bertolt Brecht pictured at his home in Spichernstraße. Like many other writers and artists Brecht moved to Berlin in the mid 1920s and embarked on a varied career as a writer and director. Photo c. 1927.

Bertolt Brecht (1898–1956), um 1927. Wie viele andere Schriftsteller und Künstler zieht Brecht Mitte der zwanziger Jahre nach Berlin und entfaltet dort eine vielfältige Tätigkeit als Schriftsteller und Regisseur.

Lotte Lenya and Rudolf Forster in the film version of Brecht's "Threepenny Opera" directed by G. W. Pabst, 1931. The play was scored by Kurt Weill and was one of the greatest theatrical successes of the Weimar Republic.

Standbild aus der Verfilmung der »Dreigroschenoper« von Bertolt Brecht mit Lotte Lenya und Rudolf Forster (1931; Regie: Georg Wilhelm Pabst). Dieses Stück, für das Kurt Weill die Musik schrieb, war einer der größten Theatererfolge der Weimarer Republik.

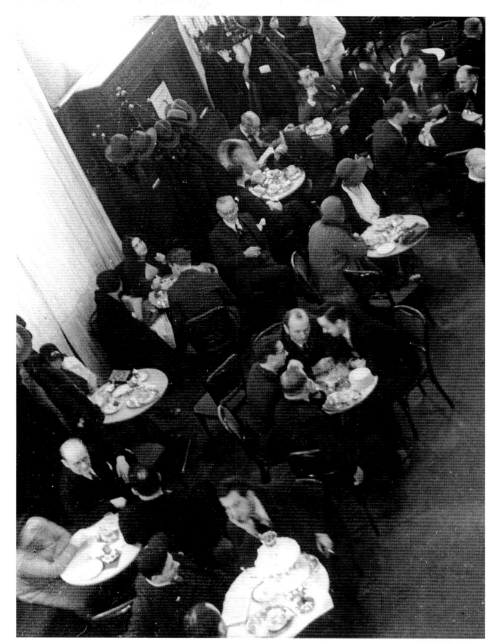

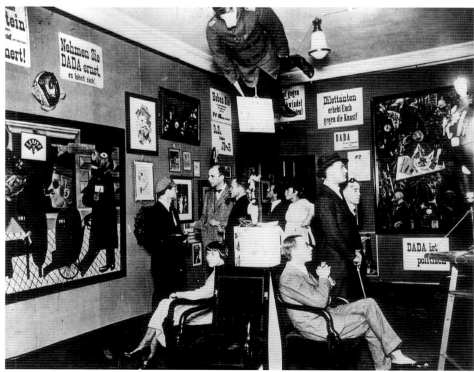

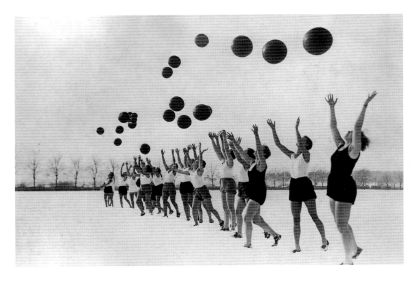

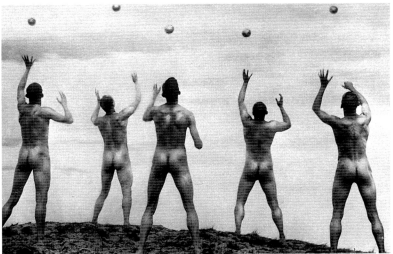

Women students of the Prussian College for
Physical Education in the Spandau district of
Berlin play with medicine balls in the snow.
Photo c. 1928.

Studentinnen der Preußischen Hochschule für
Leibesübungen in Berlin-Spandau spielen mit
Medizinbällen im Schnee, um 1928.

Shot-putting is just one of the suggested "Ways
to Strength and Beauty" in Wilhelm Prager's
UFA film of 1924/26. A renewed interest in the
body and the role of sport in society developed
during the 1920s. Publicity photo.

Dieses Standfoto aus dem Ufa-Film »Wege zu
Kraft und Schönheit« (1924/26) von Wilhelm
Prager zeigt »Kugel-Werfer«.

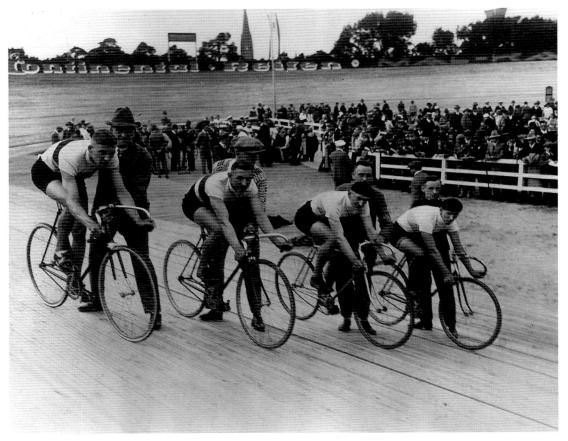

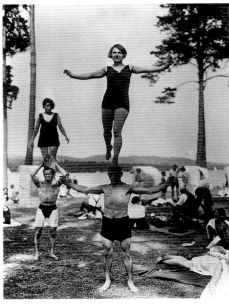

Informal acrobatics at a Berlin bathing resort.
Photo c. 1930.

Akrobatik an einem Berliner Badestrand, um 1930.

right-hand page left / rechte Seite unten links:

Autographed publicity shot of Anita Berber.
Despite (or perhaps because of) the scandals that
surrounded her life, she became one of Weimar
Berlin's best-loved cabaret stars. Photo 1920.

Porträtaufnahme von Anita Berber mit eigenhän-
digem Autogramm, um 1920. Anita Berber
(1899–1928) war Filmschauspielerin, unter ande-
rem an der Seite von Hans Albers und Heinrich
George, die Mitte der zwanziger Jahre vor allem
für ihre Nackttänze berüchtigt wurde.

Cycling in Berlin goes back a long way. Here the new Ruett Arena
hosts the Berlin District 22 one-kilometer final. Graue, the eventu-
al winner, is pictured (left) with competitors on the starting line.
Photo June 27, 1926.

Radsport hat in Berlin eine lange Tradition. So wird am
27. Juni 1926 die neue Rütt-Arena mit der Meisterschaft des
Gaus 22 (Berlin) über einen Kilometer eröffnet. Der Sieger Graue,
im Bild links, mit seinen Kontrahenten kurz vor dem Start des
Rennens.

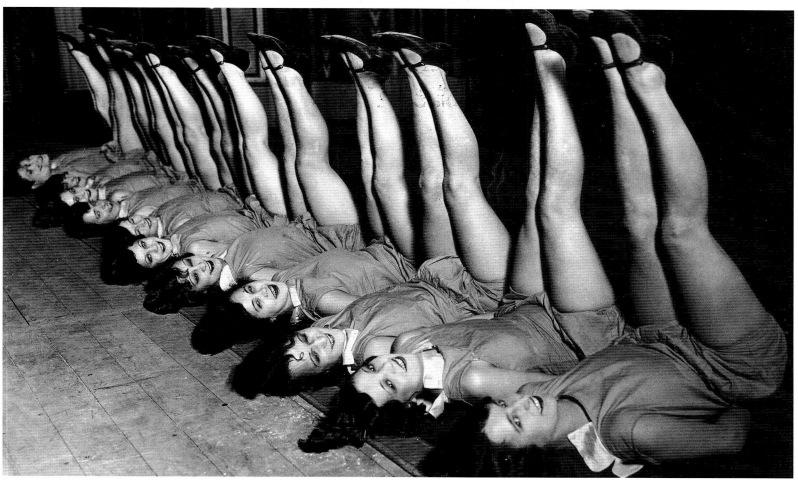

The "Scala Girls" in rehearsal at the Scala Variety Theatre. Weimar Berlin was famous for its cabarets, but the revue-style showgirl glamour proved more popular than political satire. Photo c. 1928.

Die »Scala-Girls« des Varieté-Theaters Scala bei der Probe, um 1928.

Marlene Dietrich poses provocotively in "The Blue Angel", the Josef von Sternberg film that catapulted her to world fame. Film still 1930.

Standfoto mit Marlene Dietrich aus dem Film »Der blaue Engel« (1930; Regie: Josef von Sternberg). Dieser Film macht die junge Schauspielerin auf einen Schlag weltberühmt.

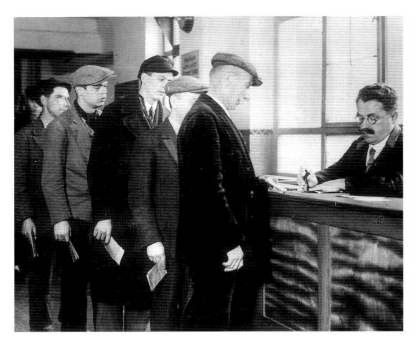

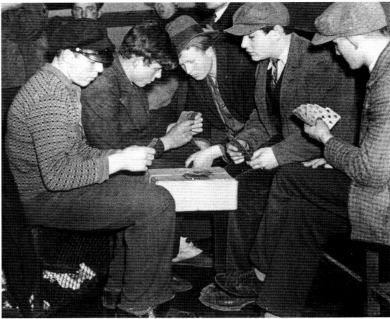

The Great Depression bursts the prosperity bubble. Unemployment figures soar and queues at employment office counters grow ever longer. Photo 1930.

Ende der zwanziger Jahre schnellen im Zuge der Weltwirtschaftskrise die Arbeitslosenzahlen nach oben: Arbeitslose am Schalter eines Arbeitsamtes. 1930.

Unemployed youths while away the hours playing cards. Photo 1930.

Arbeitslose Jugendliche beim Kartenspiel, 1930.

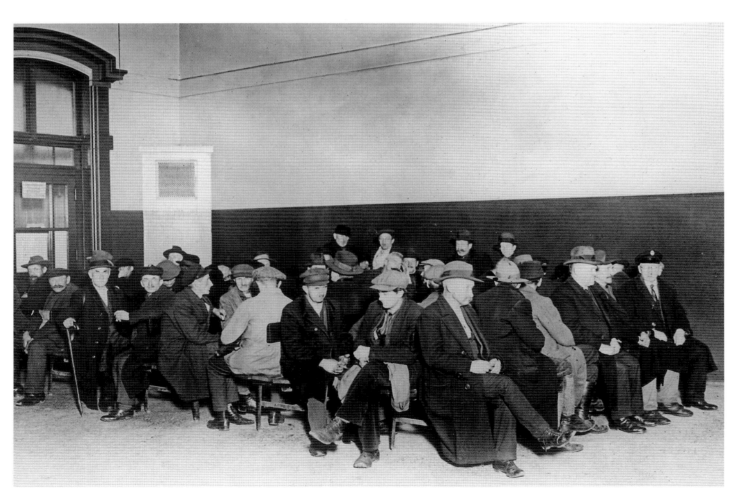

The waiting room at an employment office in Berlin. Photo 1930.

Wartende vor einer Stellenvermittlung, 1930.

Unemployed people scour the job pages.
Photo c. 1931.

Arbeitslose beim Studium der Stellenanzeigen,
um 1931.

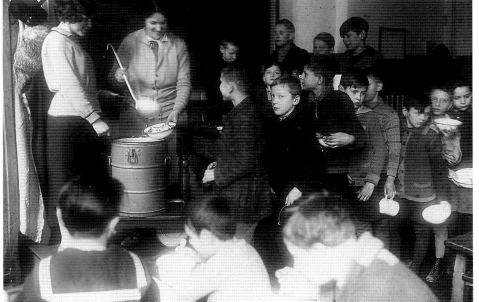

Berliners impoverished by the Great Depression
compete to let out furnished rooms in order to
pay their own rents. Photo 1929.

Die Weltwirtschaftskrise 1929 löst ein Massen-
angebot an möblierten Zimmern in Berlin aus.
Das Geld des Mieters hilft, die eigene Miete zu
zahlen.

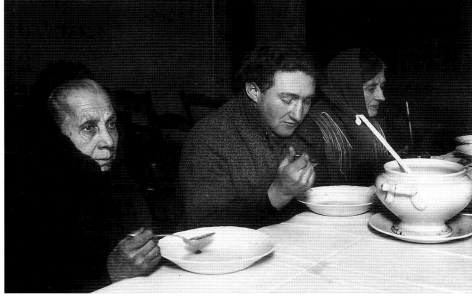

Food is ladled out to the children of jobless
parents in this primary school in the district of
Wedding. Photo c. 1930.

Essen wird gratis an Kinder arbeitsloser Eltern in
einer Grundschule in Berlin-Wedding ausgege-
ben, um 1930.

Unemployed and destitute people are fed and
warmed in a hall in Neukölln, courtesy of
privately funded charity. Photo January 1931.

Speisung von Arbeitslosen und Bedürftigen aus
privaten Mitteln in einer Wärmehalle in Berlin-
Neukölln, Januar 1931.

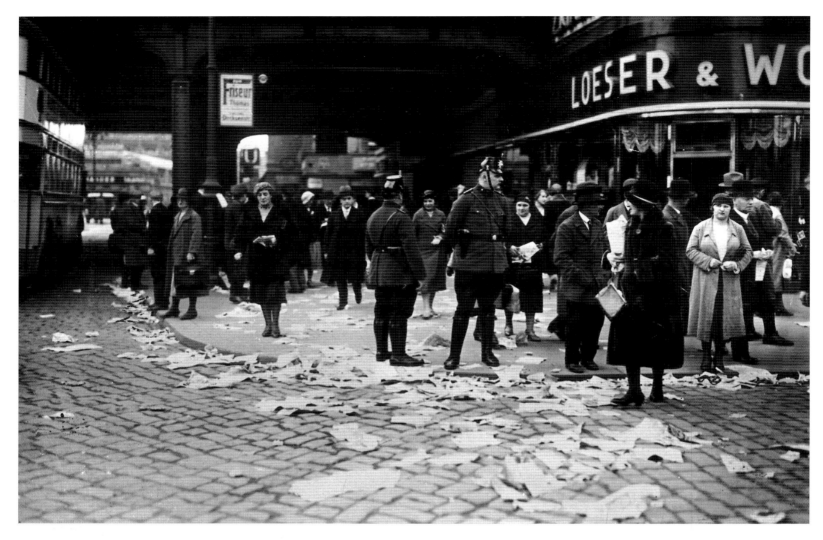

Ballot papers litter Alexanderplatz during the first round of presidential elections. After a second ballot in April, Hindenburg is elected. Photo March 1932.

Nach dem ersten Wahlgang zu den Präsidentschaftswahlen im März 1932, aus denen Hindenburg siegreich hervorgeht, ist der Alexanderplatz mit Flugblättern bedeckt.

Police break up a demonstration by the communist group RFB. (Wilhelm Pieck, who became the first president of the GDR, is on the right with the armband.) Photo June 1927.

Die Polizei löst Anfang Juni 1927 gewaltsam eine Demonstration des Rotfrontkämpferbundes auf (rechts mit Armbinde ist Wilhelm Pieck, der spätere erste Präsident der DDR, zu sehen).

Violent clashes between police and demonstrators accompany Reichstag elections. Here a demonstrator recoils from the blow of a rubber truncheon. Photo September 14, 1930.

Vor den Wahlen zum Reichstag am 14. September 1930 kommt es zu gewalttätigen Auseinandersetzungen zwischen Demonstranten und Polizisten; Polizisten gehen mit Gummiknüppeln gegen einen Demonstranten vor.

right-hand page, top / rechte Seite oben:

The National Socialist Week of Struggle opens with a student rally in the University courtyard. Photo c. 1932.

Auftaktfeier der Nationalsozialistischen Studentenorganisation zur »NS-Kampfwoche« im Innenhof der Berliner Universität, um 1932.

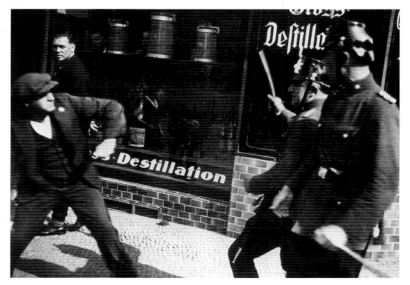

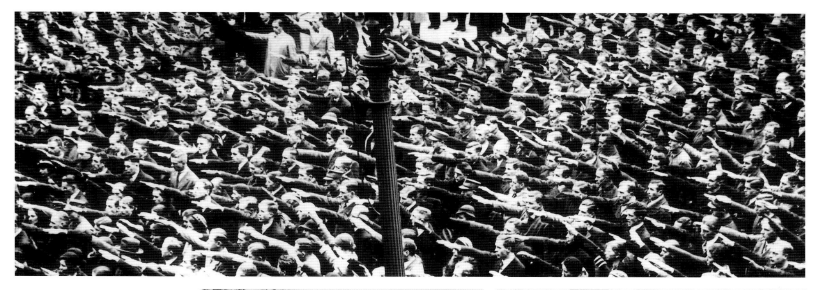

Opponents of National Socialism join forces in the "Iron Front," pictured demonstrating in the Berlin Lustgarten. Photo 1932.

Demonstration der »Eisernen Front« im Lustgarten, 1932. Sie war ein Kampfbündnis der »Reichsflagge Schwarz-Rot-Gold« und der Gewerkschaften.

Rival parties campaign for president in front of a polling station. Hitler only managed second place behind Hindenburg and in front of the communist Thälmann. Photo April 10, 1932.

Wahlagitation verschiedener Parteien vor einem Wahllokal am Tag der Reichspräsidentenwahl am 10. April 1932. Hindenburg gewinnt die Wahl vor Hitler und Thälmann.

The economic crisis gave political extremists a common agenda. "First Food! Then Rent" is the slogan in a backyard in the Köpenick district. Photo September 1932.

Die Zerrissenheit der Weimarer Republik im September 1932 wird in diesem Hinterhof in Berlin-Köpenick deutlich. Die Fahnen von KPD und NSDAP, damals die stärksten politischen Parteien, hängen nebeneinander aus den Fenstern.

The new Chancellor, Adolf Hitler, looks down on a torchlight procession of troops as they march through the Brandenburg Gate in his honour. Photo January 30, 1933.

30. Januar 1933: Hitler hält vom Fenster der Reichskanzlei in der Wilhelmstraße am Abend seiner Ernennung zum Reichskanzler eine Rede an seine Gefolgsleute.

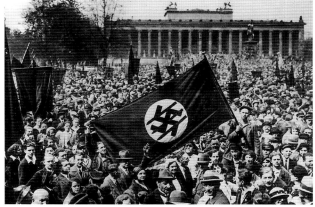

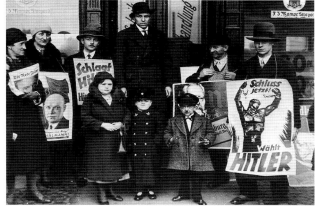

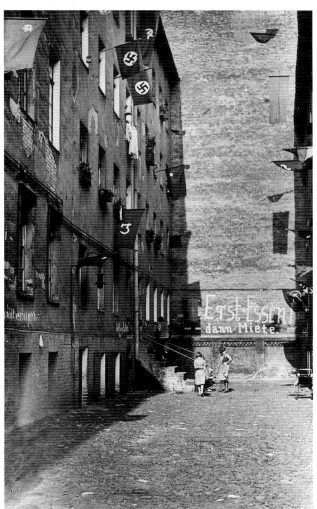

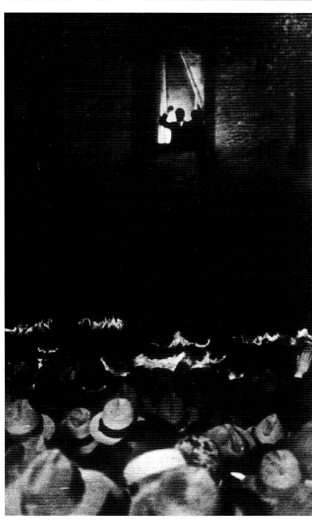

1933–1945
THE CENTRE OF POWER
DAS ZENTRUM DER MACHT

Alongside photographic records of the suffering and cruelty of twelve years of Nazi rule in Berlin, this period also provides documentation of a highly photogenic display. As well as intervening and attempting to control the worlds of art and film, the Nazis' consummate work of art can be seen rather in their creation of "stage-set Berlin", a giant theatre of banners, oversized architecture, and flaming torches. The mass public events of this period lend themselves to a photographic aesthetic which sees an attractive pattern made by the upraised arms of the crowd, rather than the terrifying realities this ritual signifies. But photography can also cut through this aestheticizing of politics by making us focus on the details of the moment that contradict the mass hypnosis. The faces of the Nazi students (right) show a wide range of emotion from fear or mania to calm dispassion. Later, their friends are caught on camera engrossed in the books they are supposed to be burning. Nor should we be enraptured by the grandiose scene of the Russian soldiers raising the Soviet flag over the war-blasted Quadriga, for such aesthetic appreciation masks the horrors of the days of occupation. The unrecognizable wasteland left after the final battles is made all the more poignant by the resumption of "normal" life as Berliners pick their way through the debris.

Gemeinsam mit den photographischen Zeugnissen des Leids und der Grausamkeit der zwölf Jahre dauernden Nazi-Herrschaft demonstriert dieser Zeitabschnitt deren ausgeprägte visuelle Inszenierungsmacht. Die Nationalsozialisten nahmen nicht nur Zugriff auf die Bereiche von Kunst und Film und versuchten, diese zu kontrollieren, sie übernahmen deren Prinzipien für ihre raffinierte Dekorationskunst, wie die Idee der »Inszenierten Stadt«, eines gigantischen Theaters aus überdimensionierter Architektur und lodernden Fackeln, zeigt. Die öffentlichen Großereignisse dieser Zeit bedienen sich einer Bildästhetik, die in den zum Hitler-Gruß erhobenen Armen die dekorative Schönheit festhält und weitaus schwächer die erschreckende Wirklichkeit, die sich hinter diesem Ritual verbarg. Aber Photographien können diese Ästhetisierung der Politik auch konterkarieren, indem sie Bruchteile eines Moments festhalten, die nicht den Rausch der Masse widerspiegeln. Die Gesichter nationalsozialistischer Studenten (rechts) zeigen ein breites Ausdrucksspektrum, von Angst oder Besessenheit bis hin zu ruhiger Abgeklärtheit. Später fängt die Kamera ihre Freunde in jene Bücher vertieft ein, die sie ins Feuer werfen sollen. Auch von der Aufnahme sowjetischer Soldaten, die auf dem kriegsversehrten Brandenburger Tor die Rote Fahne hissen, sollten wir uns nicht allzu sehr faszinieren lassen, denn eine ästhetische Wertung verschleiert den Schrecken der Besetzung. Die Wüstenei, Ergebnis des Kampfes um Berlin, erscheint angesichts der Wiederaufnahme eines »normalen« Lebens um so bitterer, wenn Berliner sich durch Ruinen hindurch ihren Weg bahnen.

Nazi students parade towards the Opernplatz (now Bebelplatz) with flaming torches. They will light the fires that burn "forbidden" books. A bust of the psychologist Max Hirschfield is also destined for the flames. Photo May 10, 1933.

Bücherverbrennung auf dem Opernplatz, dem heutigen Bebelplatz, am Abend des 10. Mai 1933: Studenten mit Fackeln und einer Büste des Sexualpsychologen Magnus Hirschfeld, die ebenfalls in die Flammen geworfen wurde.

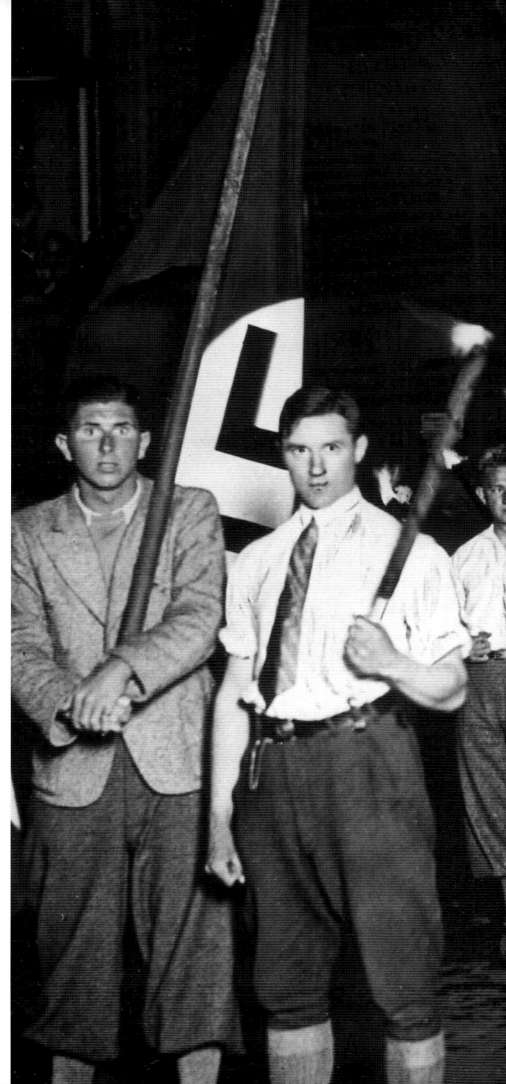

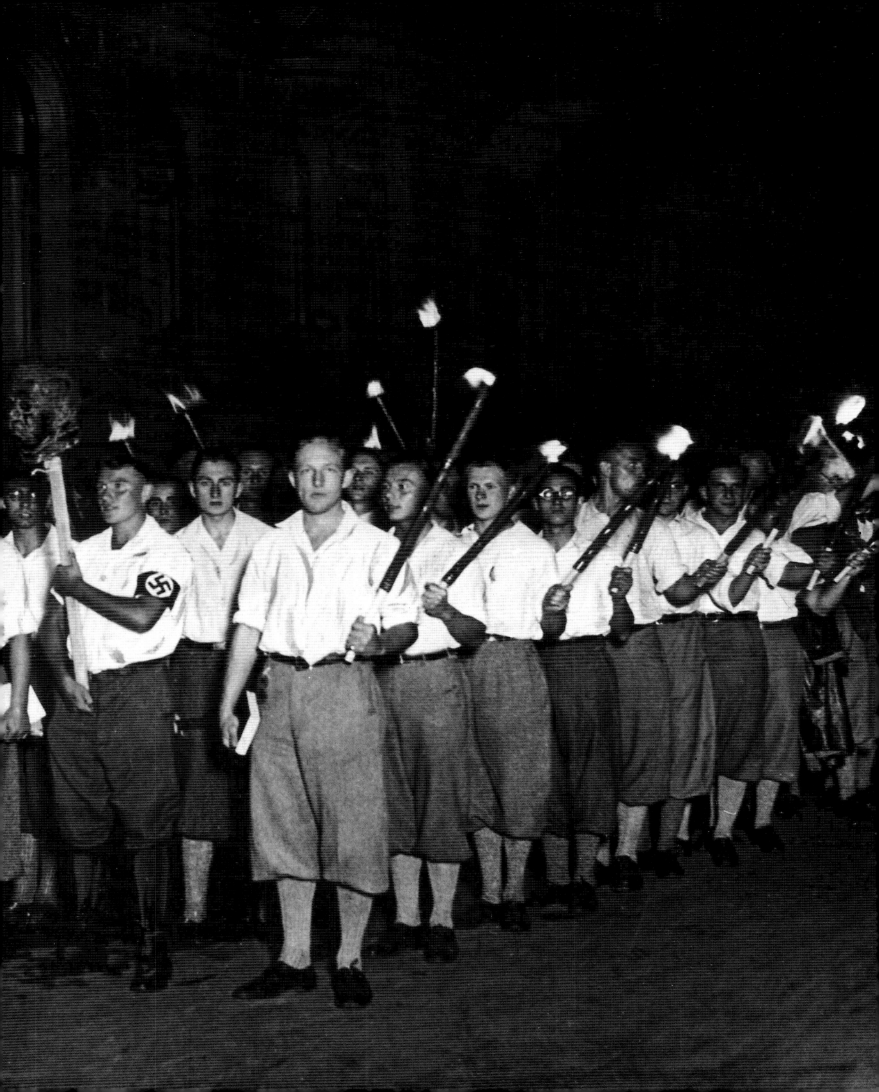

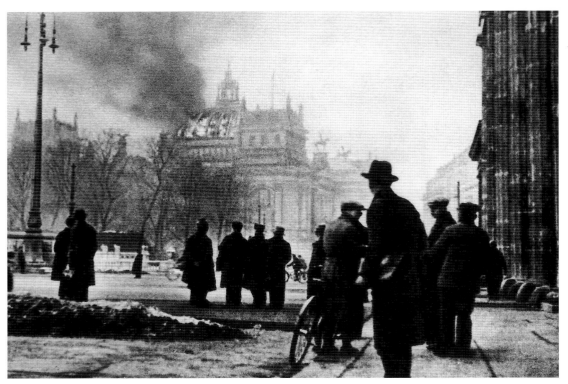

The Reichstag fire on the night of January 27, 1933 provided Hitler with the excuse he is looking for to consolidate his power. Berliners watch the smouldering remains. Photo January 28, 1933.

In der Nacht des 27. auf den 28. Februar 1933 bricht im Reichstag ein Feuer aus, das den größeren Teil des Gebäudes zerstört. Am Morgen des 28. Februar sind die Flammen wieder gelöscht. Der Brand bietet Hitler den Vorwand, seine politischen Gegner auszuschalten.

"Führer command: we will follow..." Hitler Youth drive a propaganda lorry through Wilhelmstraße on the day of the referendum. Photo August 19, 1934.

Propagandawagen der Hitlerjugend in der Wilhelmstraße am Tag der »Volksbefragung«, über das Gesetz vom 2. August 1934 (Vereinigung der Ämter von Reichskanzler und Reichspräsident), das Hitlers Griff nach unumschränkter Macht legitimieren soll, 19. August 1934.

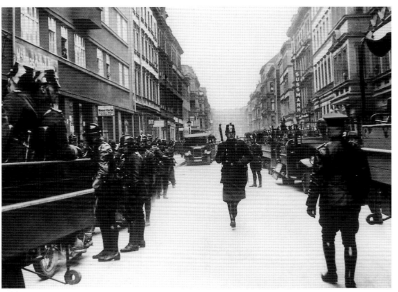

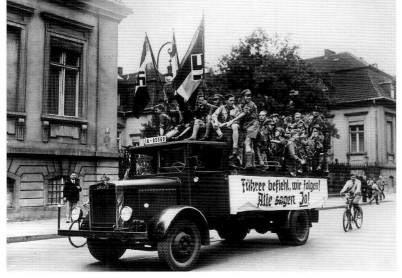

The Nazis wasted no time in ordering raids on Jewish property. Security police in vans get to work in the Grenadierstraße and Dragonerstraße. Photo April 28, 1933.

Am 28. April 1933 führt der Sicherheitsdienst gegen Juden gerichtete Razzien in der Grenadier- und der Dragonerstraße im Scheunenviertel nördlich vom Alexanderplatz durch.

right-hand page / rechte Seite:

Kristallnacht was the culmination of the persecution of the Jews in the pre-war years. Synagogues and Jewish shops were trashed and set on fire. Photo November 10, 1938.

Die Nacht vom 9. auf den 10. November 1938, die »Reichskristallnacht«, bildet den Höhepunkt der Verfolgungen von Juden vor Kriegsausbruch: Synagogen und jüdische Geschäfte werden verwüstet und in Brand gesteckt.

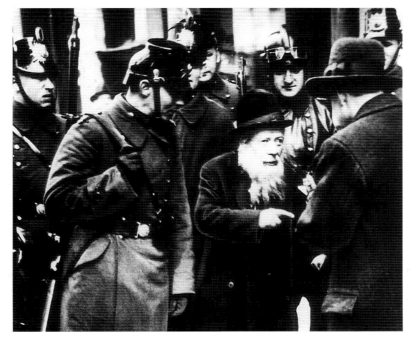

An elderly Jew is tormented by police. Photo 1934.

Die Verfolgung und Terrorisierung der deutschen Juden setzt bereits nach der »Machtergreifung« Hitlers ein, 1934.

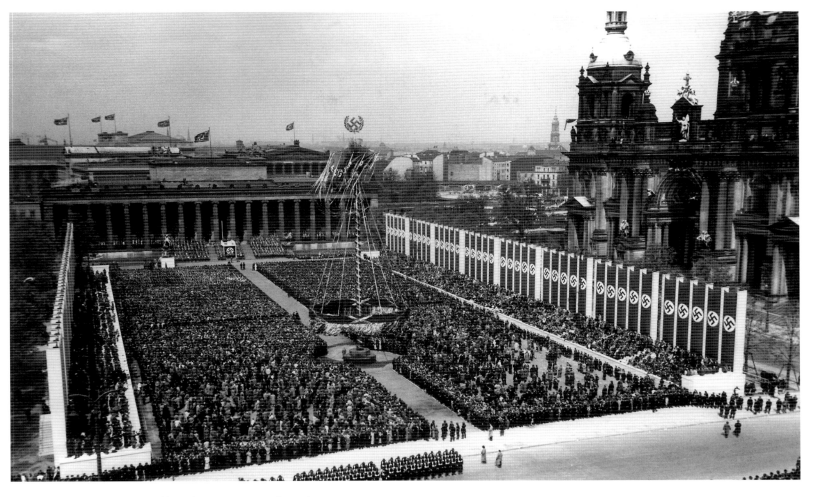

May Day is marked by a mass rally in the Lustgarten. In the mid 1930s the grass was concreted over to make a parade ground for Nazi demonstrations. Photo 1938.

Massenveranstaltung am 1. Mai 1938 im Lustgarten vor dem Alten Museum. Mitte der dreißiger Jahre wurde er zu einem gepflasterten Paradeplatz umgestaltet.

Wehrmacht parade on Pariser Platz. May 1, 1938.

Parade der Deutschen Wehrmacht auf dem Pariser Platz am 1. Mai 1938.

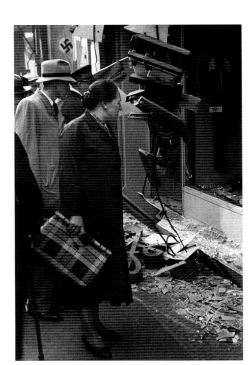

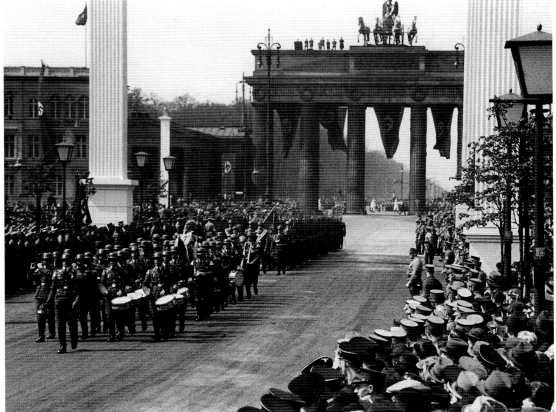

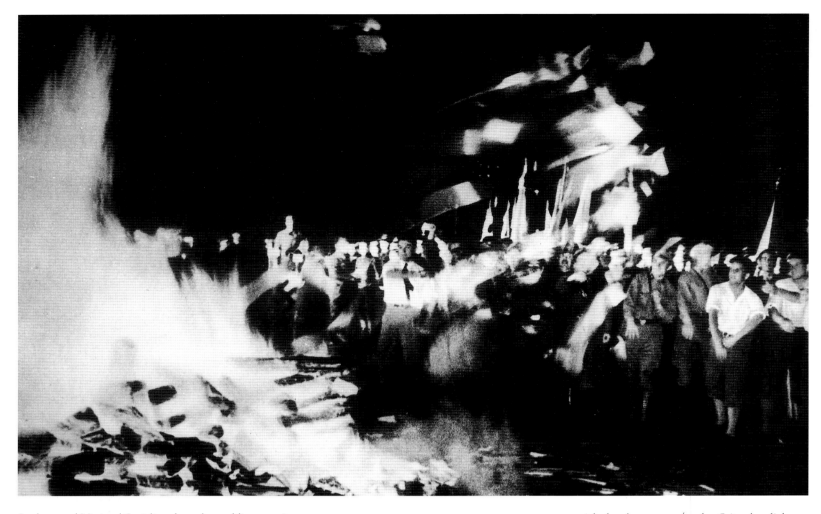

Students and National Socialists throw banned literature into the flames in an "action against the un-German spirit." Photo May 10, 1933.

10. Mai 1933: Studenten und Nationalsozialisten verbrennen Werke als »undeutsch« gebrandmarkter Schriftsteller auf dem Opernplatz gegenüber der Universität.

The works of scientists such as Magnus Hirschfeld, who pioneered research into homosexuality, lie scattered around his desecrated Institute. Photo May 10, 1933.

Konfiszierte Bücher und Schriften in Magnus Hirschfelds verwüstetem Institut für Sexualforschung. Hirschfeld leistete Pionierarbeit bei der wissenschaftlichen Erforschung der Homosexualität.

Confiscated books are loaded into trucks to be taken to the book burning. Photo May 10, 1933.

Studenten laden beschlagnahmte Bücher auf einen Lastwagen, um sie zum Opernplatz zu fahren.

right-hand page, top / rechte Seite oben links:

The "Entartete Kunst" [degenerate art] exhibition pilloried what the Nazis saw as degenerate and unwholesome art. It opened in Munich in July 1937 before traveling to Berlin and the rest of Germany. Cover of the exhibition guide 1937.

Umschlag des Kurzführers durch die Ausstellung »Entartete Kunst«, die im März 1936 in München gezeigt wurde und die moderne Kunst an den Pranger stellte. Ab Sommer 1937 tourte sie durch Deutschland.

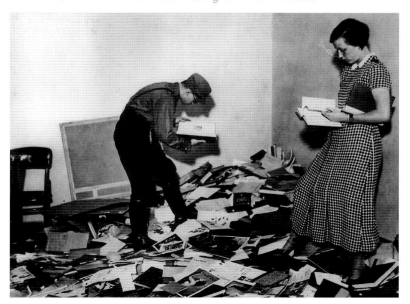

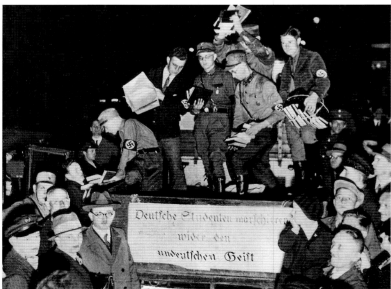

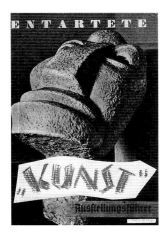

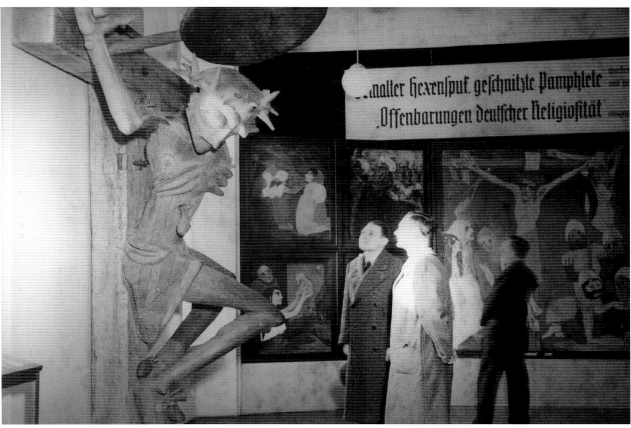

Nolde's "Life of Christ" and Gies' "Crucifix" are among the exhibits at the exhibition which attracted over 20,000 visiters per day in Berlin. Photo 1938.

Blick in die Ausstellung »Entartete Kunst«, links »Kruzifix« von Ludwig Gies, rechts »Das Leben Christi« von Emil Nolde. 1938; Gies wird nach dem Krieg den Adler für den Deutschen Bundestag in Bonn entwerfen.

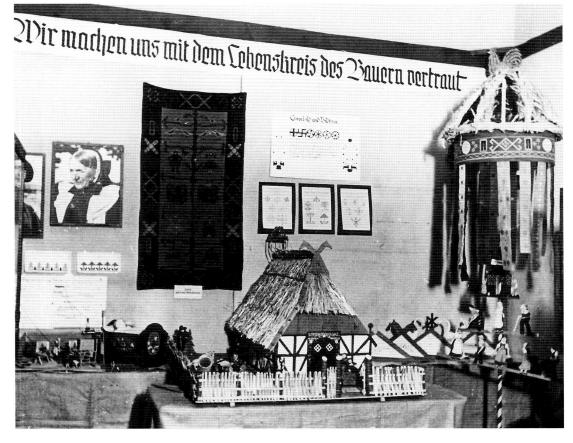

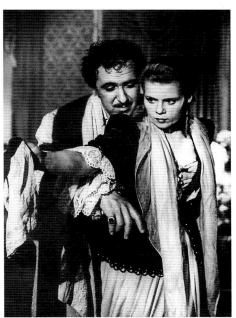

The Nazis sought to portray the wholesomeness of rural life through the so-called "blood and soil" cult. "We're getting to know the farmer's way of life" claims this exhibition. Photo 1936.

Die Nationalsozialisten propagieren einen »Blut und Boden«-Kult. Diese Aufnahme von Ausstellungsmaterial, das den »Lebenskreis der Bauern« vorstellen soll, entstand 1936 anläßlich der »Steglitzer Woche«.

Anti-semitic propaganda was rife in all areas of cultural life. Veit Harlan directed one of the most visciously anti-Jewish films of the Nazi era, "Jud Süß". Film still 1940.

Der Film »Jud Süß« (1940; Regie: Veit Harlan) mit Kristina Söderbaum, Werner Krauss und Heinrich George war der bekannteste antisemitische Hetzfilm der NS-Zeit.

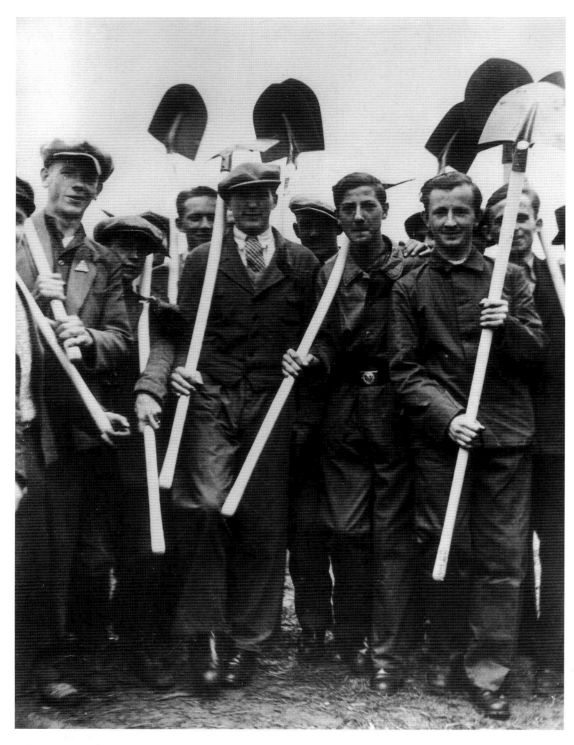

By 1939 over 80% of Berlin families had a radio. Here, a couple tune in to Telefunken-made "Meistersuper". Photo 1936.

Radiohörer mit dem Radiogerät »Meistersuper« von Telefunken, 1936. Bis 1939 verfügten mehr als 80 Prozent der Berliner Haushalte über ein Radio.

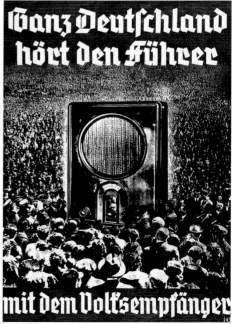

In order to reduce unemployment the National Socialists push ahead with plans to build the first motorways. The workers here are about to embark on the first stretch from Frankfurt am Main to Mannheim. Berlin featured large in Hitler's road-building program: six different motorways were to converge on the capital. Photo September 23, 1933.

Um die Arbeitslosenzahlen zu reduzieren, forcieren die Nationalsozialisten den vor 1933 ausgearbeiteten Plan, Autobahnen zu bauen. Diese Aufnahme zeigt Arbeiter am 23. September 1933 auf dem Weg zur Baustelle auf der ersten Reichsautobahn von Frankfurt am Main nach Mannheim. Berlin nahm auch beim Autobahnbau eine vordere Stelle ein: Hier liefen nicht weniger als sechs der neu angelegten Straßen zusammen.

"The whole of Germany listens to the Führer." With the spread of radio, Hitler had a mass audience for his propaganda machine at the touch of a button. Poster 1936.

Mit der Verbreitung des Volksempfängers wird der Rundfunk zum Propagandainstrument des Terrorregimes. Plakat aus dem Jahr 1936.

The exhibition entitled "Give me four more years" showed off Nazi economic successes since the seizure of power in 1933. The Führer himself opened the event and a larger-than-life poster of him presides over a model of the new motorway. Photo April 30, 1930.

Modell der Reichsautobahn vor einem überlebensgroßen Hitler-Plakat. Aufnahme aus der Ausstellung »Gebt mir vier Jahre Zeit«, die am Kaiserdamm in Berlin-Charlottenburg gezeigt wird. Hitler eröffnet diese Feier der vier Jahre seiner Herrschaft am 30. April 1937 höchstpersönlich.

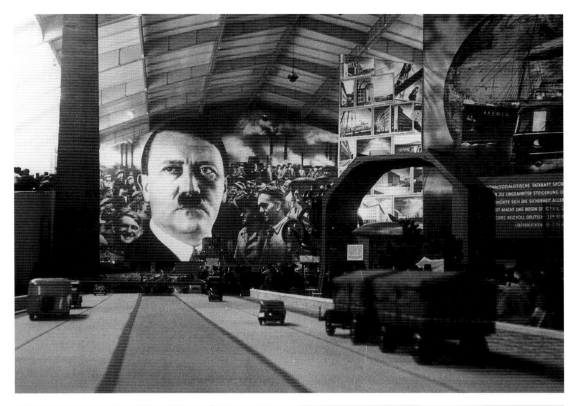

Ernst Sagebiel's design for the Army Supreme Command HQ is a prime example of the pseudo-classical style beloved of Nazi architects. The building was planned for the west side of the north–south axis. Photo of model 1938.

Ein Paradebeispiel für die maßstabslose, Antike und Klassizismus pervertierende NS-Architektur ist das Modell des Sitzes des Oberkommando des Heeres (Entwurf: Ernst Sagebiel), 1938.

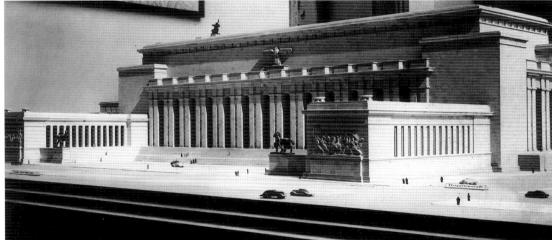

Hitler and his architect, Albert Speer, had elaborate plans for the redesigning of the capital. The unbuilt monumental Congress Hall dwarfs the Brandenburg Gate and Reichstag in this scale model. It was to be placed at the end of a north–south axis through the city. Photo 1938.

Die von Hitlers Generalbauinspektor Albert Speer geplante Nord-Süd-Achse durch Berlin sollte in der Großen Halle enden, die als größtes Gebäude der Welt angelegt war, 1938.

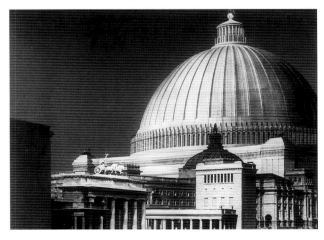

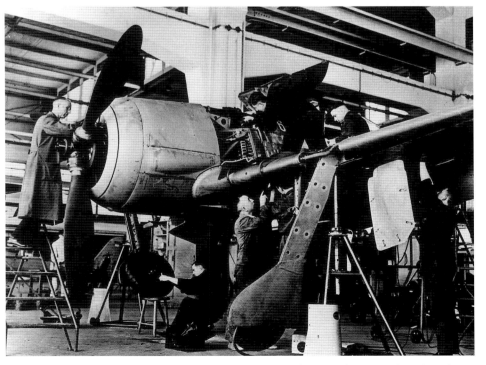

From the mid 1930s, technological advances in Germany were channelled into the armaments industry. Mechanics assemble a Focke-Wulf 190 A-O fighter airplane. Photo 1940.

Seit Mitte der dreißiger Jahre ist die gesamte technische Forschung in Deutschland auf Auf- und Hochrüstung ausgerichtet. Hier setzen Mechaniker das Kampfflugzeug Focke-Wulf A-0 zusammen, 1940.

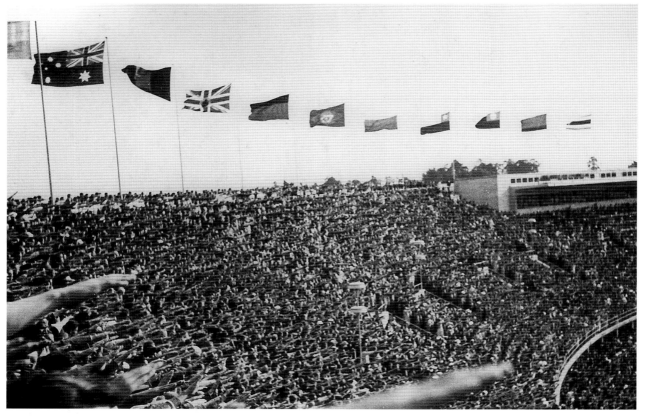

The Olympic Games were a chance for the Nazi regime to achieve recognition on the world stage. Hands are raised in the Hitler salute over a packed Olympic stadium redesigned for the occasion by Werner March. Photo August 1936.

In der ersten Augusthälfte des Jahres 1936 finden in Berlin die Olympischen Spiele statt. Im Berliner Westen wird dafür ein großes Gelände nach Entwürfen des Architekten Werner March neu bebaut. Die Olympischen Spiele geraten den Nationalsozialisten zur pompösen Selbstdarstellung ihres Regimes.

right-hand page / rechte Seite:

Unter den Linden is transformed for the celebrations of Mussolini's visit. Photo September 27, 1937.

Der Boulevard Unter den Linden wird für Mussolinis Staatsbesuch am 27. September 1937 festlich umgestaltet.

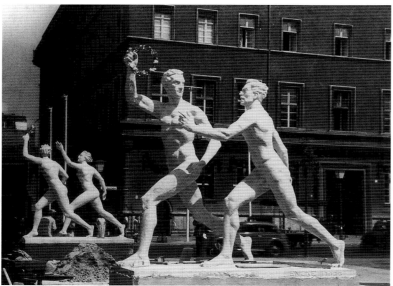

Giant sport sculptures are erected on Unter den Linden to mark the Berlin Olympic Games. Photo August 1936.

Anläßlich der Olympischen Spiele, die vom 1. bis zum 16. August 1936 in Berlin stattfinden, werden auf dem Boulevard Unter den Linden »Sportstatuen« aufgestellt.

Leni Riefenstahl films the Berlin Olympics. Innovative camera angles captured feats of athleticism in a new way, and "Fest der Völker" became one of the most notorious Nazi propaganda films. Photo August 1936.

Die Regisseurin Leni Riefenstahl im Berliner Olympiastadion während der Dreharbeiten zum Olympia-Film »Fest der Völker«.

Jesse Owens of America signs autographs at the Olympic Games after his world record in the 100 meters. Photo August 1936.

Der Amerikaner Jesse Owens gibt nach seinem Weltrekordlauf über 100 Meter bei den Olympischen Spielen Autogramme.

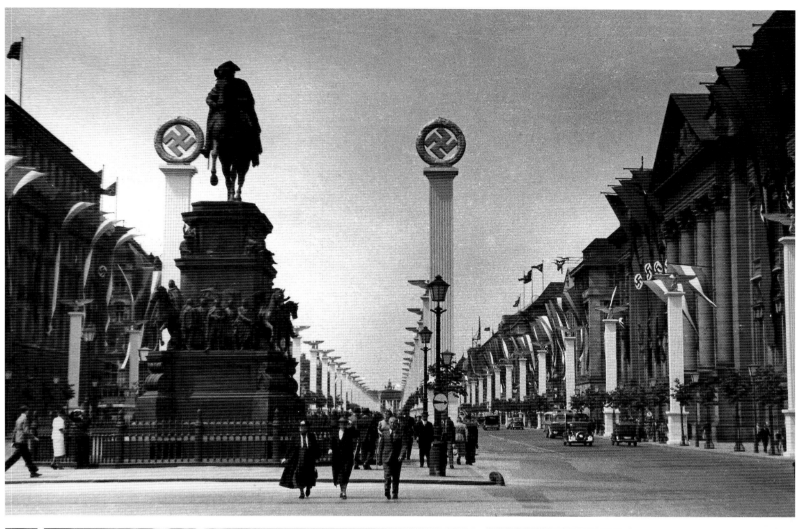

Thousands of Berliners take to the streets for a glimpse of Benito Mussolini on his visit to Berlin. Many resort to periscopes in order to witness the grand parades accompanying the Italian leader's arrival.
Photo September 27, 1939.

The imperial eagle and swastika adorn columns erected all over Berlin in honor of Il Duce's state visit. This photo was taken at the corner of Preußenallee and Heerstraße in Charlottenburg.
Photo September 27, 1937.

Während des Staatsbesuchs von Benito Mussolini in Berlin am 27. September 1939 ist der Andrang auf den Straßen so groß, daß sich einige Zuschauer mit Periskopen behelfen müssen, um einen Blick auf den Duce zu erhaschen.

Festlich dekorierte Straßen anläßlich des Staatsbesuchs Mussolinis. Zahlreiche Säulen mit Reichsadler und Hakenkreuz werden, wie hier an der Kreuzung von Preußenallee und Heerstraße, in der Stadt aufgestellt.

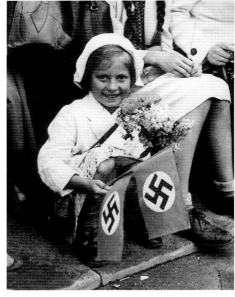

A small girl with swastikas and flowers at the parade to celebrate the victorious campaign in France. Photo July 18, 1940.

Ein kleines Mädchen mit Blumenstrauß und Hakenkreuzfähnchen während der Militärparade am 18. Juli 1940, mit der der siegreiche Feldzug in Frankreich gefeiert wird.

Members of the Air Raid Defence Unit instruct civilians in the use of gas masks. Photo September 1, 1937.

Am 1. September 1937 werden die Berliner von Mitgliedern der Reichsluftschutzeinheit im Umgang mit der neuen Gasmaske VM 37 geschult.

Young Berliners are evacuated to Marienbad.
Photo October 25, 1941.

Kinderlandverschickung nach Marienbad. 25. Oktober 1941.

Cabaret and variety shows were a welcome diversion in wartime Berlin. Dancer at the "Berolina". Photo 1940.

Im Reich übernehmen nach Kriegsausbruch Cabaret- und Varietévorstellungen die Funktion der Ablenkung und Zerstreuung, hier eine Tänzerin im Varieté »Berolina«, 1940.

War veterans' associations donate the metal tips of their flagpoles to the war effort on the Gendarmenmarkt. Photo March 19, 1940.

Vertreter der Berliner Kriegervereine montieren auf dem Gendarmenmarkt die eisernen Spitzen ihrer Verbandsfahnen ab, um sie für Kriegszwecke zu spenden. 19. März 1940.

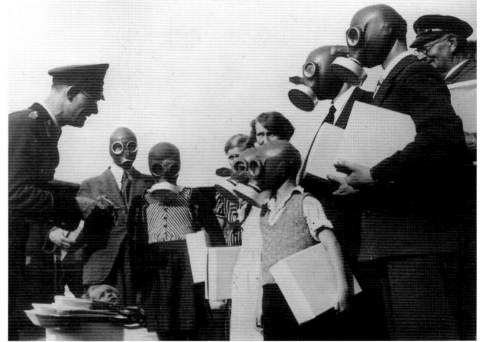

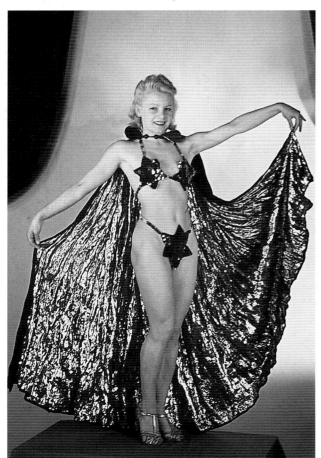

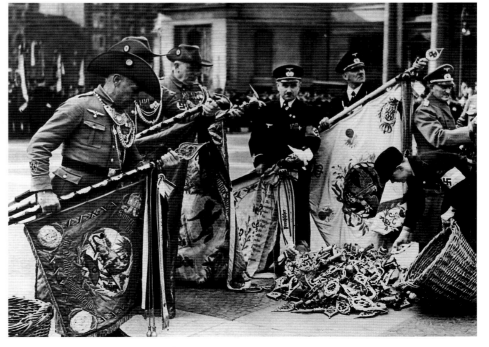

Berlin had already suffered a certain amount of aerial bombardment by 1941 and the clearly visible line of the east–west axis was a great help in the orientation of allied planes. The Nazis covered the road with huge camouflage nets in an attempt to confuse the enemy forces. Photo 1941.

1941 ist bereits in der Reichshauptstadt mit Bombardements der Alliierten zu rechnen. Tarnnetze sind über die Ost-West-Achse, die heutige Straße des 17. Juni, die durch den Tiergarten verläuft, zum Schutz gegen Fliegerangriffe gespannt.

War-weary civilians take shelter after the air-raid siren has sounded. Photo 1945.

Aufnahme aus dem Jahr 1945. Einige Berliner haben sich nach einem Bombenalarm in einen Schutzbunker geflüchtet.

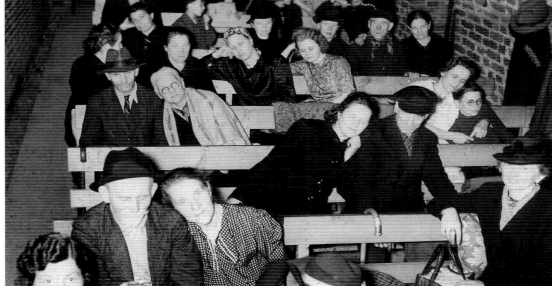

Troops parade through the Brandenburg Gate to celebrate the fall of France. The last time this had happened was in 1871. Photo July 18, 1940.

Aufnahme von der Siegesfeier am 18. Juli 1940, mit der die Deutsche Wehrmacht die Besetzung Frankreichs feiert.

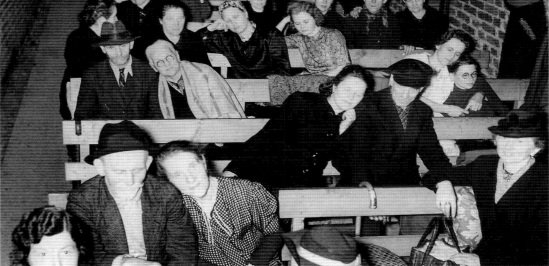

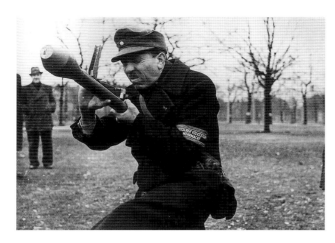

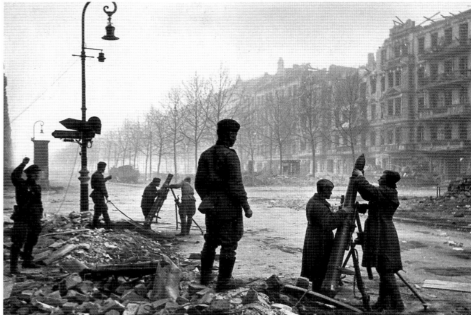

A newly enlisted civilian is trained to use a bazooka. Old men and young boys were recruited indiscriminately in the later years of the war. Photo April 1945.

Ein zum Volkssturm eingezogener Mann übt Anfang April 1945 den Umgang mit einer Panzerfaust. Für den Deutschen Volkssturm werden alte Männer und Jugendliche eingezogen.

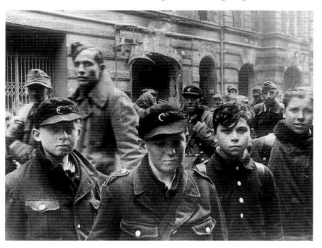

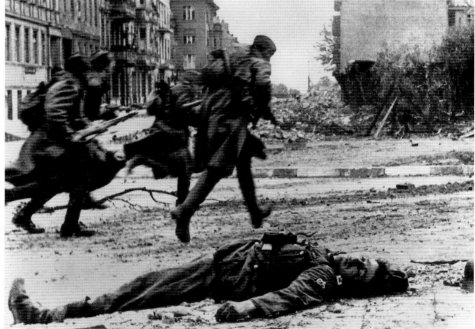

German soldiers are led to prisoner of war camps after their surrender. Child soldiers in uniform stare out of the picture. Photo May 1945.

In Gefangenschaft geratene Kindersoldaten in Volkssturmuniform; im Hintergrund werden deutsche Soldaten in ein Kriegsgefangenenlager abgeführt, Mai 1945.

The battle for Berlin began on April 16, 1945 and the fall of the city to the Red Army on May 2 signalled the German capitulation. Soviet soldiers set up a mortar position on a deserted street in central Berlin. Photo April 1945.

Sowjetische Soldaten mit Mörserwerfern während der Straßenkämpfe im Zentrum Berlins. Ende April 1945. Der Endkampf um Berlin dauert vom 16. April bis zum 2. Mai 1945 und endet mit der Einnahme der Stadt und der Kapitulation Deutschlands am 8. Mai.

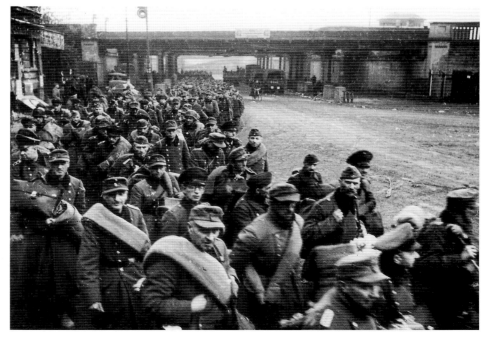

Russian soldiers storm a German position in the city centre. Bitter street battles claimed the lives of countless soldiers and civilians. Photo April 1945.

Soldaten der Roten Armee beim Sturm auf eine deutsche Stellung in der Innenstadt, April 1945. Im Kampf um jeden Straßenzug fallen zahllose Soldaten und Zivilisten.

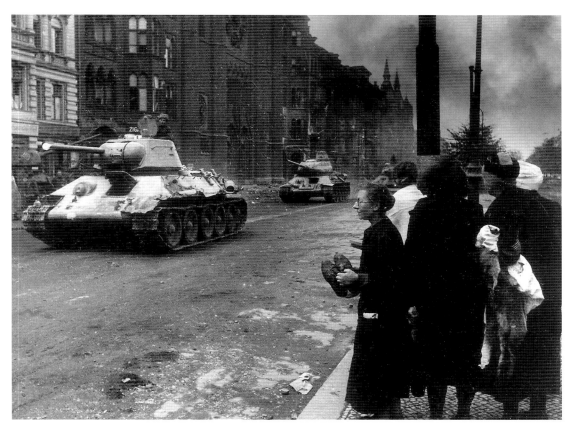

Soviet tanks roll towards the city centre while a handful of civilians looks on. Photo April 29, 1945.

Panzer der Sowjetarmee auf ihrem Weg in die Stadtmitte, 29. April 1945.

On April 30 Russian soldiers advanced on the Reich Chancellery. A young Russian soldier sits among the debris of the bunker where Hitler is said to have committed suicide that same day. Photo April 30, 1945.

Ein Soldat der Roten Armee im Führerbunker. Als sowjetische Truppen unmittelbar vor der Eroberung der Reichskanzlei stehen, begeht Hitler am 30. April 1945 Selbstmord.

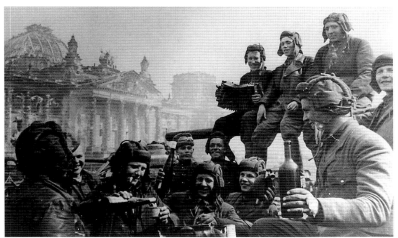

Red Army soldiers celebrate their victory in front of the bombed Reichstag. Photo May 1945.

Soldaten der Roten Armee feiern ihren Sieg vor dem zerschossenen Reichstagsgebäude.

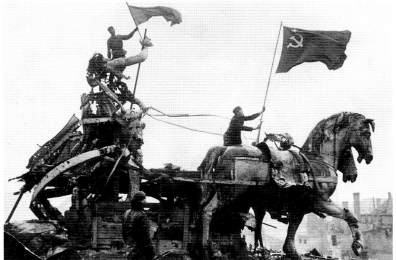

left-hand page bottom / linke Seite unten:

German soldiers are led away to Soviet prisoner-of-war camps. Photo April 1945.

Deutsche Kriegsgefangene werden in sowjetische Lager abtransportiert, April 1945.

Soviet soldiers hoist the Red Flag over the battered remains of the Quadriga on the Brandenburg Gate. Photo May 2, 1945.

Auf der Quadriga des Brandenburger Tors hissen sowjetische Soldaten die Rote Fahne, 2. Mai 1945.

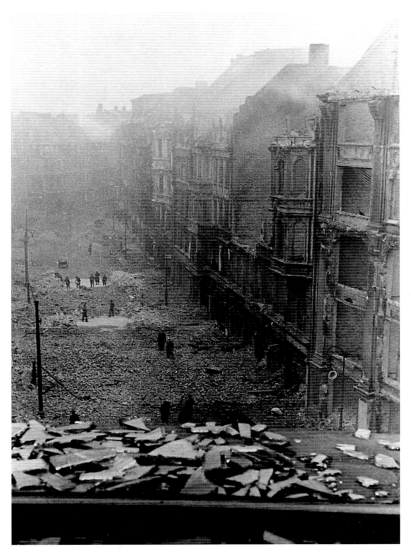

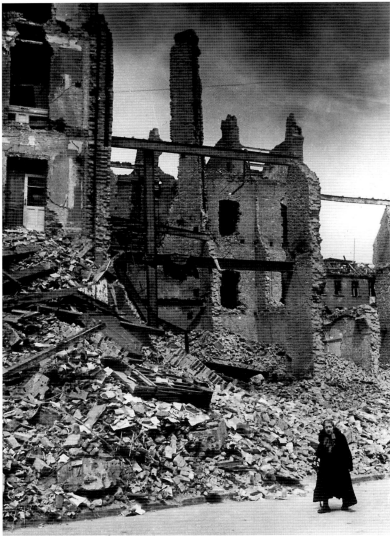

right-hand page / rechte Seite:

Refugees arrive at the "Knie," now Ernst-Reuter-Platz in Charlottenburg. Berlin's slender resources were squeezed still further as millions of Germans expelled from the East made the capital their first port of call. Photo 1945.

Flüchtlingstrecks kommen am Knie, dem heutigen Ernst-Reuter-Platz, in Berlin-Charlottenburg an. 1945. Berlin war für die zahllosen Flüchtlinge aus dem Osten die erste größere Anlaufstation; dadurch verschärfte sich die Lage in der zerstörten Stadt noch zusätzlich.

Desperate times, desperate measures. Two men in Tempelhof cut meat from the rotting corpse of a horse. Photo May 1945.

Berlin-Tempelhof, Mai 1945: Zwei Männer schneiden Fleischstreifen aus einem verendeten Pferd.

A young girl gathers firewood. Photo May 1945.

Ein kleines Mädchen sammelt Feuerholz, Mai 1945.

Women and children return to a city in ruins at the end of the war. Photo 1945.

Junge Mütter kehren kurz nach dem Ende des Krieges mit ihren Kindern in das zerstörte Berlin zurück, 1945.

Attempts are made to clear the rubble from a street in central Berlin. Photo 1945.

Nach einem Luftangriff versuchen die Menschen, zumindest einige Trümmer zu beseitigen, 1945.

A solitary figure walks past the bombed shells of houses. Photo April 1945.

Eine alte Frau vor ausgebombten Häusern. April 1945.

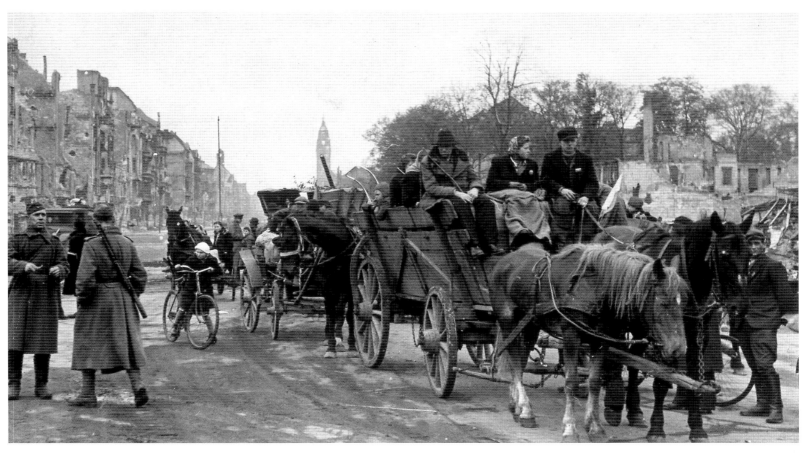

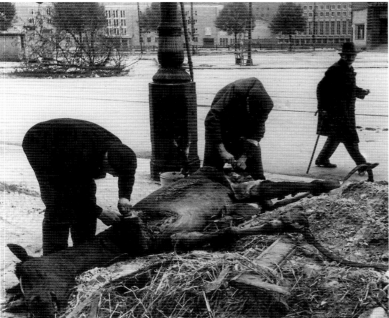

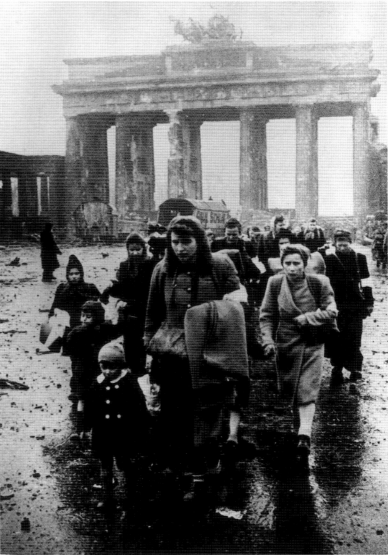

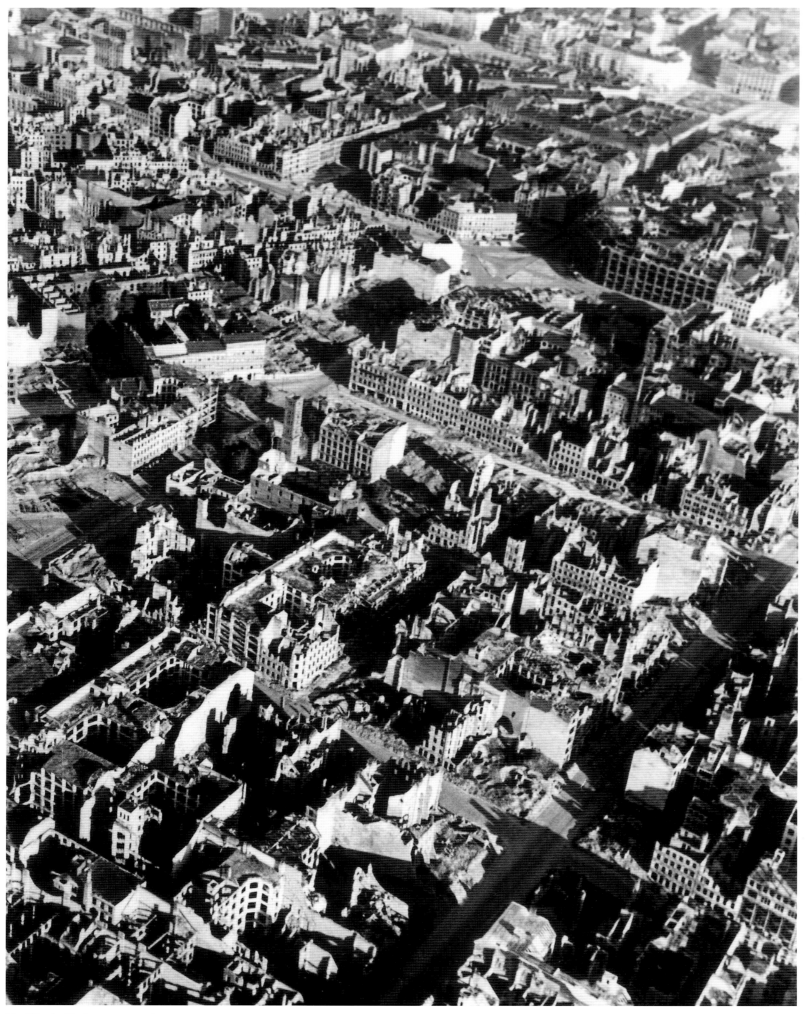

72　Wasteland Berlin　Wüstenei Berlin

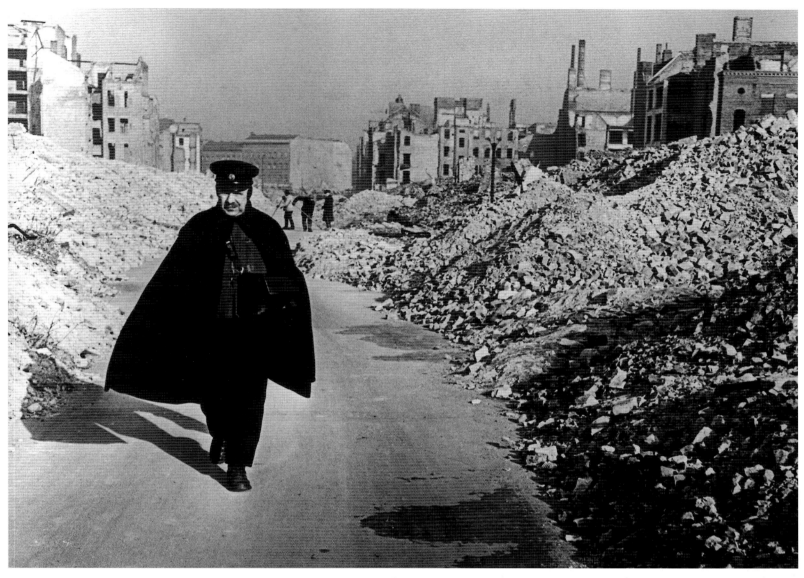

A postman walks among ruins where addresses have lost their meaning. Photo c. 1947.

Leben inmitten einer Trümmerlandschaft: ein Briefträger in seinem Zustellbezirk, in dem die Adressen ihre Gültigkeit verloren haben, um 1947.

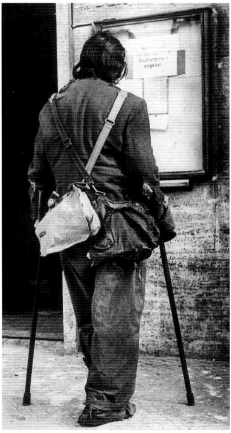

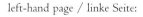 left-hand page / linke Seite:

612,000 homes and 30% of the town lie in ruins. This aerial shot shows Oranienstraße and Moritzplatz in the Kreuzberg district. Photo 1945.

Berlin im Jahr Null. Luftaufnahme von Berlin-Kreuzberg mit der Oranienstraße und dem Moritzplatz. 612000 Wohnungen sind vollständig zerstört, 30 Prozent der Stadtfläche Ruinenfelder.

A women and children cook on an open fire outside temporary accommodation.
Photo July 1945.

Eine Frau mit Kindern beim Kochen auf offener Feuerstelle vor einem Notquartier, Juli 1945.

A war veteran in civilian dress at a railway station.
Photo 1945.

Ein ehemaliger Soldat in Zivil vor einer Bahnstation, 1945.

1945–1989
THE DIVIDED CITY
DIE GETEILTE STADT

After the devastation of the war years Berliners had no choice but to watch as the topography of their city was invented once again. The scars visible on the landscape symbolize the sufferings of the woman, children, and old men who are pictured navigating their way through their shattered city. Even when life begins to return to normal relics of past traumas can still be discerned: the sparse trees in the Tiergarten; the massed flags and placards of East German youth group marches.

The streets are still a battleground whether between East German workers and Soviet occupiers, or in the competitive rebuilding in contrasting architectural styles of the eastern and western sectors. While West Berliners take to the streets to protest against the nuclear arms race or the visit of the Shah of Iran, the working conditions and personal freedoms of the East Berliners are the point of focus for the more clandestine protests on the other side of the Wall.

The backdrop to the political activity in Berlin at this time is, as always, an instinctive pursuit of the pleasures of city life. The means to this enjoyment are clearly very different from East to West, as are the results, but the aims are the same on either side of the Wall, and foreshadow the scenes of the greatest street party to come at the moment of reunification.

Nach der Verwüstung im Krieg mußten die Berliner zusehen, wie die Topographie ihrer Stadt einmal neu erschaffen wurde. Die der Stadtlandschaft geschlagenen Wunden mögen für die Leiden der Frauen, Kinder und alten Menschen stehen, die sich durch ihre zerstörte Heimatstadt bewegen. Auch wenn man wieder zur Normalität zurückkehrt, so stehen die Traumata der Vergangenheit noch immer deutlich vor Augen: die wenigen unversehrten Bäume im Tiergarten, die Aufmärsche ostdeutscher Jugendorganisationen mit Fahnen und Transparenten.

Die Straßen sind noch immer Kampfzone – während der Auseinandersetzung von Ost-Berliner Arbeitern und der sowjetischen Besatzungsarmee und während des Wettstreits zwischen Ost und West auf dem Gebiet der Architektur. Während West-Berliner auf die Straßen gingen, um gegen Aufrüstung oder den Besuch des Schahs von Persien zu demonstrieren, sind Arbeitsbedingungen und individuelle Freiheit für die Ost-Berliner von vorrangiger Bedeutung für die mehr im verborgenen ablaufenden Protestaktionen jenseits der Mauer.

Den Hintergrund der politischen Vorgänge im Berlin jener Jahre bildet, wie dies immer der Fall gewesen ist, die instinktive Suche nach den Freuden des Großstadtlebens. In Wegen und Ergebnissen unterscheidet sich Ost von West deutlich, doch die Ziele sind auf beiden Seiten der Mauer dieselben, und dies gibt bereits einen zarten Vorgeschmack auf das bevorstehende größte Straßenfest der Welt, das anläßlich der Wiedervereinigung auf den Straßen der Stadt gefeiert wurde.

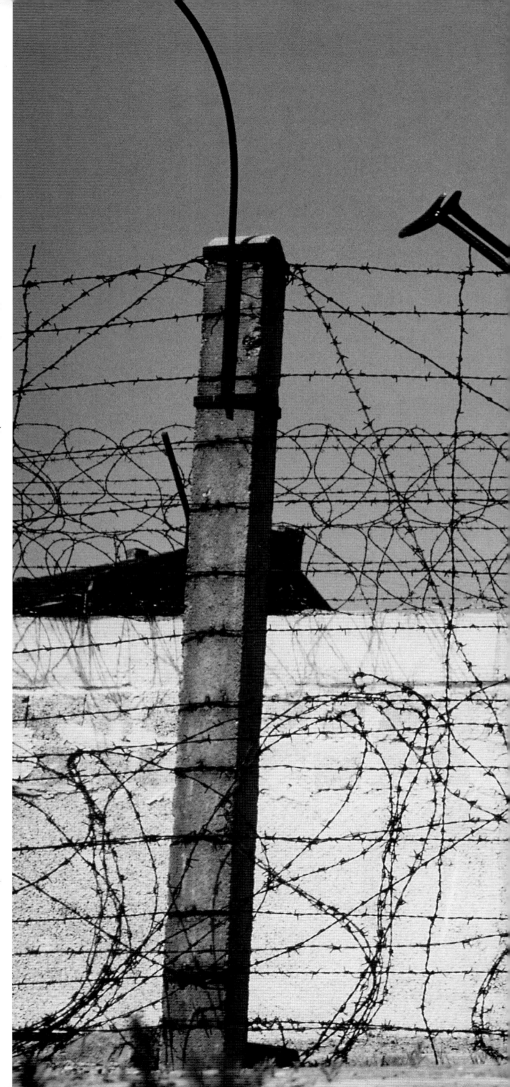

An East German border guard on observation duty on Leipziger Platz. The Wall has been standing for three years. Photo 1964.

Ein DDR-Grenzpolizist auf Beobachtungsposten am Leipziger Platz, 1964. Die Mauer steht seit knapp drei Jahren.

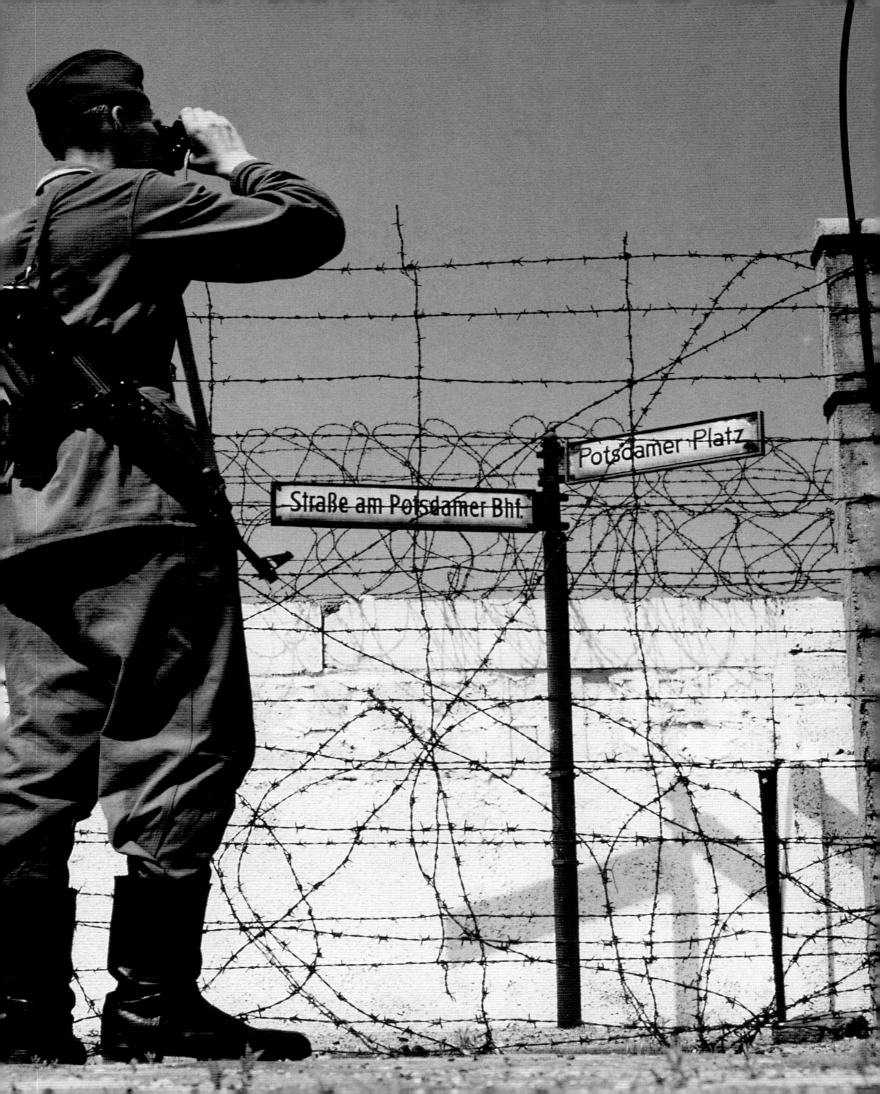

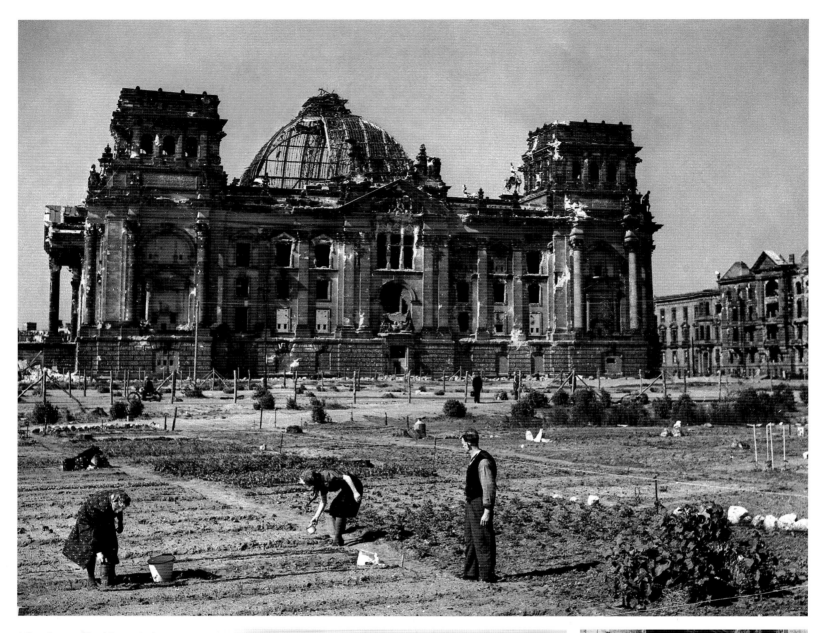

After the war, food is a priority. The Tiergarten in front of the remains of the Reichstag has been deforested, and Berliners tend root vegetables on allotments. Photo summer 1946.

Das völlig zerstörte Reichstagsgebäude ein Jahr nach Kriegsende. Die Berliner haben seit Sommer 1945 den Tiergarten vollständig abgeholzt und zu ihrer Versorgung Beete mit Nutzpflanzen angelegt, Sommer 1946.

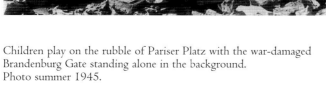

right-hand page, top / rechte Seite oben:
Frail-looking "rubble women" move a heavy piece of railway track. Photo 1946.

Trümmerfrauen bei der Arbeit, 1946.

Children play on the rubble of Pariser Platz with the war-damaged Brandenburg Gate standing alone in the background. Photo summer 1945.

Sommer 1945: Kinder spielen auf Schuttbergen, die sich auf dem Pariser Platz türmen; im Hintergrund das schwer beschädigte und fast freistehende Brandenburger Tor.

Berlin women are drafted as workers to clear rubble following a bill passed by the Allied Control Council. A "rubble woman" prepares bricks for re-use. Photo 1946.

»Trümmerfrau« beim Abklopfen von Ziegelsteinen für deren Wiederverwendung.

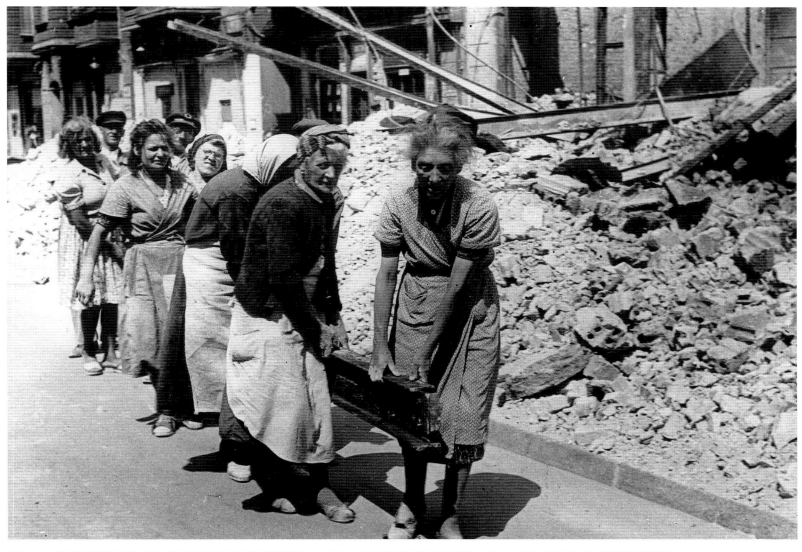

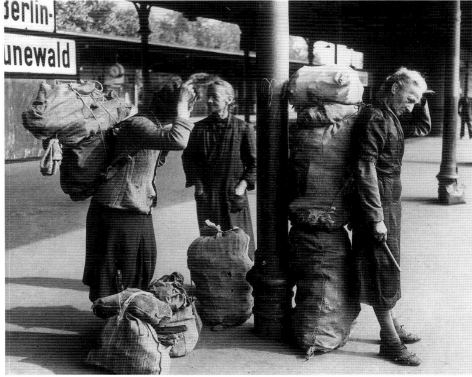

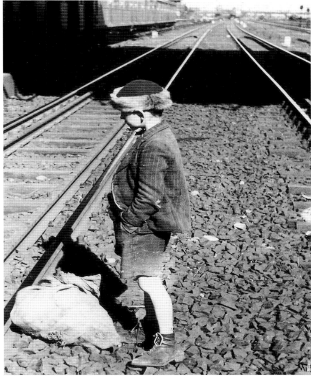

People were forced to travel to the outskirts of the city to look for fuel. Women with sacks of firewood wait at Grunewald S-Bahn station. Photo 1946.

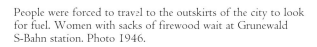

A small boy manages to "acquire" a sack of coal at a Berlin S-Bahn station. Photo 1946.

Ein Berliner Junge, der auf einem S-Bahnhof einen Sack Kohlen ›organisieren‹ konnte, 1946.

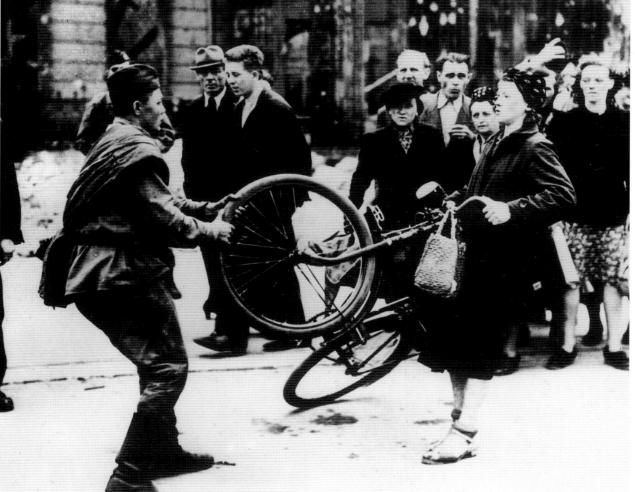

A Berliner exchanges his camera for American cigarettes. Once the fraternization ban was lifted, bartering between locals and occupying troops was commonplace. Photo July 25, 1945.

Ein Berliner tauscht seine Filmkamera gegen amerikanische Zigaretten, 25. Juli 1945. Nach der Aufhebung des Fraternisierungsverbots floriert der Tauschhandel zwischen Berlinern und den Besatzungssoldaten.

A Red Army soldier meets strong resistance when he tries to confiscate a woman's bicycle in front of the Brandenburg Gate. Photo 1945.

Ein Soldat der Roten Armee versucht vor dem Brandenburger Tor, gegen den Widerstand einer Frau deren Fahrrad zu konfiszieren, 1945.

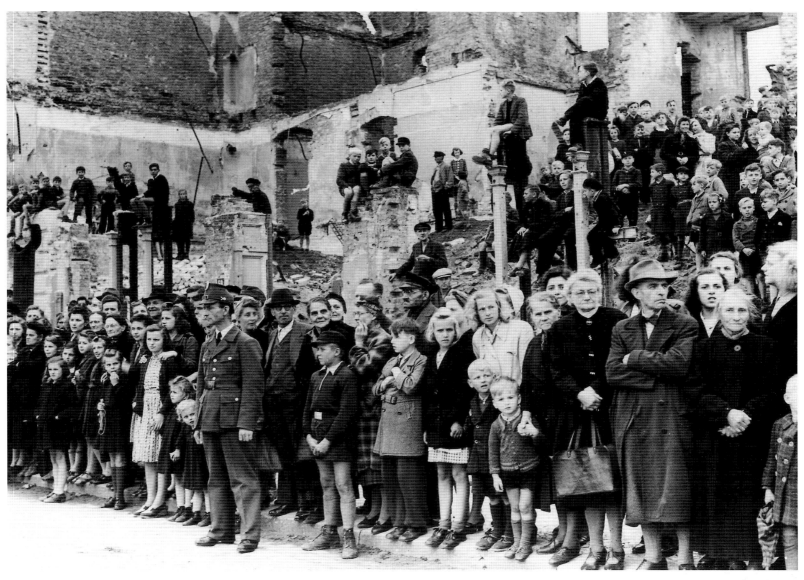

Berliners line the streets to watch the Desert Rats take up occupation of the British sector in the bombed city.
Photo July 4, 1945.

Die Einwohner Berlins säumen während des Einmarsches der britischen »Desert Rats« die Straßen der zerbombten Stadt. 4. Juli 1945.

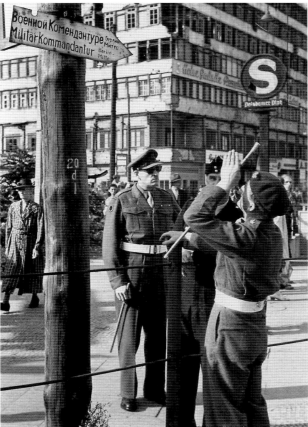

A British officer indicates the positions of the border signs for the British sector to his Soviet counterpart. The Columbus-Haus on Potsdamer Platz is in the background.
Photo August 21, 1948.

Berlin, 21. August 1948: Ein britischer Offizier markiert den Verlauf der Grenzen des Britischen und des Sowjetischen Sektors auf dem Potsdamer Platz, im Hintergrund das Columbus-Haus.

Life for the occupying forces: British soldiers and their families watch the coronation of Queen Elizabeth II on television. The coronation was the first BBC broadcast in West Germany.
Photo June 2, 1953.

Am 2. Juni 1953 verfolgen Angehörige der britischen Schutzmacht in Berlin die Fernsehübertragung der Krönung Elizabeths II. von England.

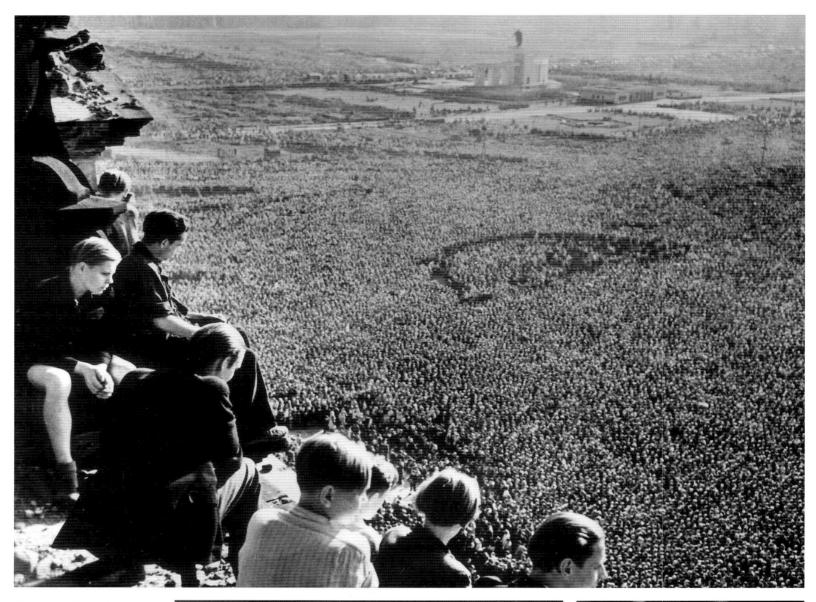

The uneasy alliance between Stalin and the West was irrevocably broken when Stalin blockaded Berlin in June 1948. 350,000 Berliners gather on the Platz der Republik to hear Ernst Reuter's appeal to the people of the world not to desert Berlin in her hour of need. View from the roof of the Reichstag.
Photo September 9, 1948.

Die von Anfang heikle Allianz von Stalin und den Westmächten zerbrach im Juni 1948 endgültig, nachdem sowjetische Truppen die Versorgung der Berliner Westsektoren blockierten. Am 9. September 1948 versammeln sich während der Blockade 350 000 Menschen auf dem Platz der Republik vor dem Reichstagsgebäude, um Ernst Reuter zuzuhören, der an die Völker der Welt appelliert, der Stadt während der Krise beizustehen.

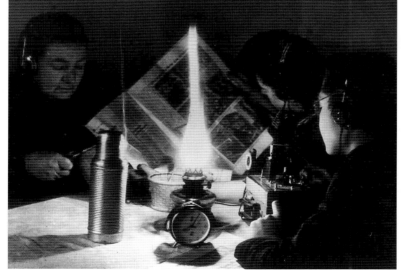

Electric light was only available for two hours a day during the blockade. The people here gather round a petrol lamp. Photo June 1948.

Während der Berlin-Blockade gibt es täglich nur für zwei Stunden elektrisches Licht. Die Berliner behelfen sich mit Petroleumlampen, Juni 1948.

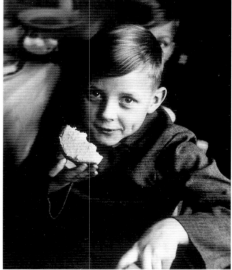

A young boy's eyes light up at the sight of food as he is fed in the US Air Force mess at Tempelhof airport. Photo 1948.

Ein Junge beim Essen. Berliner Kinder werden im Kasino der US-Truppen am Flughafen Tempelhof verpflegt, 1948.

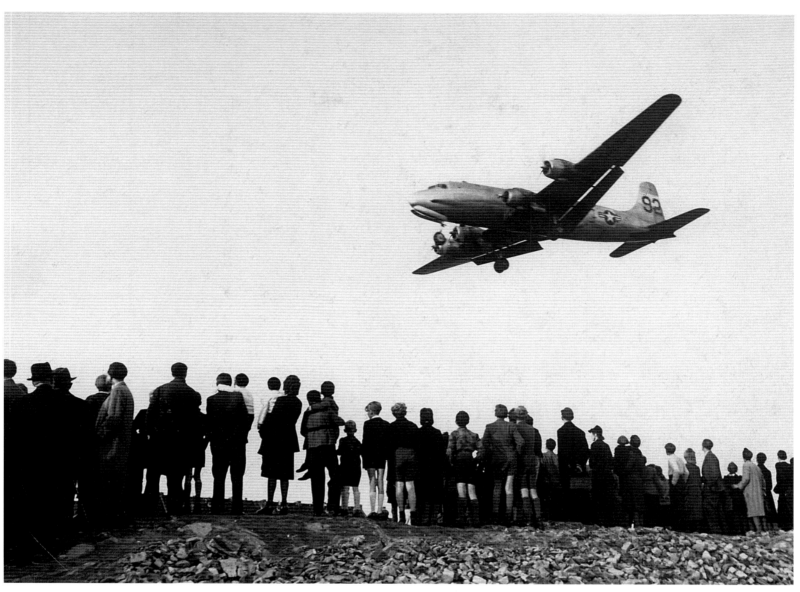

Allied planes were quickly dubbed "raisin bombers" as they
dropped their precious cargo from the air. Crowds look on as an
American plane approaches Tempelhof airport. Photo June 1948.

Ein »Rosinenbomber« im Anflug auf den Flughafen Tempelhof,
August 1948. Drei Jahre nach Ende des Krieges sind aus Feinden
Freunde geworden.

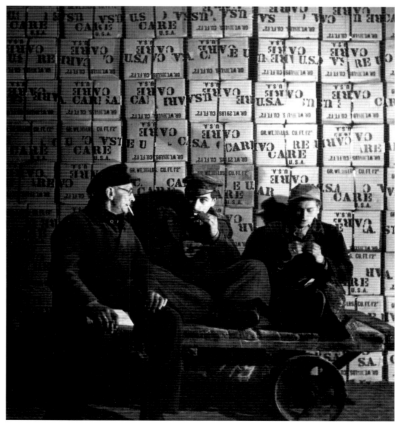

Care packets, such as these in storage from America, were flown in
to ease the worst of the subsequent food crisis. The blockade was
to last until May 1949. Photo June 1948.

Momentaufnahme in einem Care-Paket-Lager im Juni 1948
während der Berlin-Blockade, die von Juni 1948 bis Mai 1949
dauert. Die Allianz der gegen Hitler-Deutschland verbündeten
Mächte zerbricht; der Kalte Krieg zwischen der Sowjetunion und
dem transatlantischen Bündnis beginnt.

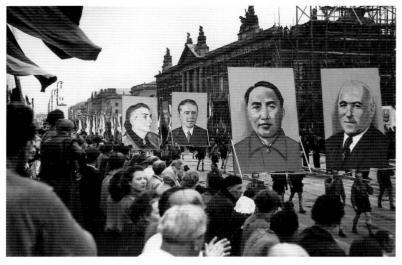

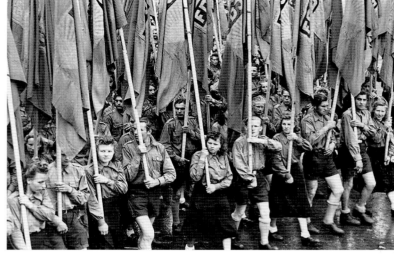

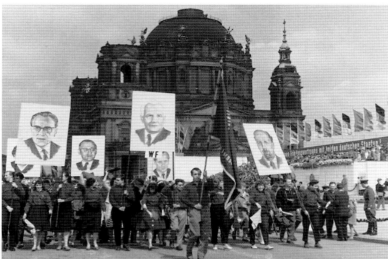

A convoy drives past the armory on Unter den Linden during the 1st German Convention of the FDJ [Free German Youth]. Photo May 1950.

Demonstrationszug vor dem Zeughaus während des »I. Deutschlandtreffens« der Freien Deutschen Jugend (FDJ) in Ost-Berlin, Mai 1950.

Children and young people in East Berlin were soon channelled into communist organisations. Flag-bearing FDJ members parade towards the Lustgarten in East Berlin. Photo May 1950.

Eine Fahnengruppe der FDJ aus dem Demonstrationszug des »Deutschlandtreffens«. Von 1946 bis 1955 war Erich Honecker Vorsitzender der ostdeutschen Jugendorganisation.

A May Day rally of the FDJ on Marx-Engels-Platz, the former Lustgarten, with the cathedral in the background. Photo 1956.

Parade der FDJ am 1. Mai 1956 auf dem Marx-Engels-Platz, dem ehemaligen Schloßgarten, im Osten Berlins, im Hintergrund der Berliner Dom.

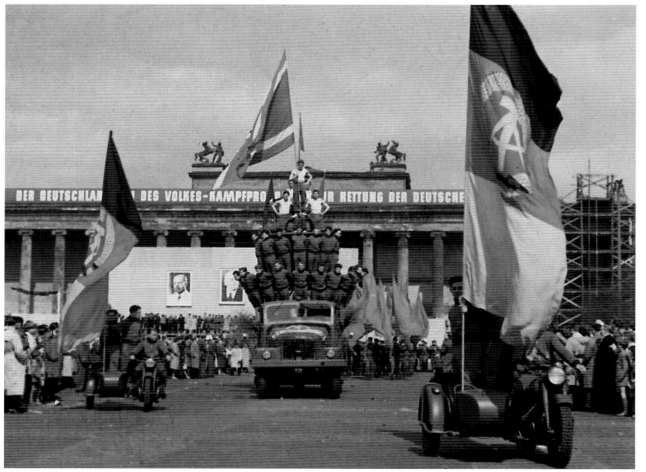

Ten years of the German Democratic Republic is commemorated with parades and placards of communist leaders. Schinkel's Altes Museum is in the background. Photo May 1, 1959.

Der 1. Mai 1959 wird von der zehn Jahre zuvor gegründeten DDR mit einem großen Aufmarsch vor Schinkels Altem Museum begangen.

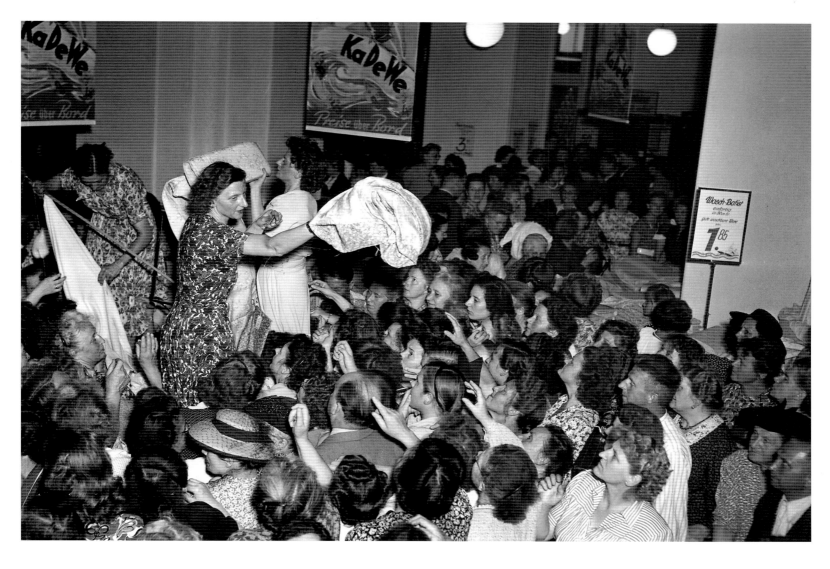

The 1950s saw the beginning of the German economic miracle. At this summer sale in the KaDeWe department store, the new prosperity is already visible as women clamour for bargains in the fabric department. Photo 1951.

Sommerschlußverkauf 1951 im Kaufhaus des Westens am Wittenbergplatz. An einem Verkaufsstand mit Meterware herrscht starkes Gedränge.

To celebrate the first direct flight from Berlin to Düsseldorf, models from the Ursula Schewe boutique show off the new summer fashions at Tempelhof airport. Photo April 26, 1954.

Damenmode 1954. Anläßlich der Eröffnung der direkten Flugverbindung Berlin – Düsseldorf am 26. April zeigen Mannequins des Salons Ursula Schewe auf dem Flugfeld Tempelhof die aktuelle Sommermode.

A young woman enjoys the freedom of a rubber dinghy on a lake in the Tiergarten. The Siegessäule is visible in the background: most of the trees in the Tiergarten had been chopped down for firewood after the war. Photo c. 1950.

Freizeitvergnügen im Tiergarten, um 1950: eine junge Frau im Schlauchboot, im Hintergrund die Siegessäule. Der Tiergarten war von den Berlinern in den ersten Kriegsjahren fast vollständig abgeholzt worden, um Brennholz zu gewinnen.

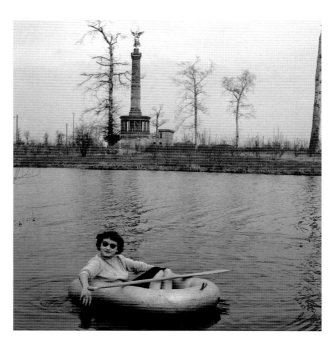

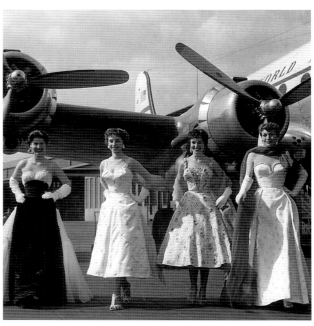

Appalling work conditions and impossible state targets provoked the workers' uprising of June 17, 1953 which soon developed into a full-scale demonstration for democracy. Protesters tear up the Red Flag in front of the Brandenburg Gate in a short-lived mood of optimism. Photo 1953.

Während des Arbeiteraufstands am 17. Juni 1953 zerreißen Aufständische hoffnungsfroh vor dem Brandenburger Tor die Rote Fahne. Die Revolte nimmt ihren Anfang in der Stalinallee, nachdem Bauarbeiter dort gegen die Erhöhung ihrer Arbeitsnorm protestiert hatten, und entwickelt sich zu einem Aufstand für Demokratie und Menschenrechte.

Demonstrators hold aloft a stolen border sign. East Berlin officials had coined the name "democratic sector" for the Russian-occupied zone. Photo June 17, 1953.

Demonstranten am 17. Juni 1953 mit einem abgerissenen Grenzschild; der Ostteil der Stadt heißt in der Amtssprache der DDR »Demokratischer Sektor«.

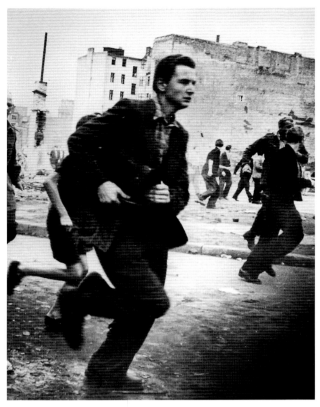

Demonstrators flee towards the American sector from the advancing Soviet tanks; few escaped with their lives. Photo June 17, 1953.

Jähes Ende des Aufstands: Demonstranten fliehen vor den nahenden sowjetischen Panzern in den amerikanischen Sektor Berlins.

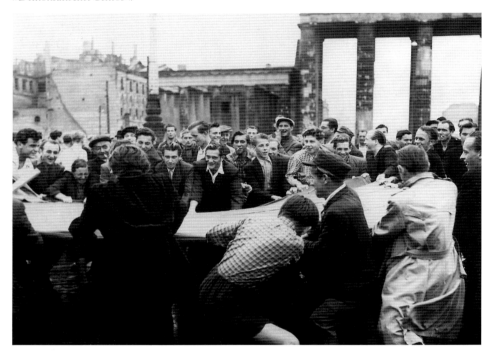

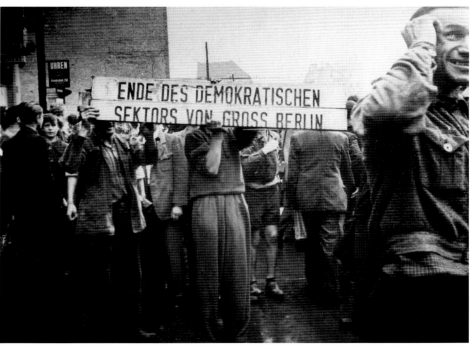

right-hand page / rechte Seite

The city centre is cordoned off by Soviet blockades, such as this one in Wilhelmstraße, in order to crush the mounting rebellion in the streets. Photo June 17, 1953.

Straßensperre der sowjetischen Armee in der Wilhelmstraße in Berlin-Mitte, 17. Juni 1953.

A raised fist, a distant tank, and the debris of an empty street. A symbol of despair for the crushed uprising. Photo June 17, 1953.

Macht – Ohnmacht – Wut. Diese Aufnahme ist ein Sinnbild des niedergeschlagenen Arbeiteraufstands am 17. Juni 1953.

Crowds gather on Potsdamer Platz at midday to watch the Columbus-Haus go up in smoke. A celebrated example of modern architecture during the Weimar period, it had passed into the hands of the SS under the Nazis and now housed part of the GDR administration. Photo June 17, 1953.

Der Potsdamer Platz am Mittag des 17. Juni: Schaulustige haben sich versammelt, um das Wüten der Flammen im Columbus-Haus, in dem Teile der Verwaltung der DDR-Behörden untergebracht sind, zu beobachten.

Soviet tanks were quick to react to the crisis. Here they advance down the Leipziger Straße. Photo June 17, 1953.

Panzer der Sowjet-Armee sind bis in die Stadtmitte vorgedrungen – hier auf der Leipziger Straße – und bringen die Lage wieder unter Kontrolle.

A simple wooden cross marks the spot where a Berliner was killed by a Soviet tank. Photo June 17, 1953.

Ein schlichtes Holzkreuz markiert die Stelle vor dem Zeughaus Unter den Linden, an der ein Berliner von einem russischen Panzer überrollt wurde.

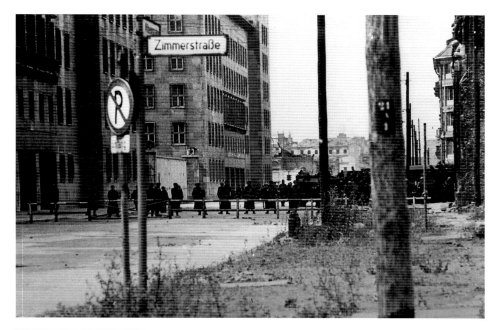

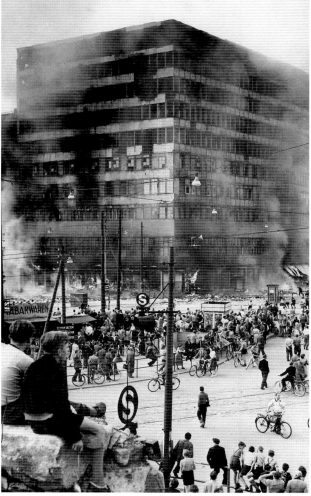

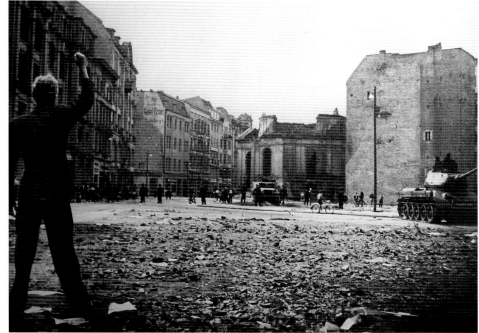

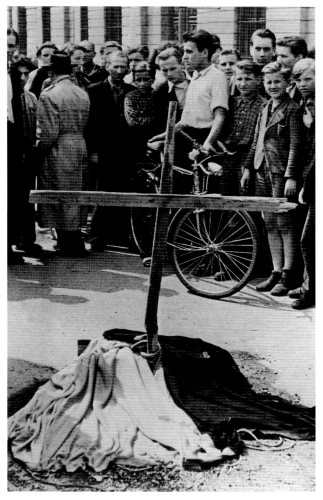

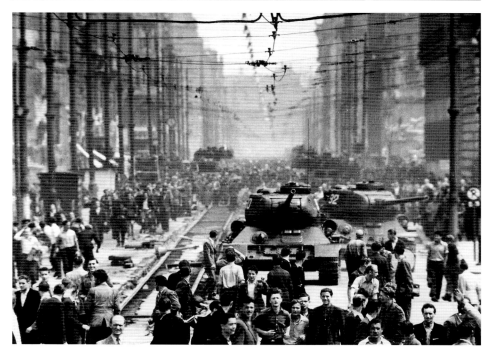

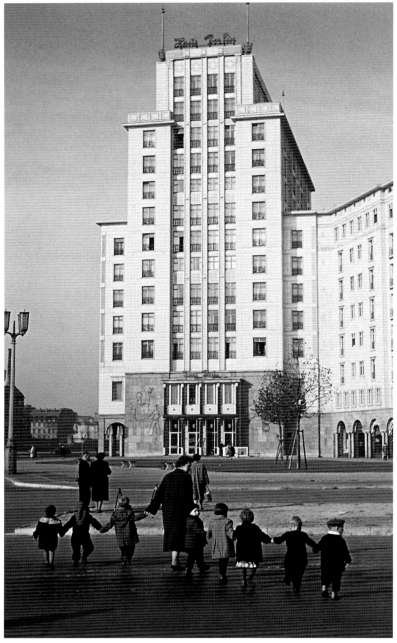

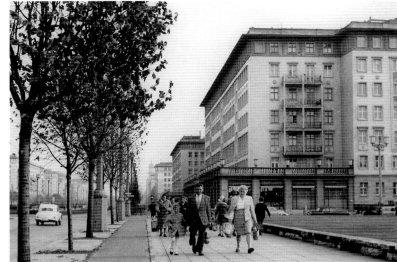

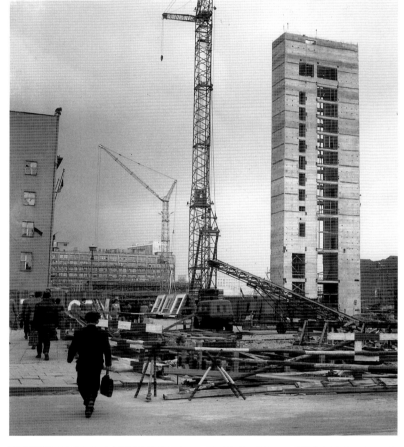

Changing street names reflected the turbulent recent history of East Berlin. People stroll along Karl-Marx-Allee, which was Frankfurter Allee before the allied occupation, then Stalinallee until 1961. Photo 1961.

Straßenszene in der Karl-Marx-Allee in Ost-Berlin, 31. Oktober 1961.

Work continues on the Rathaus arcades, a new shopping centre near the town hall in East Berlin. It took four years to complete. Photo 1968.

Der Rohbau der Rathaus-Passagen in Berlin-Mitte (Bauzeit 1968 bis 1972) in der Nähe des Roten Rathauses.

This partial view of Haus Berlin on Strausberger Platz shows the influence of Moscow's post-war architecture. It was designed by the Hermann Henselmann Collective. Photo 1956.

Teilansicht des »Hauses Berlin«, einem von zwei Turmhäusern am Strausberger Platz, dem zentralen Rondell der Stalinallee, 1956. Der Architekt Hermann Henselmann lehnt sich eng an die Moskauer Nachkriegsarchitektur an.

The policy in East Berlin was that new buildings should be standardized, functional, and cheap to produce. This aerial view of Alexanderplatz is evidence of this policy. In the foreground is the tourist hotel, Haus des Reisens. Photo 1974.

Blick vom Fernsehturm auf die Neubauten am Alexanderplatz und entlang der Grunertstraße, 1974, im Vordergrund das »Haus des Reisens«.

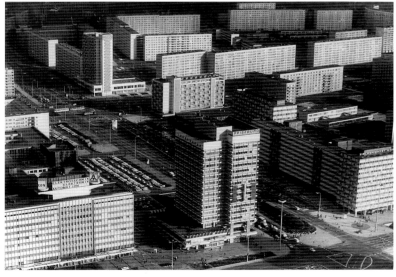

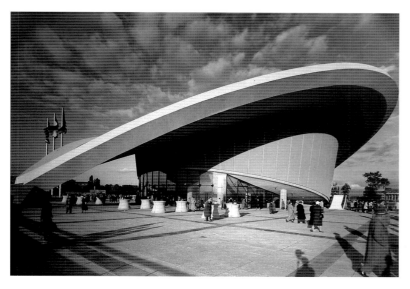

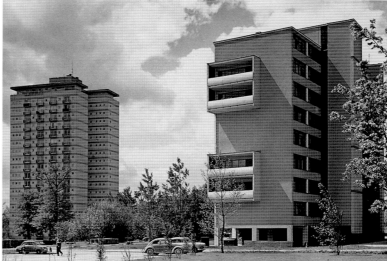

"Pregnant Oyster" was the nickname given to the American contribution to the International Building Exhibition. The Congress Hall in the Tiergarten was designed by Hugh Stubbins. Photo 1957.

Die in den Jahren 1956/57 als Beitrag der USA zur Internationalen Bauausstellung (IBA) erbaute Kongreßhalle (Entwurf: Hugh Stubbins) im Tiergarten. Der Berliner Volksmund tauft das Gebäude auf den Namen »Schwangere Auster«.

The war-time ruins of the Hansa quarter offered contemporary architects the chance to experiment, and the area was rebuilt for the International Building Exhibition in 1957. Walter Gropius' nine-storey apartment block on the right faces the seventeen-storey high-rise by architects Klaus Müller-Rehm and Gerhard Siegmann. Photo c. 1960.

Das im Krieg zerstörte Hansa-Viertel wurde Experimentierfeld zeitgenössischer Architektur und im Zuge der Internationalen Bauausstellung (IBA) 1957 neu bebaut. Rechts ein neungeschossiges Wohnhaus von Walter Gropius, links ein siebzehngeschossiges Hochhaus von Klaus Müller-Rehm und Gerhard Siegmann.

A girl pushes her doll's pram through the newly built Hansa quarter. Photo c. 1957.

Ein Mädchen mit Puppenwagen vor einem der neuen Wohnhäuser im Hansaviertel, um 1957.

West Berliners anxious to break with their Nazi past adopted modern architectural styles, many of them a result of American projects. In this view of the Kurfürstendamm and Joachimsthaler Straße, only the jagged ruins of the Gedächtniskirche tower serve as a memorial to the past. The roof-terrace of the Café Kranzler in the foreground, and the Europa-Center in the distance are symbols of the new Berlin. Photo 1970.

Blick über die Kreuzung Kurfürstendamm und Joachimsthaler Straße mit der charakteristischen Dachterrasse des Café Kranzler (links) zur Kaiser-Wilhelm-Gedächtniskirche und dem Europa-Center am Breitscheidplatz, 1970. Der Modernismus hat Einzug in die West-City gehalten.

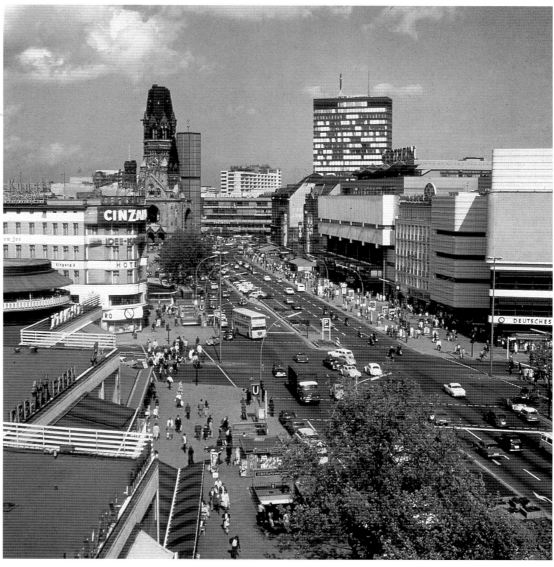

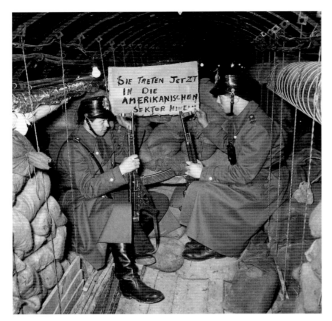

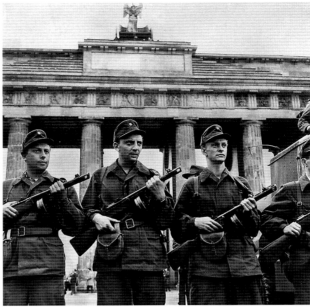

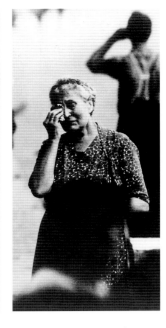

An escape- and spy-tunnel is discovered between Rudow in the Neu-Kölln district of West Berlin and Alt-Glienicke (Treptow) in the East. Two armed police guard the tunnel after its discovery: border controls apply even underground.
Photo April 22, 1956.

Am 22. April 1956 wird ein Flucht- und Spionagetunnel zwischen dem West-Berliner Ortsteil Rudow, der zu Neukölln gehört, und Alt-Glienicke (Bezirk Treptow) in Ost-Berlin entdeckt.

"The troops from our state firms and institutions guard our borders on the western side of the Brandenburg Gate." This East German press photo is designed to reassure its citizens.
Photo August 14, 1961.

Ein offizielles Pressefoto der DDR vom 14. August 1961. »Die Kämpfer aus unseren VEB und Staatlichen Institutionen auf der westlichen Seite des Brandenburger Tores schützen unsere Grenzen.«

A woman weeps to see the completion of a border control post. Many families were separated by the wall and it was two years before visitor's rights were granted.
Photo October 1961.

Eine Frau beobachtet die Fertigstellung eines Grenzübergangs in der Berliner Mauer, Oktober 1961. Der Bau der Mauer führt dazu, daß Familien getrennt werden. Erst zwei Jahre später wird ihnen wieder ein Besuchsrecht eingeräumt.

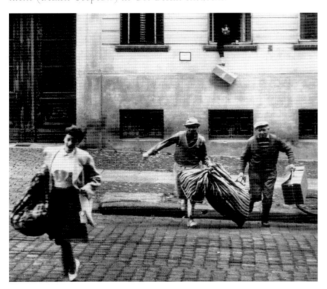

As the building of the Wall commences East Berliners make a last ditch run for the West. Residents of Bernauer Straße escape through windows. Photo August 13, 1961.

Anwohner der Bernauer Straße, durch die die Sektorengrenze zwischen dem Osten und Westen verläuft, fliehen nach West-Berlin, 13. August 1961.

The refusal by the East German police to let American officials pass unchecked through the border exacerbates the crisis: US tanks line the border at Checkpoint Charlie.
Photo October 25, 1961.

25. Oktober 1961: Die Weigerung der Volkspolizei der DDR, amerikanische Beamte unkontrolliert passieren zu lassen, führt zu einer Zuspitzung der Lage. Panzer der US Army fahren am Checkpoint Charlie auf.

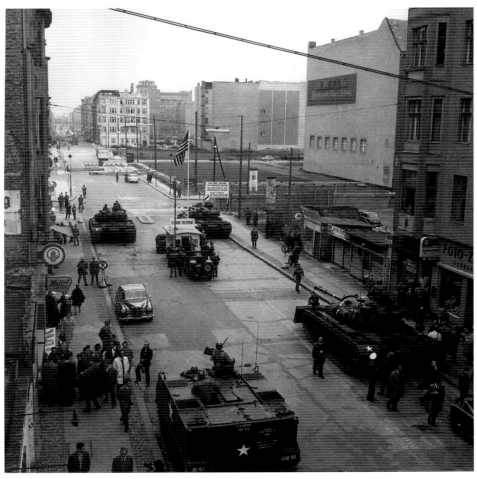

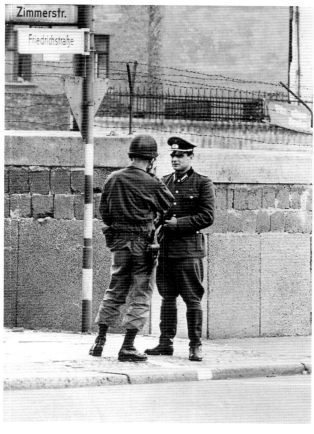

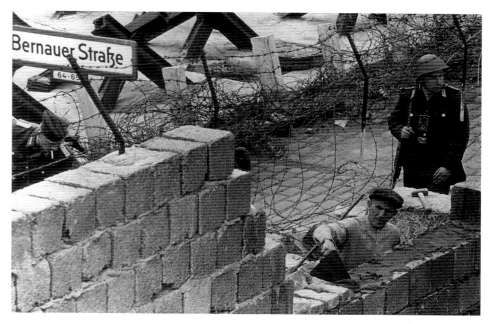

A lieutenant of the East
German border guards and
a US soldier stand opposite
each other on the border line
at Friedrichstraße.
Photo October 1961.

A building worker, watched over by East German guards, repairs
part of the Berlin Wall in Bernauer Straße which has been
damaged by an unexplained explosion. Photo May 26, 1962.

An der mit weißer Farbe aufge-
malten Grenzlinie in der Fried-
richstraße in Berlin-Mitte ste-
hen sich ein Leutnant der
Grenztruppen der DDR und
ein amerikanischer Soldat
direkt gegenüber. Oktober
1961.

Ein DDR-Grenzposten bewacht einen Maurer, der Ausbesse-
rungsarbeiten an der Mauer in der Bernauer Straße ausführt.
Die Schäden sind durch eine ungeklärte Explosion entstanden,
26. Mai 1962.

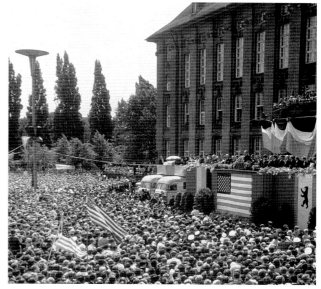

US President John F. Kennedy receives a hero's
welcome from Berliners. Chancellor Adenauer
joins him on the podium in front of the
Schöneberg City Hall. Photo June 26, 1963.

Als Präsident John F. Kennedy am 26. Juni 1963
West-Berlin besucht, wird er begeistert empfan-
gen; hier sieht man ihn und Bundeskanzler
Konrad Adenauer am Rednerpult vor dem
Rathaus Schöneberg.

View over the Wall at Potsdamer Platz towards
Leipziger Straße in the East. Photo c. 1970

Blick über die Mauer am Potsdamer Platz in die
Leipziger Straße, um 1970.

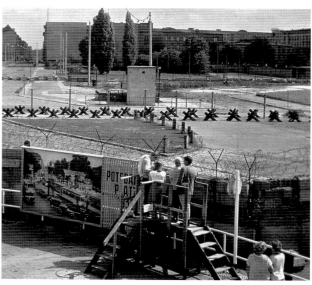

The 18-year-old East Berlin building worker
Peter Fechter is shot whilst trying to escape to
West Berlin near Friedrichstraße. Neither West
nor East German guards intervene, and Fechter
bleeds to death in no-man's-land.
Photo August 17, 1962.

Am 17. August 1962 versucht der 18-jährige
Peter Fechter in der Nähe der Friedrichstraße
nach West-Berlin zu fliehen und wird von
Grenztruppen der DDR angeschossen. Während
sich die westlichen und östlichen Grenzschützer
in Schach halten und nicht eingreifen, verblutet
er im Niemandsland.

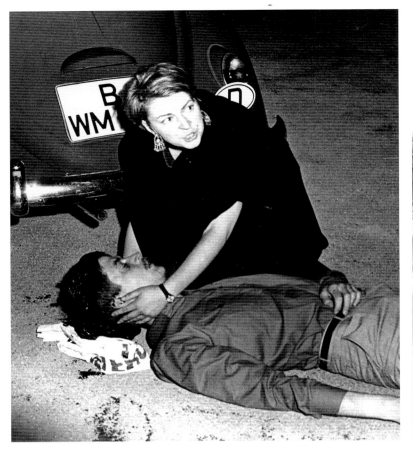

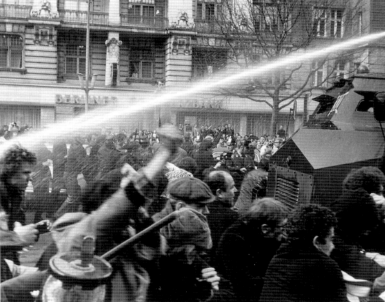

The Vietnam War sparked a wave of anti-American protest, particularly among young Berliners. On a state visit to Berlin by the American-backed Shah of Iran, Reza Pahlewi, student demonstrations escalate into riots outside the Opera House and the student Benno Ohnesorg is shot dead by police. Photo June 2, 1967.

Im Lauf der gegen den Besuch des persischen Schahs Reza Pahlewi und seiner Frau in West-Berlin gerichteten Demonstrationen kommt es vor der Deutschen Oper in Berlin-Charlottenburg zu Ausschreitungen, bei denen der Student Benno Ohnesorg von einem Polizisten erschossen wird, 2. Juni 1967.

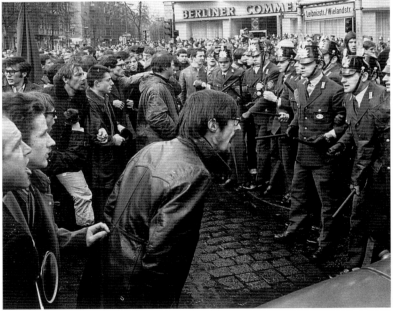

Dieter Kunzelmann (left) at a Jimi Hendrix concert in the Berlin Sportpalast. Kunzelmann was a member of the Apo [Extra-parliamentary Opposition] and founder of the protest group Kommune I in 1967. Photo January 24, 1969.

Dieter Kunzelmann, Mitglied der Außerparlamentarischen Opposition (Apo) und einer der Mitbegründer der Kommune I am 24. Januar 1969 bei einem Konzert von Jimi Hendrix im Berliner Sportpalast.

Police react with water cannon as students take to the streets in protest at the assassination attempt on Rudi Dutschke, founder of the APO. Photo April 12, 1968.

Demonstration von Studenten am 12. April 1968 auf dem Kurfürstendamm anläßlich des Attentats auf Rudi Dutschke am Vortag. Die Polizei setzt Wasserwerfer ein.

Demonstrators on the Kurfürstendamm face a police line. Police behaviour was called into question many times during the protests of the late 1960s. Photo April 12, 1968.

Aufgebrachte Demonstranten vor einer Polizei-kette, 12. April 1968.

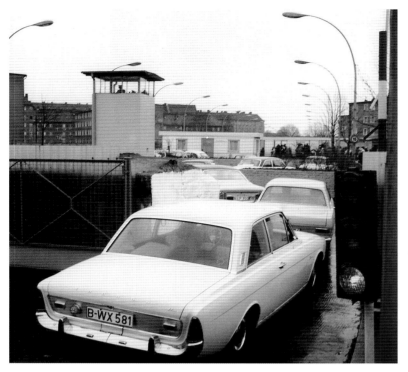

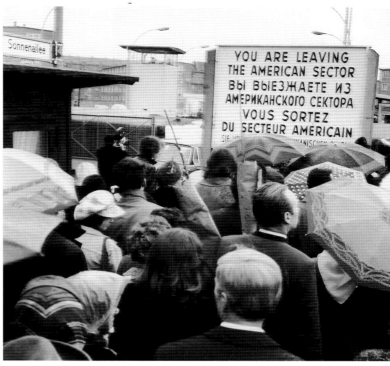

A temporary ruling on visits between the GDR and the Federal Republic gives rise to dense traffic at the border checkpoint Sonnenallee/Baumschulenweg over the Easter period. Photo March 30, 1972.

Nach Inkrafttreten der zeitweiligen Regelung über den Besuchs- und Transitverkehr zwischen der DDR und der Bundesrepublik Deutschland herrscht während der Osterfeiertage 1972 reger Betrieb, so am 30. März am Grenzübergang Sonnenallee/Baum- schulenweg in Berlin-Treptow/Britz.

Pedestrians wait to cross the border checkpoint into the East at Sonnenallee and Baumschulen- weg. Photo March 30, 1972.

Fußgänger stehen an, um den Grenzübergang Sonnenallee/Baumschulenweg am 30. März 1972 in Richtung Osten zu passieren.

West Berliners cross the border at the Ober- baumbrücke checkpoint. In the autumn of this year regulations for day passes for West Berliners wanting to visit the East came into force. Photo November 1, 1964.

West-Berliner am Grenzübergang Oberbaum- brücke, 1. November 1964. Im Herbst dieses Jahres waren Regelungen für Tagesaufenthalte von West-Berlinern im Ostteil der Stadt in Kraft getreten.

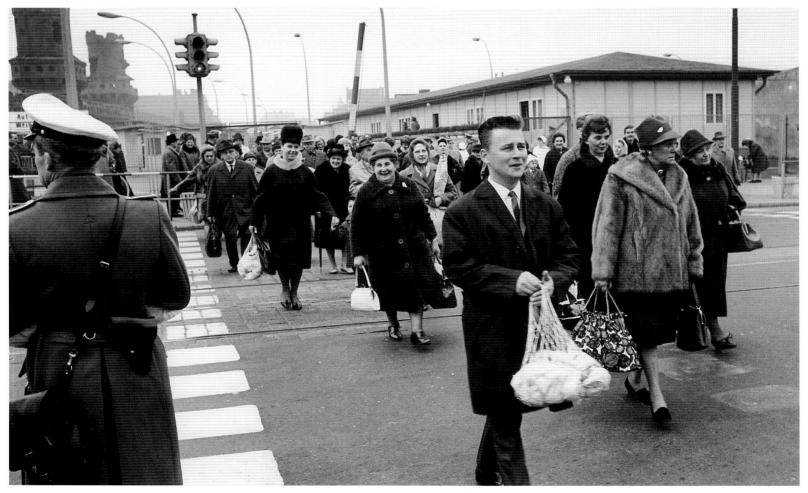

A horse and cart transport building rubble at the intersection of Französische Straße and Wilhelm-Külz-Straße, now renamed Markgrafenstraße in the Mitte district. Photo c. 1967.

Ein Pferdewagen mit Bauschutt an der Kreuzung Französische Straße und Wilhelm-Külz-Straße, der heutigen Markgrafenstraße, in Berlin-Mitte, um 1967.

The propaganda poster in the background shows the SED General Secretary Walter Ulbricht (right). Photo 1964.

Mutter mit Kindern vor einer Photowand mit einem Propagandabild der SED (rechts der damalige Generalsekretär Walter Ulbricht), 1964.

Window undressing: a passer-by looks at the display in a lingerie shop in Karl-Marx-Allee, East Berlin. Photo 1964.

Ein Passant vor den Schaufensterauslagen eines Miederwarengeschäfts in der Karl-Marx-Allee in Ost-Berlin, 1964.

Tea—or coffee—for three in Köpenick, East-Berlin. Photo 1983.

Momentaufnahme in einem Café im Ost-Berliner Bezirk Köpenick, 1983.

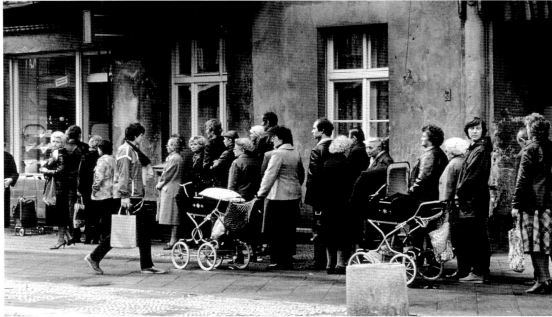

Queuing at the baker's in Prenzlauer Berg. Photo 1982.

Berlin-Prenzlauer Berg, 1982: Schlangestehen vor einem Bäckerladen.

A lone figure walks among the panel constructions of the housing estate on Thomas-Mann-Strasse in the Prenzlauer Berg district of East Berlin. Photo 1982.

Plattenbauten der Wohnsiedlung in der Thomas-Mann-Straße in Berlin-Prenzlauer Berg, 1982.

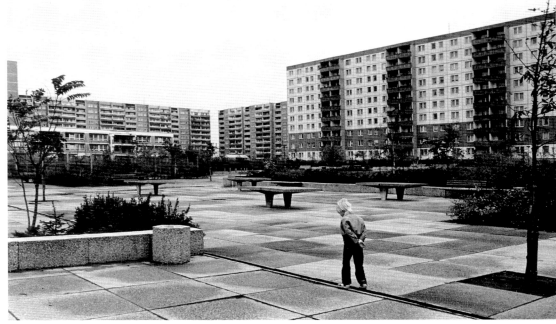

Display in the window of a hairdressing salon in East Berlin. Photo 1980s.

Dekoration im Souterrainfenster eines Friseursalons in Ost-Berlin, achtziger Jahre.

The lure of the exotic entrances one passer-by in the East Berlin district of Prenzlauer Berg. Photo 1982.

Ein Passant vor dem Schaufenster einer Vogelhandlung im Ost-Berliner Bezirk Prenzlauer Berg, 1982.

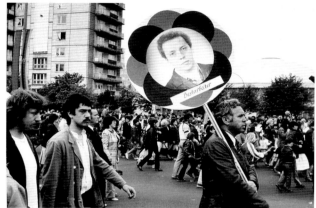

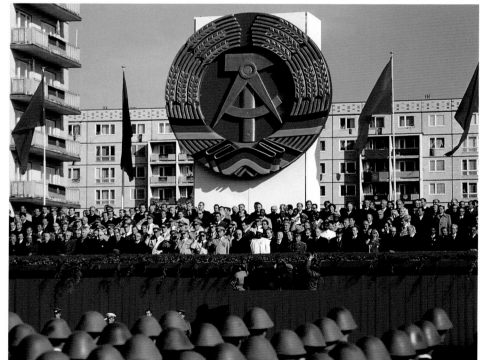

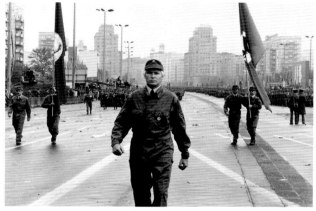

A state worker on Alexanderplatz celebrates the fulfilment of his sector's quota by 102 percent. Photo May 1, 1983.

Demonstration am 1. Mai 1983 in Ost-Berlin: ein Angehöriger eines Volkseigenen Betriebes mit einem Transparent vor dem »Haus des Lehrers« auf dem Alexanderplatz.

A winner of the "best worker" prize displays his own image on his placard. "Best workers" were employees who had been commended for their exceptional contribution to output. Photo May 1, 1983.

Karl-Marx-Allee in Ost-Berlin, 1. Mai 1983: ein »Bestarbeiter« mit seinem Porträtfoto bei der Mai-Demonstration. Bestarbeiter waren Betriebsangehörige, die für ihre überdurchschnittliche Arbeit ausgezeichnet wurden.

Workers' militias parade on Karl-Marx-Allee on May Day. Hermann Henselmann's gatehouses on Strausberger Platz frame the background. Photo 1983.

Betriebskampfgruppen während der 1.-Mai-Parade 1983 auf der Karl-Marx-Allee; im Hintergrund die zwei Torhäuser Hermann Henselmanns am Strausberger Platz.

At celebrations for the 30th anniversary of the founding of the GDR, the National Peoples' Army staged a parade of honour in Karl-Marx-Allee. View of the VIP stand with Erich Honecker, Leonid Brezhnev, and other dignitaries from home and abroad. Photo October 7, 1979.

Ehrenparade der NVA anläßlich der Feier zum 30-jährigen Bestehen der DDR am 7. Oktober 1979. Auf der Ehrentribüne in der Karl-Marx-Allee war die Staats- und Parteiführung der DDR versammelt sowie ausländische Staatsgäste, u.a. Leonid Breschnew und Jasir Arafat.

Alexanderplatz with (from left) the department store Centrum, the international clock, and the hotel Stadt Berlin. Photo 1974.

Der Alexanderplatz mit der Weltzeituhr, dem Hotel »Stadt Berlin« (rechts) und dem Centrum-Warenhaus, das die für die Bauweise der DDR charakteristischen vorgehängten Fassadenelemente zeigt, 1974.

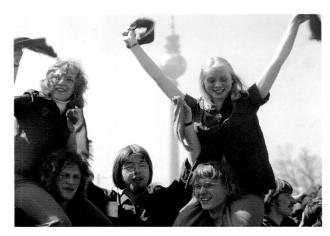

The unofficial symbol of East Berlin was the Trabant car, one of only two types of car to be produced in the Democratic Republic. A "Trabi" spotted in Leipziger Straße just before the fall of the Berlin Wall. Photo 1989.

Ein parkender Trabant in der Leipziger Straße in Ost-Berlin, Herbst 1989. Der Trabant war einer von zwei Autotypen, die in der DDR produziert wurden.

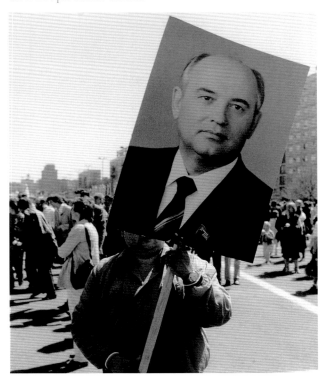

left / links:

Members of the FDJ participate in East Berlin's World Youth Festival. Invitees came from all regions of the eastern bloc, as well as from socialist organizations in Western Europe, Africa, and North America. Photo 1973.

Mitglieder der Freien Deutschen Jugend (FDJ) während der Weltfestspiele der Jugend in Ost-Berlin, 1973. Zu diesen Spielen wurden Abordnungen aus den Ländern des Ostblocks sowie sozialistischer Organisationen aus Westeuropa, Afrika und Nordamerika eingeladen.

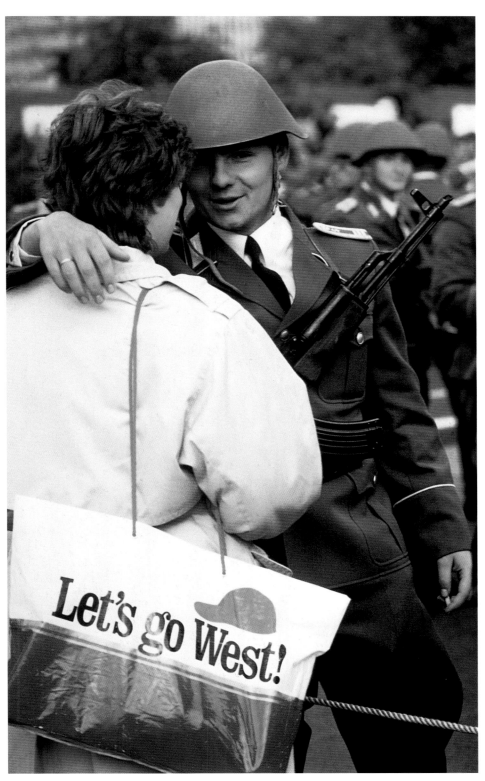

A May Day parader carries a portrait of Michail Gorbachev, the Soviet leader whose "glasnost" policy pushed through a liberalization of the communist regime. Photo 1986.

Ein Teilnehmer der Parade am 1. Mai 1986 mit einem Porträt Michail Gorbatschows, dem Generalsekretär der Kommunistischen Partei der Sowjetunion, der für eine Liberalisierung des kommunistischen Herrschaftssystems eintrat.

Snapshot at the end of the GDR 40th anniversary celebrations in East Berlin. A soldier of the National Peoples' Army embraces an onlooker. Her bag, advertising a cigarette company, carries the prophetic slogan "Go West."

Schnappschuß am Rande der Feierlichkeiten zum 40. Jahrestag der DDR im Oktober 1989. Ein Soldat der NVA umarmt eine Zuschauerin, die eine Tragetasche mit symbolträchtiger Aufschrift geschultert hat.

1989–2000
THE NEW CAPITAL
DIE NEUE HAUPTSTADT

The turning point in November 1989 when the Berlin Wall effectively ceased to exist was the beginning of yet more dramatic changes to the landscape of the city. The graffiti-covered Wall became the backdrop for protests and celebrations, and finally its fragments found a new life as objects of fascination, if not quite works of art. The international architectural world rapidly colonized the lost centre of the city, and with their characteristic love of material pleasures, Berliners are watching as the city regains the sparkle and glamour of the beginning of the century.

The continuity provided by Berlin's marketplaces—from trade fairs to ethnic food stalls—underpins the diversity of big-city life. A range of international art exhibitions have appeared Berlin, organized with a speed and enthusiasm that betrays the underlying conviction of Berliners that their status as world city would inevitably return. Whether celebrating alongside old familiar monuments such as the Brandenburg Gate, creating 1920s pastiches on Marlene-Dietrich-Platz, or opening up innovative artistic spaces, Berlin displays a taste for both a planned future, and also one which can surprise. The new capital has wasted no time in revealing to the world its most recent face.

Der Fall der Berliner Mauer im November 1989 war zugleich der Beginn eines tiefgreifenden Wandels der Stadtlandschaft. Vor der mit Graffiti überzogenen Mauer fanden Protestumzüge ebenso wie Feierlichkeiten statt; in der Zwischenzeit sind die Mauerstücke als faszinierende Sammler-Objekte und sogar als Kunstwerke neu entdeckt worden. Die internationale Architekturwelt hat rasch die verlorengeglaubte Mitte der Stadt in Beschlag genommen, und die Berliner beobachten mit der für sie typischen Lust an Vergnügungen, wie der Glanz und Glamour des Berlins um 1900 in ihre Stadt zurückkehren.

Die Tradition von Märkten in Berlin, seien es Handelsmessen oder türkische Gemüsestände, unterstreicht den Facettenreichtum des Lebens in der Großstadt. Eine Vielzahl internationaler Kunstausstellungen war in Berlin zu sehen, alle mit einer Geschwindigkeit und einem Enthusiasmus auf die Beine gestellt, die im Grunde der latenten Überzeugung der Berliner widersprechen, daß der Rang Berlins als Weltstadt sich wie von selbst wieder einstellen werde. Ob nun vor alten, wohlbekannten Monumenten wie dem Brandenburger Tor gefeiert, eine an die Zwanziger Jahre erinnernde Urbanität auf dem Marlene-Dietrich-Platz neu geschaffen wird oder innovative Räume für junge Kunst entstehen, Berlin beweist mit alldem sowohl seine Vorliebe für eine Planung der Zukunft wie auch seine Offenheit für überraschende Entwicklungen. Die neue Hauptstadt hat der Welt innerhalb kurzer Zeit ein neues Gesicht präsentiert.

Spectacular celebrations mark the 10th anniversary of the fall of the Berlin Wall. The Brandenburg Gate is silhouetted against fireworks. Photo November 9, 1999.

Das Feuerwerk am Brandenburger Tor zum zehnten Jahrestag des Mauerfalls bildete den Abschluß der Festveranstaltung am 9. November 1999.

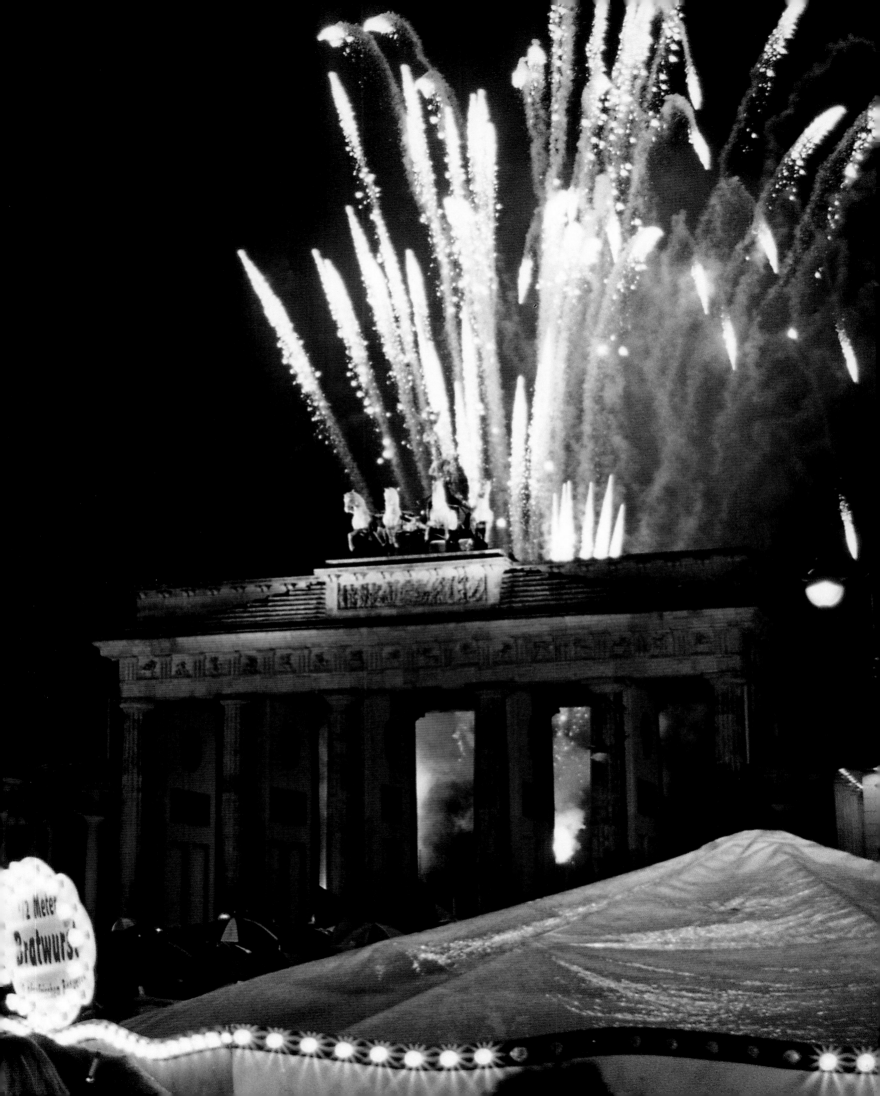

Members of the GDR Peace Movement form a human chain from the US to the Soviet Embassies in East Berlin. Demonstrators, pictured here in front of the US Embassy, are dispersed by police. Photo September 1, 1983.

Mitglieder der Friedensbewegung der DDR bilden am 1. September 1983 eine Menschenkette von der amerikanischen zur sowjetischen Botschaft in Ost-Berlin, die von der Polizei aufgelöst wurde.

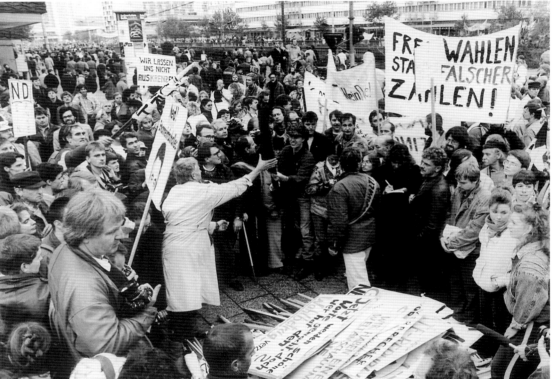

Over 500,000 East Berliners add their voices to the nationwide call for political reform. After the closing demonstration for democracy, freedom of speech and freedom of movement, demonstrators on Alexanderplatz lay down their placards. Photo November 4, 1989.

Nach der Abschlußkundgebung der Großdemonstration für Meinungs-, Reise- und Wahlfreiheit und Demokratie auf dem Alexanderplatz am 4. November 1989 legen Teilnehmer ihre Plakate und Transparente ab.

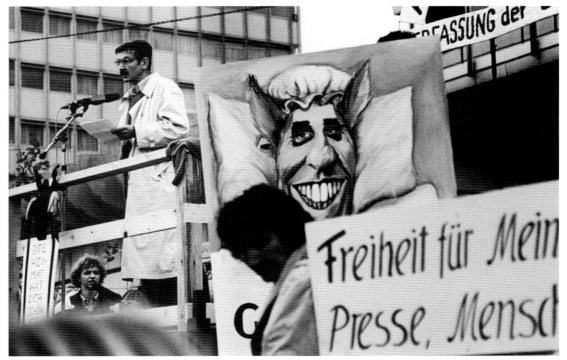

The writer Christoph Hein makes a speech during the "Monday Demonstration" for civil rights, organized by members of the Deutsches Theater on Alexanderplatz. Photo September 4, 1989.

Der Schriftsteller und Dramatiker Christoph Hein auf dem Rednerpodium während der Prostestdemonstration in Ost-Berlin am 4. November 1989 auf dem Alexanderplatz.

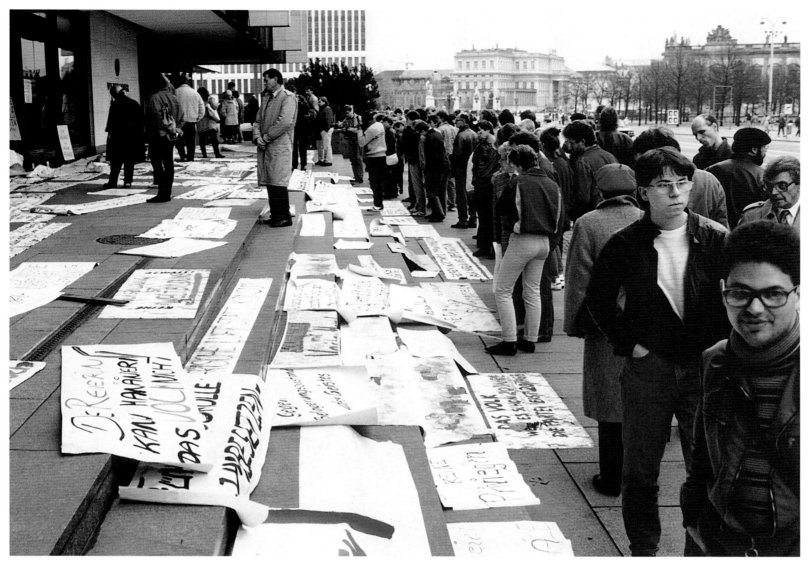

Demonstrators lay placards demanding more democracy on the steps of the Palast der Republik. Photo November 4, 1989.

4. November 1989: Demonstranten legen Plakate mit Forderungen nach mehr Demokratie auf den Stufen des Palasts der Republik ab.

Placards and demonstrators in front of the East German symbol on the government building, Palast der Republik, during the mass demonstrations for democracy. Photo November 4, 1989.

Demonstranten mit Plakaten auf dem Palast der Republik während der Großdemonstration am 4. November 1989, bei der sich im Stadtzentrum mehr als 100 000 Menschen versammelten.

Opening conference of the people's movement New Forum in the Akademie der Künste. New Forum, formed on September 9, 1989, was the first official protest group and gave rise to similar groups in the rest of East Germany. One of the leaders of the group was the scientist Jens Reich, seen here with outstretched arms. Photo January 27, 1989

Am 27. und 28. Januar 1990 konstituiert sich das »Neue Forum«. Einer der führenden Köpfe dieser Bürgerrechtsbewegung ist der Naturwissenschaftler Jens Reich, hier mit ausgebreiteten Armen.

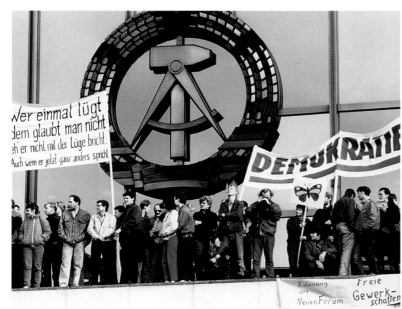

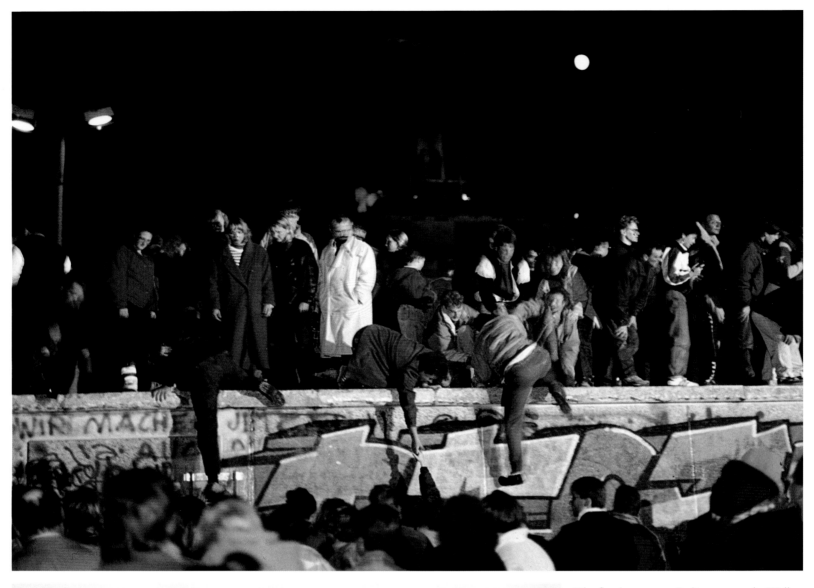

The floodgates open: Berliners storm the Wall near the Brandenburg Gate on the night of November 9, 1989.

In der Nacht vom 9. auf den 10. November 1989 erstürmen die Berliner nahe des Brandenburger Tores die Mauer.

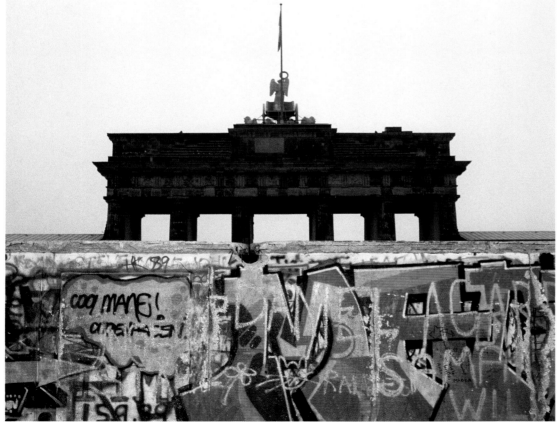

Graffiti on the west side of the Berlin Wall, near the Brandenburg Gate. Photo 1989.

Die mit zahllosen Graffiti bedeckte Westseite der Mauer vor dem Brandenburger Tor, 1989.

Schoolchildren from the Wedding district of West Berlin form a welcome party for East Berliners on the Bösebrücke near the Bornholmer Straße border checkpoint. Photo November 10, 1989.

Schülerinnen und Schüler aus Wedding im Westteil der Stadt begrüßen am 10. November 1989 auf der Bösebrücke Ostdeutsche, die mit ihren Wagen nach Westen fahren.

A day after East Germany opened her borders to the West, crowds squeeze their way through the Chausseestraße border checkpoint for a glimpse of the other side. Photo November 10, 1989.

Einen Tag, nachdem die DDR am 9. November 1989 ihre Grenzen in Richtung Westen öffnete, herrscht am Grenzübergang Chausseestraße reger Andrang.

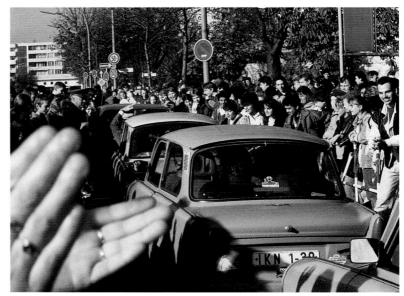

The Glienicke Bridge, once famous as a meeting point for spies from the two enemy states, is now the scene of rejoicing as West Berliners welcome Potsdamers over the bridge. Photo November 10, 1989.

Auf der Glienicker Brücke, berühmt geworden als Austauschort von Agenten der Ost- und Westmächte, werden am 10. November 1989 Potsdamer von West-Berlinern begrüßt.

All over the capital, East Germans are greeted enthusiastically as they arrive in West Berlin. Pictured is the Sonnenallee border checkpoint. Photo November 1989.

Am Grenzübergang Sonnenallee begrüßen West-Berliner begeistert ankommende Ostdeutsche, November 1989.

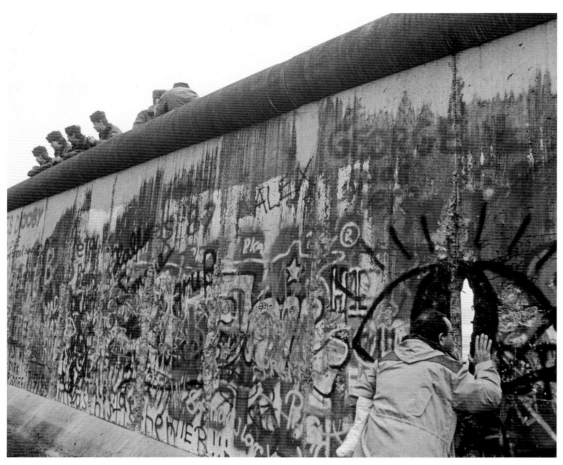

A man peers through a hole in the Wall on Potsdamer Platz towards the East whilst East German border guards look over the Wall towards the West. Photo December 2, 1989.

Ein Mann blickt durch ein Loch in der Mauer am Potsdamer Platz nach Osten, während DDR-Grenzposten über die Mauer in Richtung Westen schauen. 2. Dezember 1989.

New Year's Eve fireworks at the Brandenburg Gate. Photo December 31, 1989.

Silvester 1989 am Brandenburger Tor.

The first car to cross the border into West Berlin at Potsdamer Platz is greeted by cheering crowds. Photo November 12, 1989.

Am 12. November 1989 passiert das erste Fahrzeug unter großem Jubel der versammelten Menge den neuen Grenzübergang am Potsdamer Platz.

Young Germans on the wall near the Brandenburg Gate greet the new year with optimism. Their placard reads: "Germany one Fatherland." Photo December 31, 1989.

Ein Schnappschuß an Silvester 1989: Junge Deutsche gehen mit Optimismus und eindeutigen Forderungen ins Neue Jahr.

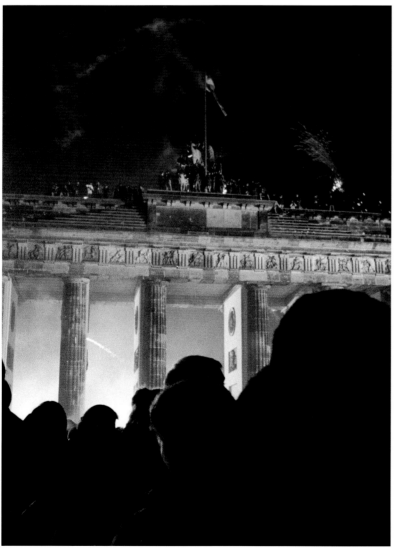

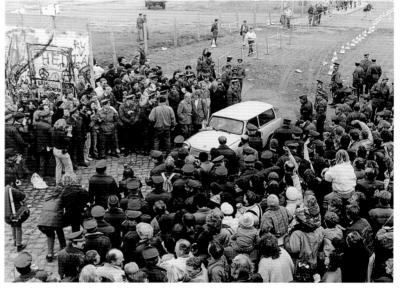

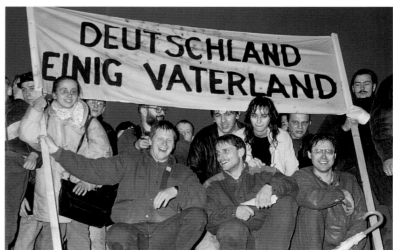

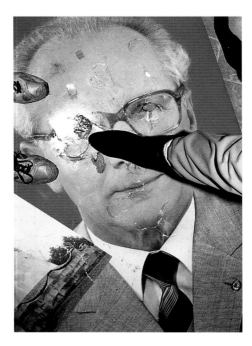

The Stasi headquarters are stormed; a portrait of Erich Honecker (SED Party Secretary since 1971) is trampled underfoot.
Photo January 15, 1990.

Ein symbolischer Akt während der Erstürmung der Stasi-Zentrale: Ein Porträt Erich Honeckers wird mit Füßen getreten, 15. Januar 1990.

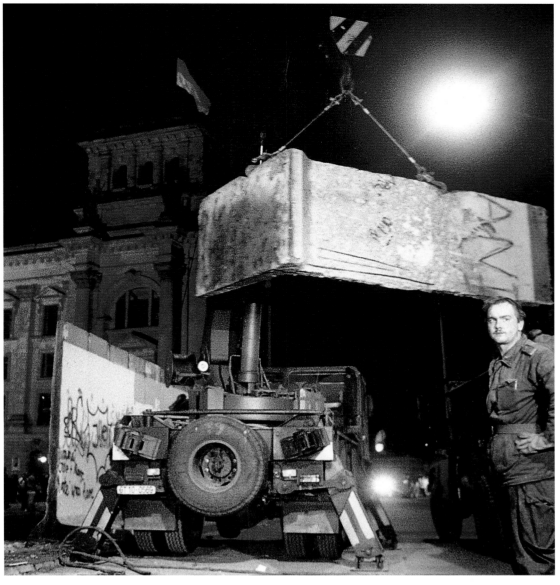

Demolition of the Wall in front of the Reichstag. Photo February 20, 1990.

Am 20. Februar 1990 wird in unmittelbarer Nähe zum Reichstagsgebäude mit dem Abbau der Mauer begonnen.

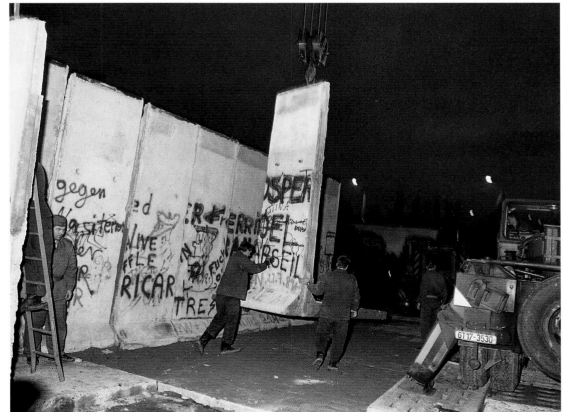

The physical removal of the Wall begins at Bernauer Straße thus creating a new crossing point. Photo November 10, 1989.

An der Bernauer Straße wird die Mauer Stück für Stück abgetragen und ein neuer Grenzübergang geschaffen, 10. November 1989.

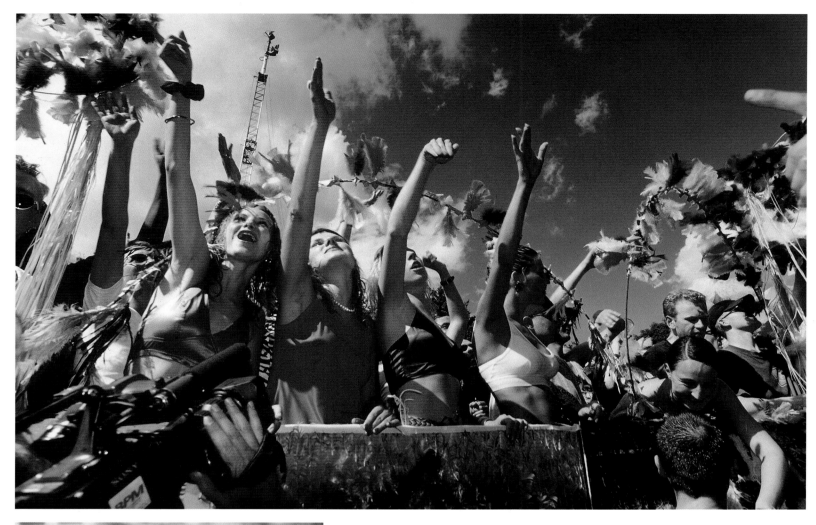

Girls on a decorated float during the Love Parade. Over a million people dance to techno music on the Straße des 17. Juni. Photo July 1997.

Raverinnen auf einem geschmückten Wagen während der »Love Parade« im Juli 1997. Mehr als eine Million Teilnehmer tanzen zu Techno-Klängen auf der Straße des 17. Juni.

A man dressed up for the Love Parade. Photo July 1995.

Ein fantasievoll kostümierter Teilnehmer der »Love Parade«, 1995.

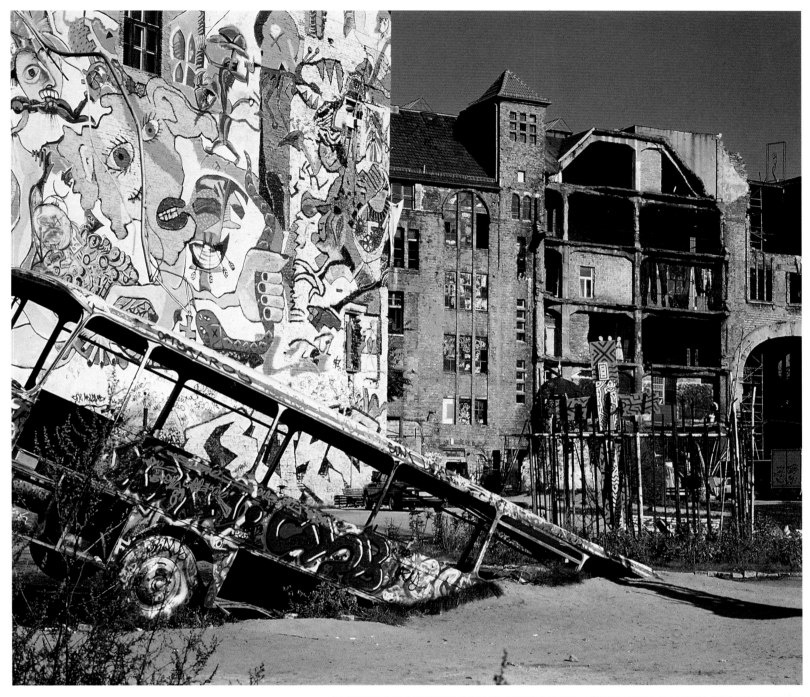

The sculpture garden at the rear of Tacheles on Oranienburger Straße. Once a department store, then abandoned to the elements during the 40 years of the GDR, the building has been resurrected as an alternative arts venue, housing studios, bars, and a cinema. Photo October 10, 1995.

Die rückseitige Ansicht des Tacheles in der Oranienburger Straße mit dem Skulpturengarten, 10. Oktober 1995. Einst ein Kaufhaus und 40 Jahre Wind und Wetter ausgesetzt, beherbergt dieses Gebäude heute zahlreiche Künstlerateliers, Bars und ein Kino.

Navroz, the Kurdish New Year festival, is celebrated with a leap over a bonfire. Photo 1994.

Berliner Kurden begehen das kurdische Neujahrsfest »Navroz« mit dem Sprung über ein offenes Feuer, 1994.

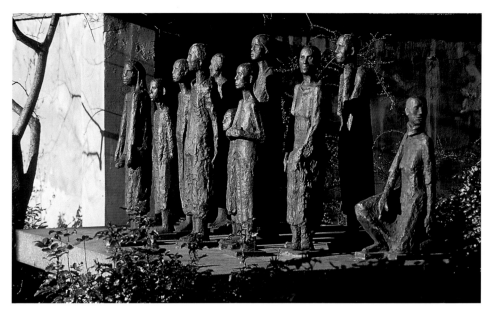

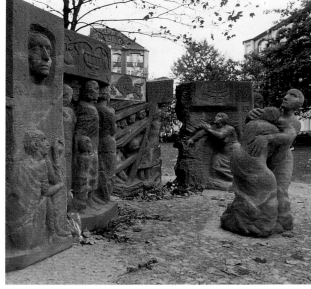

The history of the Old Jewish Cemetery on Große Hamburger Straße echoes that of Berlin Jewry. Built in 1672, closed in 1827 and destroyed by the Gestapo in 1943, it was rebuilt as a memorial in 1985 by Willi and Mark Lammert. Photo 1995.

Denkmal von Willi und Mark Lammert aus dem Jahr 1985 auf dem Alten Jüdischen Friedhof in der Großen Hamburger Straße in Berlin-Mitte. Der 1672 angelegte Friedhof wurde 1827 geschlossen und 1943 durch die Gestapo zerstört; heute ist er eine Gedenkstätte, 1995.

The Hamburger Bahnhof, built in 1845/47 by F. Neuhaus, was used as a museum space as early as 1906 when it housed the Transport and Building Museum until 1945. Since 1987 it has presented exhibitions, such as here the "Ethos and Pathos" exhibition of 1990.

Haupthalle des Hamburger Bahnhofs im Bezirk Tiergarten während der Ausstellung »Ethos und Pathos«, 1990. 1996 wurde das bis 1945 als Verkehrs- und Baumuseum und dann als Ausstellungshaus genutzte Gebäude nach grundlegender Renovierung als »Museum für Gegenwart« der Nationalgalerie neu eröffnet.

"Concrete Cadillacs" on Rathenauplatz, built by Wolf Vostell in 1987.

»Beton-Cadillacs« auf dem Rathenauplatz. Diese Arbeit Wolf Vostells, 1987 als Abschluß des Skulpturenboulevards auf dem Kurfürstendamm aufgestellt, ist in der Öffentlichkeit umstritten.

The Martin-Gropius-Bau in the Kreuzberg district was built 1877/81 by Martin Gropius and Heino Schmieden as an arts and crafts museum. Interior view during the 1991 "Metropolis" exhibition.

Blick in den Lichthof des Martin-Gropius-Baus während der Ausstellung »Metropolis«, 1991. Das ehemalige Kunstgewerbemuseum wird seit 1986 als Ausstellungsort für moderne Kunst genutzt.

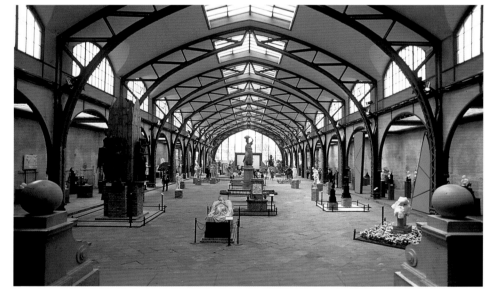

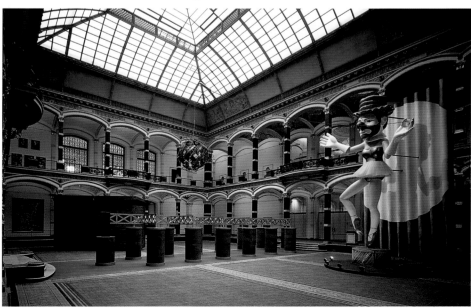

Memorial in Rosenstraße, designed in 1995 by Ingeborg Hunzinger, in memory of the women of so-called mixed marriages who, in March 1943, staged a public protest and brought about the release of their Jewish husbands from the building of the former Jewish welfare administration. Photo October 1995.

Denkmal Ingeborg Hunzingers in der Rosenstraße in Berlin-Mitte. Es wurde 1995 zur Erinnerung an Frauen aus sogenannten Mischehen errichtet, die im März 1943 durch ihren öffentlichen Protest die Freilassung ihrer inhaftierten jüdischen Ehemänner erreichten, Oktober 1995.

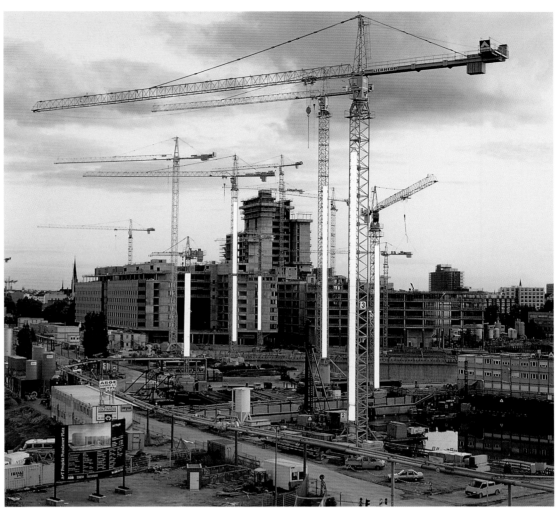

Europe's biggest building site is itself turned into a giant light-sculpture installation. Artist Gerhard Merz mounted 2200 fluorescent light tubes on 11 cranes, lit daily between 6 p.m. and midnight. Photo 1996.

»Lichtskulptur« des Künstlers Gerhard Merz auf der Baustelle der debis-Hauptverwaltung auf dem Potsdamer Platz, 1996. 2200 Leuchtstoffröhren leuchteten vom 2. bis 18. August jenes Jahres jeden Abend von 18 bis 24 Uhr.

Daniel Libeskind's Jewish Museum in Kreuzberg, with its E. T. A. Hoffmann garden, is built in the form of an opened Star of David.

Der Bau des Jüdischen Museums in Berlin-Kreuzberg mit dem E.T.A. Hoffmann-Garten stammt von Daniel Libeskind und hat die Form eines gesprengten Davidssterns.

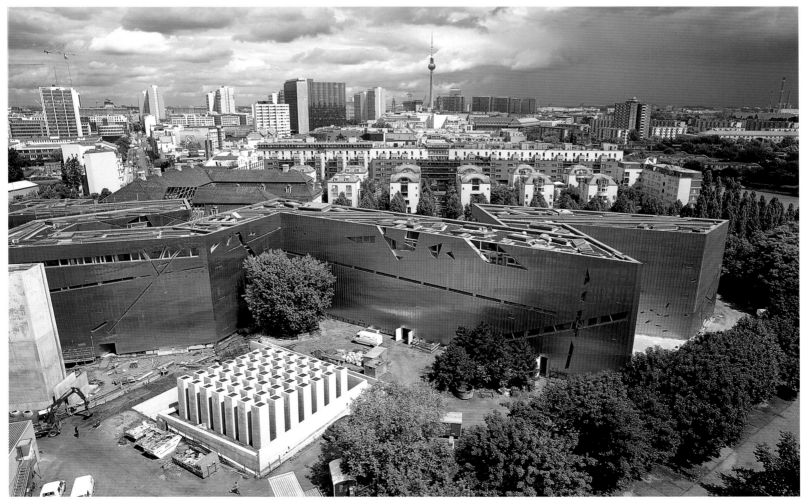

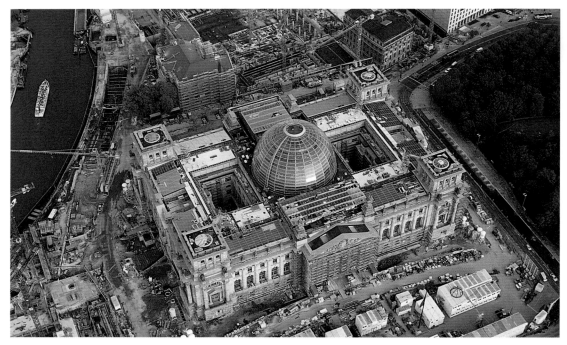

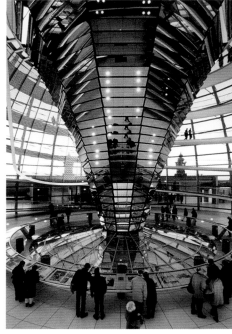

Sir Norman Foster's glass dome adds a transparency touch to the solidity of Paul Wallot's designs for the nineteenth-century Reichstag building. Beginning in 1996, Foster redesigned the Reichstag as the new seat of the German government. Photo September 25, 1998.

Das Reichstagsgebäude während der Umbauarbeiten, 25. September 1998. Das Wuchtige dieses Gebäudes, das 1894 nach Entwürfen von Paul Wallot fertiggestellt wurde, zeigt sich aus der Vogelperspektive mit aller Deutlichkeit.

Futuristic architecture for the new millennium. Visitors to the Reichstag experience the interior of Norman Foster's glass dome. Photo January 2000.

Das verspiegelte Entlüftungselement der Kuppel des Reichstagsgebäudes versorgt das darunter liegende Plenum des Deutschen Bundestages mit Hilfe seiner vielen Spiegelplatten nicht nur mit Licht, sondern sorgt auch für einen regelmäßigen Luftaustausch, Januar 2000.

The Hotel Adlon was rebuilt 1995/97 by Patzschke, Klotz and Partners, having been destroyed in World War II. Its imperial predecessor was opened in 1907 as a luxury hotel to attract, then as now, foreign visitors to "Weltstadt Berlin". Photo 1997.

Außenansicht des Hotels Adlon am Pariser Platz. Dieses Luxushotel wurde 1907 eröffnet und beherbergte zahlreiche illustre Gäste. 1945 ausgebrannt, wurde der Neubau (Architekturbüro: Patzschke & Klotz), der sich am historischen Vorbild orientiert, 1997 neu eröffnet.

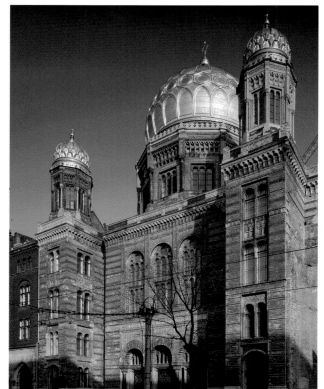

Named for the long-serving post-war economics minister, whose slogan "prosperity for all" heralded the economic miracle in West Germany, the Ludwig-Erhard-Haus is built to the modern design of architect Nicholas Grimshaw. It houses the Stock Exchange. Photo 1998.

Ansicht des Ludwig-Erhard-Hauses in der Fasanenstraße in Berlin-Charlottenburg, das Nicholas Grimshaw entwarf. Hier haben die Berliner Börse und die Industrie- und Handelskammer ihren Sitz, 1998. Das Gebäude wurde nach dem ersten Bundeswirtschaftsminister der Bundesrepublik benannt.

Restoration work began on the Oranienburger Straße synagogue in 1988, towards the end of the GDR. The original building was erected 1859/66 by Eduard Knoblauch in Spandau which, until 1933, was a strongly Jewish district of Berlin. Photo 1991.

Die Große Synagoge in der Oranienburger Straße wurde noch zu DDR-Zeiten wiederaufgebaut, 1991. Die Spandauer Vorstadt, der Stadtteil nördlich der Oranienburger Straße, war bis 1933 ein jüdisch geprägtes Stadtviertel.

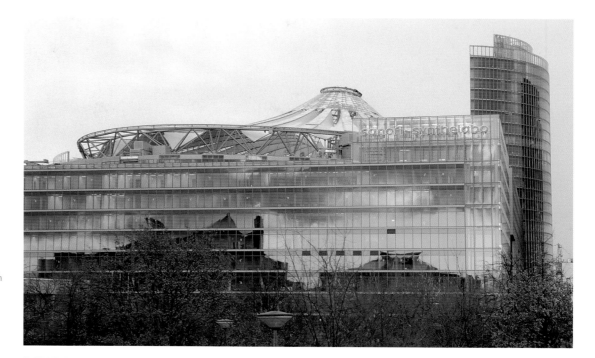

The glass dome of the Sony Center on Potsdamer Platz, seen from the Philharmonie. The unusual tent roof, designed by the German-American architect Helmut Jahn, posed a challenge for the engineers. Photo January 2000.

Das Sony-Center am Potsdamer Platz, das nach Entwürfen des deutsch-amerikanischen Architekten Helmut Jahn errichtet wurde, von der Philharmonie aus gesehen. Das ungewöhnlich geformte Zeltdach war eine große Herausforderung an die Ingenieure, Januar 2000.

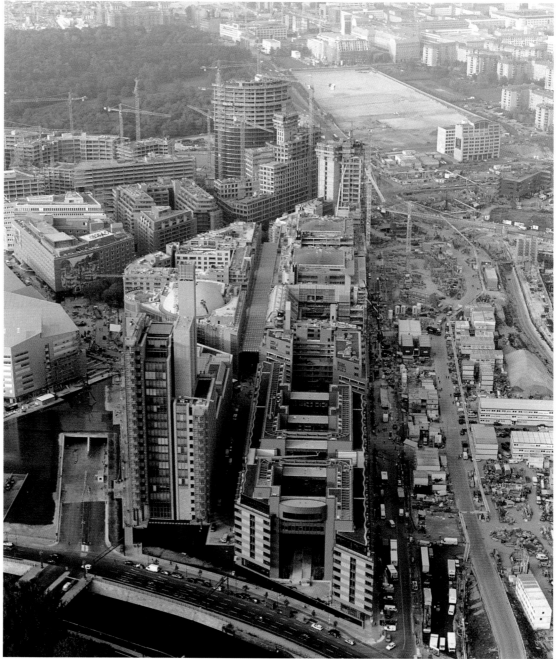

This 1998 aerial shot shows the extent of the building work on Potsdamer Platz. The as yet undeveloped site in the background is reserved for the local government offices and the Holocaust Memorial.

Diese Luftaufnahme von 1998 zeigt die Dimensionen der Bauvorhaben am Potsdamer Platz. Die noch unbebaute Fläche im Hintergrund ist für die Vertretungen verschiedener Bundesländer sowie für das Holocaust-Mahnmal reserviert.

Paris comes to Berlin. The Galeries Lafayette department store, designed by architect Jean Nouvel, opened its Berlin branch on Friedrichstraße. Photo 1997.

Der gläserne Kegel im Inneren der Galeries Lafayette übt eine starke Anziehungskraft auf die Besucher des von Jean Nouvel entworfenen Blocks 205 in der Friedrichstraße aus, 1997.

Trade at the Marheineke covered market dates back to 1891/92 when it was built by the architect Moebius. Destroyed in 1942, rebuilt in 1953 and reconstructed further in 1991, it continues to attract shoppers to its colourfall stalls. Photo January 2000.

Ein Verkaufsstand mit Wurst- und Fleischwaren in der belebten Marheineke-Markthalle am Marheineke-Platz in Berlin-Kreuzberg. 1991 wurden die alten, exakt einhundert Jahre zuvor errichteten Kopfbauten der im Zweiten Weltkrieg zerstörten und seit 1953 wiederaufgebauten Halle rekonstruiert, Januar 2000.

The Kreuzberg district of Berlin is noted for its large Turkish population. Here a grocer serves a customer Turkish delicacies in a market on Paul-Lincke-Ufer. Photo January 2000.

Ein türkischer Lebensmittelhändler bedient eine Kundin auf dem Markt am Paul-Lincke-Ufer im Bezirk Kreuzberg.

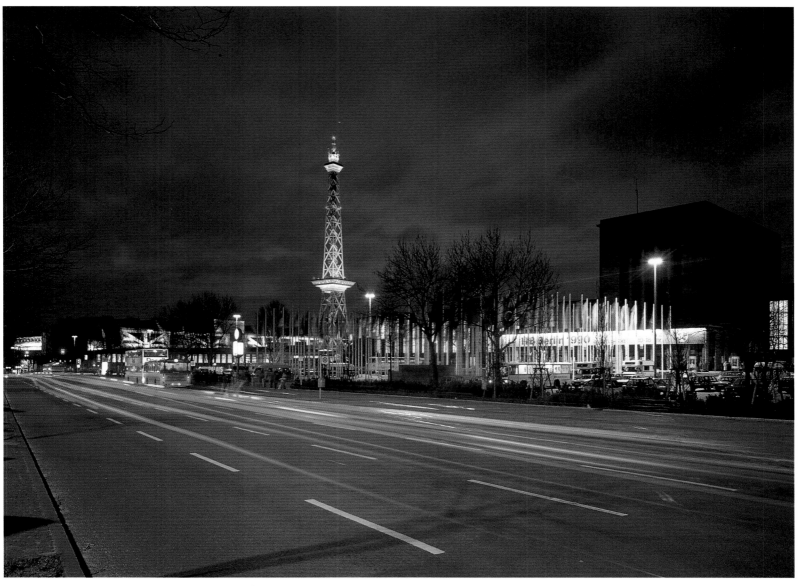

Berlin's importance as a centre for exhibitions and trade fairs increases further with its new status as capital city. This view is of the exhibition halls on Hammarskjöldplatz at night. In the foreground is the Masurenallee, in the background the radio tower. Photo 1990.

Blick bei Nacht auf die Messe-hallen am Hammarskjöldplatz in Berlin-Charlottenburg, vorn die Masurenallee, im Hinter-grund der beleuchtete Funk-turm, 1990.

Exhibition halls on Messe-damm are lit up by TV screens for the International Radio and TV Exhibition.
Photo August 25, 1995.

Großmonitore auf der Inter-nationalen Funkausstellung, 25. August 1995. Die Funk-ausstellung findet jedes Jahr auf dem Ausstellungs- und Messe-gelände am Messedamm statt und ist einer der Messe-Höhe-punkte Berlins.

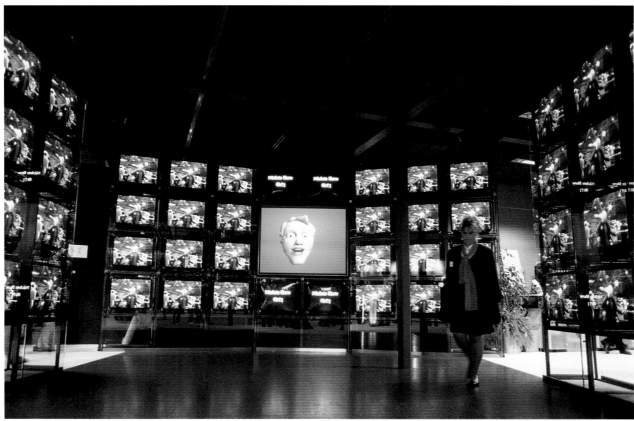

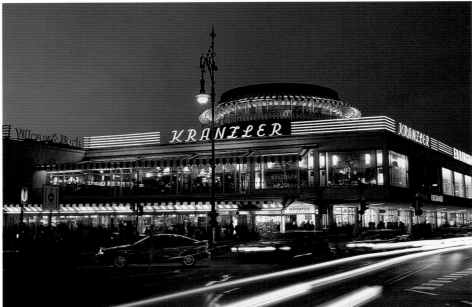

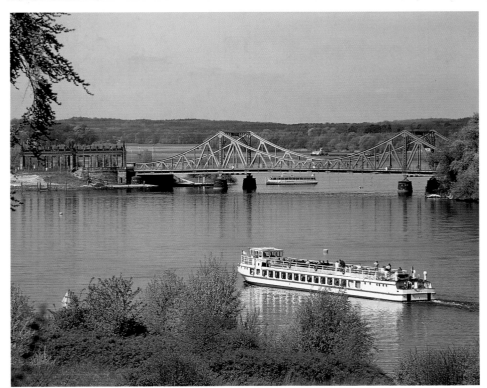

top left / oben links:

The bright lights of the Daimler Chrysler-Areal on Marlene-Dietrich-Platz tempt one into the Stella Musical theatre and the casino Spielbank Berlin. The architects are Renzo Piano and Christoph Kohlbecker. Photo 1999.

Der Marlene-Dietrich-Platz mit der Spielbank. 1999. Im Zuge der Neuplanung des Potsdamer Platzes wurde dieser Platz zu Ehren der in Berlin geborenen Schauspielerin benannt.

top right / oben rechts:

Exterior view of the Literaturhaus in Fasanenstraße—a leafy street off the Kurfürstendamm. Photo May 1999.

Das Literaturhaus in der Fasanenstraße in Berlin-Charlottenburg. Einst eine Privatvilla, befindet sich seit den achtziger Jahren in diesem Haus das zur Institution gewordene Literaturhaus, in dem Lesungen und Ausstellungen stattfinden.

left-hand page, bottom /
linke Seite Mitte und unten:

A city landmark since the days
of the Kaiser, the bright lights
of the Cafe Kranzler on the
Kurfürstendamm still attract
hordes of visitors. Photo 1992.

Das Café Kranzler an der
Kreuzung von Kurfürstendamm
und Joachimsthaler Straße be-
fand sich vor 1945 auf dem
Boulevard Unter den Linden.
1958 bezog es den Neubau mit
der charakteristischen Rund-
terrasse und ist seither markan-
ter Treffpunkt für Berliner und
Touristen. 1992.

Christmas 1999: the inner
courtyard of the Stilwerk
Design Center (built 1998/99
by Novotny, Maehner and
Assocs.) is festooned with
decorations. Photo
December 1999.

Das Stilwerk Design Center an
der Kantstraße in Berlin-Char-
lottenburg wurde im November
1999 eröffnet und vereint
unter seinem Dach zahlreiche
Design- und Einrichtungs-
shops.

The Glienicke Bridge, the
so-called Bridge of Unity,
connects Potsdam and Berlin-
Glienicke. It was first built
in 1831/34 to designs by
Schinkel, and rebuilt in 1906
and again after World War II.
A scene of joyful reunion
between East and West in
November 1989, the bridge
has been a witness to many
Berlin boat trips. Photo 1992.

Blick vom Schloß Babelsberg
auf die Glienicker Brücke, die
Verbindung zwischen Potsdam
und Glienicke, 1992. 1831 bis
1834 nach einem Entwurf
Schinkels erbaut, wurde sie im
Krieg zerstört, bis 1950 neu
errichtet und diente zur Zeit
des Kalten Krieges als Aus-
tauschort von Agenten.

The end of a century; the start
of a new millennium. Lasers
light up the Brandenburg Gate.
Photo December 31, 1999.

Lichtinstallation am Branden-
burger Tor während der großen
Millenniumsfeier vom
31. Dezember 1999 zum
1. Januar 2000. Zwischen der
Siegessäule im Tiergarten und
dem Alexanderplatz versammel-
ten sich rund 500 000 Men-
schen, um das neue Jahrtausend
zu begrüßen.

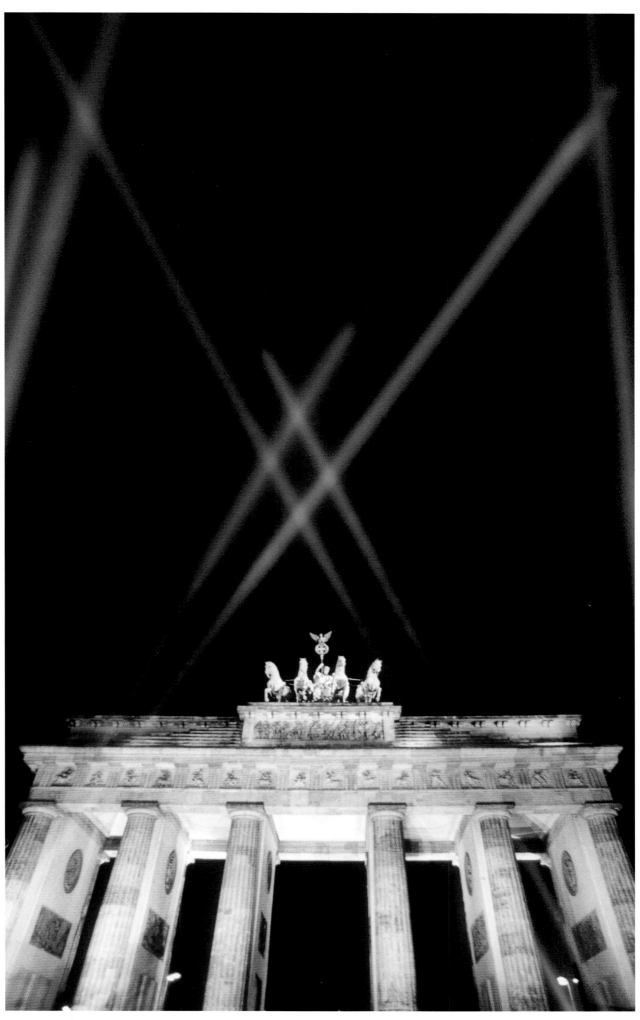

CHRONOLOGY OF EVENTS
CHRONOLOGIE DER EREIGNISSE

1900–1918 Unter den Linden

May–October 1901	3rd Art Exhibition of the Berlin Secession.
1905	Max Reinhardt appointed director of the Deutsches Theater.
September 4, 1909	Wright brothers fly over Berlin's Tempelhof field.
August 1, 1914	Outbreak of World War I and start of mobilization.
Winter 1914/1915	Turnip winter: extreme food shortages and hardship.
March 1915	Women have taken over men's roles in many financial, military and government offices, as well as major branches of industry: heavy, munitions, chemical, and manufacturing. This activity will fuel the post-war drive for equal rights with men.
February 1917	Outbreak of Russian Revolution.
January 1918	Strike by nearly half a million metal and munitions workers demanding food and a speedy end to the war.
March 21, 1918	Hindenburg and Ludendorff announce huge German offensive on Western Front. Campaign fails on a massive scale, but Ludendorff maintains complete victory is in his grasp.
September 30, 1918	Leaders of all political parties in Berlin are called to Reichstag to hear that the war is lost.
November 9, 1918	Revolution in Berlin. Soldiers' councils are formed on the Bolshevik model and workers threaten to strike. Kaiser abdicates. Friedrich Ebert is appointed Chancellor. Philipp Scheidemann proclaims the Social Democratic Republic from the Reichstag. Two hours later Karl Liebknecht proclaims Soviet Republic from the palace.
November 11, 1918	Armistice Day: end of World War I.

1919–1930 The New Reality

January 5–15, 1919	Spartacus Uprising.
February 6–August 11, 1919	German National Assembly meets in Weimar and draws up the constitution which gives the new republic its name.
1919	Walter Gropius founds the Bauhaus school in Weimar (1932 the School moves to Berlin).
March 13, 1920	Kapp Putsch.

1900–1918 Unter den Linden

Mai–Oktober 1901	III. Kunstausstellung der Berliner Secession
1905	Max Reinhardt wird zum Direktor des Deutschen Theaters berufen
4. September 1909	Die Gebrüder Wright demonstrieren ihre Flugkünste auf dem Tempelhofer Feld
1. August 1914	Ausbruch des Ersten Weltkriegs; allgemeine Mobilmachung
März 1915	Frauen haben in vielen Bereichen der Wirtschaft, der Armee und der Verwaltung so-wie vor allem in der Schwer-, der Rüstungs-, der chemischen und der produzierenden Industrie die Aufgaben von Männern übernommen. Diese neuen Tätigkeiten führen neben anderen Faktoren nach 1918 zur rechtlichen Gleichstellung von Frauen.
Winter 1916/17	»Kohlrübenwinter«: aufgrund massiver Lebensmittelknappheit eine Zeit der Entbehrung
Januar 1918	Fast eine halbe Million Metall- und Rüstungsarbeiter treten in den Ausstand und fordern bessere Versorgung mit Lebensmitteln und eine schnelle Beendigung des Krieges
21. März 1918	Hindenburg und Ludendorff verkünden eine große Offensive an der Westfront. Trotz Niederlage verkündet Ludendorff weiterhin, der Sieg Deutschlands sei gewiß
30. September 1918	Die Vertreter aller Parteien sind in den Reichstag geladen: Dort verkündet die Oberste Heeresleitung, daß der Krieg verloren und mit sofortigem Waffenstillstand beendet ist
9. November 1918	Revolution in Berlin. Soldatenräte nach sowjetischem Vorbild werden gebildet, Arbeiter drohen mit Streik. Kaiser Wilhelm II. dankt ab. Friedrich Ebert wird zum Reichskanzler ernannt. Philipp Scheidemann ruft von einem Balkon des Reichstags die Republik aus. Zwei Stunden später verkündet Karl Liebknecht vom Balkon des Schlosses die »Sozialistische Republik«
11. November 1918	Unterzeichnung des Waffenstillstandsvertrages: Der Erste Weltkrieg ist zu Ende

1919–1930 Die neue Realität

5. bis 15. Januar 1919	Spartakusaufstand
6. Februar bis 11. August 1919	Wegen der Unruhen in Berlin tagt die Nationalversammlung in Weimar und beschließt dort die Verfassung der »Weimarer Republik«
1919	Walter Gropius gründet in Weimar das Bauhaus (1932 wird es nach Berlin verlegt)
13. bis 17. März 1920	Kapp-Putsch

July 5, 1920	Opening of 1st International Dada Fair in Berlin.	5. Juli 1920	Eröffnung der »Ersten Internationalen Dada-Messe« in Berlin
1922	1st Russian Art Exhibition opens at Galerie van Dieman in Berlin.	1922	»Erste Russische Kunstausstellung« in der Galerie van Diemen in Berlin. Der russische Konstruktivismus beeinflußt zahlreiche deutsche Künstler
	Many German artists are inspired by the Russian Constructivist style.		
November 1923	Hyperinflation, triggered by war debts and reparations, reaches its peak.	November 1923	Bedingt durch Kriegsreparationen und die hohe Staatsverschuldung erreicht die Inflation ihren Höhepunkt.
1924	Bertolt Brecht moves to Berlin.	1924	Bertolt Brecht zieht von München nach Berlin
1929	Marlene Dietrich stars in "The Blue Angel", Germany's first "talkie".	Herbst 1929	Die Weltwirtschaftskrise läßt die Arbeitslosenzahlen steigen
Autumn 1929	Economic Depression provokes mass unemployment.	1930	Marlene Dietrich spielt die Hauptrolle in dem Film »Der Blaue Engel«
September 10, 1930	Hitler gives first speech in Berlin, at the Sportpalast, which is packed for the occasion.	10. September 1930	Hitler hält im ausverkauften Sportpalast seine erste Rede in Berlin
September 14, 1930	Elections: Nazis breakthrough into national politics, winning 14.7 percent of the vote.	14. September 1930	Bei den Wahlen zum Reichstag gewinnt die NSDAP 107 Sitze und kommt in Berlin auf 14,7 Prozent
June 1932	Hindenburg dissolves Reichstag. Lifts ban on SA and SS.	Juni 1932	Der von Reichspräsident Hindenburg ernannte Reichskanzler Franz von Papen löst den Reichstag auf. Zuvor läßt er die verbotene SA wieder zu. Neuwahlen werden angesetzt
	Calls for new elections.		
July 31, 1932	Elections: Nazis become strongest party in Germany with 37.3 percent of the vote. Hindenburg names Franz von Papen as Chancellor. Von Papen dissolves Reichstag and calls new elections later that year.	31. Juli 1932	Bei der Wahl zum Deutschen Reichstag wird die NSDAP mit 37,3 Prozent aller abgegebenen Stimmen stärkste Partei. Hindenburg ernennt Franz von Papen zum Reichskanzler
November 6, 1932	Elections: Nazis are again the strongest party, again Hitler is not named Chancellor: the post goes to General von Schleicher.	6. November 1932	Wahlen: Die NSDAP wird wieder stärkste Partei, doch zum Reichskanzler wird nicht Hitler ernannt, sondern General Kurt von Schleicher
January 30, 1933	Hitler is named Chancellor.	30. Januar 1933	Hitler wird zum Reichskanzler ernannt

1933–1945 The Centre of Power

1933–1945 Das Zentrum der Macht

February 27–28, 1933	Reichstag fire. Hindenburg signs emergency decree "for the Protection of the People and the State." Civil liberties effectively cease to exist.	27. bis 28. Februar 1933	Reichstagsbrand. Hindenburg unterzeichnet die Notverordnung »zum Schutz von Volk und Staat«, die die wichtigsten Grundrechte und Grundprinzipien der Weimarer Verfassung und des Rechtsstaates außer Kraft setzt
March 5, 1933	New elections: Nazis still theoretically dependent on nationalist DNVP for a majority.	5. März 1933	Bei den Reichstagswahlen sind die Nationalsozialisten für die Bildung einer Mehrheitsregierung auf den Koalitionspartner DNVP angewiesen
March 23, 1933	New Reichstag meets at the Krolloper and passes the Enabling Act which gives government power to the Nazis.	23. März 1933	Der Reichstag verabschiedet gegen die Stimmen der SPD das Ermächtigungsgesetz und schaltet sich dadurch selbst aus
April 1, 1933	Boycott of all Jewish businesses and professions.	1. April 1933	Inszenierter »Boykott« jüdischer Geschäfte und Büros
April 7, 1933	1st anti-Semitic law passed. All non-Aryans and political undesirables are excluded from public office.	7. April 1933	»Gesetz zur Gleichschaltung der Länder mit dem Reich«. Alle Deutschen »nicht-arischer« Herkunft und politisch unerwünschte Personen werden aus dem öffentlichen Dienst entfernt
May 10, 1933	Nazi book burning.		
June 30, 1933	Night of the Long Knives: murder of "unruly" SA men by SS firing squads.		
July 14, 1933	Law is passed to say that Nazi party is the only		

	legal party in Germany. Effectively removes all opposition.
September 1933	Creation of the Reichskulturkammer to regulate all aspects of cultural life.
August 19, 1934	Referendum to legitimize Hitler's assumption of power.
August 1–6, 1936	Berlin Olympic Games.
July 1937	"Entartete Kunst" exhibition opens in Munich. It moves to Berlin later in the year.
March 16, 1938	Anschluß of Austria.
November 9–10, 1938	Kristallnacht – "Night of the Broken Glass."
March 15, 1939	Germany annexes the Sudetenland.
August 23, 1939	Hitler and Stalin sign non-aggression pact.
September 1, 1939	Germany invades Poland. Outbreak of World War II.
September 27, 1939	Mussolini's state visit to Berlin.
July 18, 1940	France falls to Germany.
November 18, 1943	Battle of Berlin begins – the longest and most intensive single bombing campaign of the war. The Americans make last drop on Hitler's birthday, April 20, 1945. 70 percent of the city would be in ruins.
April 16, 1945	Red Army offensive launched on Berlin.
April 20, 1945	Nazi leadership meets for the last time in the Reichskanzlei.
April 30, 1945	Hitler commits suicide.
May 2, 1945	Berlin falls to the Red Army.

1945–1989 The Divided City

February 1945	Yalta conference: Germany divided into four occupied territories. Berlin, within the Russian Zone, is also divided up into four sectors.
July 4, 1945	British soldiers take up occupation of the British Sector in Berlin.
July 17–August 2, 1945	Potsdam Conference confirms Stalin's gains in eastern and central Europe.
June 24, 1948	Stalin blockades Berlin. The airlift begins two days after.
April 4, 1949	North Atlantic Treaty signed to counter Soviet military presence in Europe.

10. Mai 1933	»Verbrennung un-deutschen Schrifttums« auf dem Opernplatz vor der Universität
30. Juni 1934	»Röhm-Putsch«: Hitler läßt durch SS und Sicherheitsdienst (SD) die Führer der SA sowie alte politische Gegner und Konkurrenten ermorden
14. Juli 1933	Alle Parteien außer der NSDAP werden verboten oder zur Auflösung gezwungen
22. September 1933	Die Reichskulturkammer wird gegründet; sie kontrolliert das gesamte kulturelle Leben
19. August 1934	Die »Volksbefragung« zur Vereinigung der Funktionen von Reichspräsident und Reichskanzler soll offiziell Hitlers Griff nach unumschränkter Macht legitimieren
1. bis 6. August 1936	Olympische Spiele in Berlin
Juli 1937	Die Ausstellung »Entartete Kunst« wird in München eröffnet und ist später auch in Berlin zu sehen
27. September 1937	Staatsbesuch Benito Mussolinis in Berlin
16. März 1938	Anschluß Österreichs
9. November 1938	»Reichskristallnacht«
15. März 1939	Die Deutsche Wehrmacht besetzt die Tschechoslowakei
23. August 1939	Hitler und Stalin unterzeichnen den Nichtangriffspakt zwischen Deutschland und der Sowjetunion
1. September 1939	Angriff auf Polen. Beginn des Zweiten Weltkriegs
22. Juni 1940	Niederlage Frankreichs, deutsch-französischer Waffenstillstand
18. November 1943	Beginn der englischen Luftoffensive auf Berlin, des längsten und intensivsten Bombardements des Zweiten Weltkriegs. Die letzte Bombe wird am 25. April 1945, Hitlers 56. Geburtstag, abgeworfen. Rund 70 Prozent der Stadt sind zerstört
16. April 1945	Sowjetische Offensive gegen Berlin
20. April 1945	Letztes Treffen von Nazi-Größen in der Reichskanzlei
30. April 1945	Hitler begeht Selbstmord
2. Mai 1945	Berlin kapituliert vor der Roten Armee

1945–1989 Die geteilte Stadt

Februar 1945	Konferenz in Jalta: Deutschland wird in vier Besatzungszonen und Berlin in vier Besatzungssektoren eingeteilt
4. Juli 1945	Einzug der britischen Armee in Berlin
17. Juli bis 2. August 1945	Auf der Konferenz der drei Siegermächte in Potsdam wird Stalins Herrschaft über Mittel- und Mittelosteuropa festgeschrieben
24. Juni 1948	Beginn der Berlin-Blockade durch die Sowjets. Als Reaktion wird zwei Tage später die »Luftbrücke« installiert

May 12, 1949	Blockade is lifted.	4. April 1949	Der Nordatlantikpakt (NATO) wird als Verteidigungsbündnis gegen die sowjetische Militärpräsenz in Europa gegründet
May 23, 1949	Federal Republic of Germany founded.		
October 7, 1949	German Democratic Republic founded with East Berlin as its capital.	12. Mai 1949	Aufhebung der Berlin-Blockade
November 3, 1950	Bonn named capital of the Federal Republic.	23. Mai 1949	Gründung der Bundesrepublik Deutschland
January 18, 1951	Ernst Reuter (SPD) elected mayor of West Berlin.	7. Oktober 1949	Gründung der Deutschen Demokratischen Republik
June 1951	1st Berlin film festival in Titania Palast (West Berlin).	3. November 1950	Bonn wird Hauptstadt der Bundesrepublik Deutschland
February 3, 1953	Foundation stone of the building project Stalin-Allee is laid (East Berlin).	18. Januar 1951	Nach der im Oktober 1950 verabschiedeten »Verfassung von Berlin« wird Ernst Reuter (SPD) Regierender Bürgermeister von Berlin
May 26, 1952	Road connections between East and West Berlin are severed, although the borders remain open.	Juni 1951	Die 1. Filmfestspiele finden im Titania-Palast in Berlin-Steglitz statt
June 17, 1953	Uprising of June 17 (East Berlin).	3. Februar 1953	Grundsteinlegung für die Neubebauung in der Stalinallee in Ost-Berlin
May 14, 1955	Warsaw Pact formed as a counter-force to NATO.	26. Mai 1953	Die Straßenverbindungen zwischen den Westsektoren und dem Ostteil der Stadt werden gekappt, Grenzverkehr ist aber weiterhin möglich
October 3, 1957	Willy Brandt (SPD) elected as mayor of West Berlin.	17. Juni 1953	Arbeiteraufstand in Ost-Berlin
July 6, 1957	Opening of the International Building Exhibition, with Hansa quarter as its focal point (West Berlin).	14. Mai 1955	Der Warschauer Pakt wird als gegen die NATO gerichtetes Militärbündnis gegründet
October 22, 1958	German parliament rejects the idea that the capital of West Germany be moved to West Berlin	3. Oktober 1957	Willy Brandt (SPD) wird Regierender Bürgermeister von Berlin
November 10, 1958	Khrushchev demands that Western powers leave West Berlin immediately. Threat of World War III looms.	6. Juli 1957	Internationale Bauausstellung (IBA); im Zuge dieser Ausstellung wird das Hansaviertel in West-Berlin von Architekten neu bebaut
September 8, 1960	West Germans can only visit East Berlin with ID.	22. Oktober 1958	Der Deutsche Bundestag stimmt gegen den Vorschlag, den Regierungssitz nach West-Berlin zu verlegen
August 13, 1961	Erection of the Berlin Wall between the Soviet and Western sectors.		
June 26, 1963	Kennedy visits West Berlin.	10. November 1958	Chruschtschow fordert die Westmächte auf, umgehend ihre Truppen aus West-Berlin abzuziehen. Ein Dritter Weltkrieg droht
June 2, 1967	Riots and demonstrations break out on occasion of Shah of Iran's visit to West Berlin. The death of a student fuels the unrest.	8. September 1960	Westdeutsche können Ost-Berlin nur gegen Vorlage ihres Ausweises besuchen
April 12, 1968	Student riots in response to the assassination attempt on Rudi Dutschke.	13. August 1961	Abriegelung aller Verkehrsverbindungen nach West-Berlin. Der Bau der Mauer beginnt einige Tage später
May 14, 1970	Ulrike Meinhof frees activist Andreas Baader. The two found the terrorist Red Army Faction aimed at the destruction of West German society from their base in West Berlin.	26. Juni 1963	Der US-Präsident John F. Kennedy besucht West-Berlin
September 3, 1971	Four-power talks result in the Quadripartite Agreement on Berlin: officially recognises the status quo. West Berlin remains under allied control and the Soviets guarantee unimpeded access from West Germany to West Berlin. West Berliners also given permission to enter East Germany and East Berlin.	2. Juni 1967	Bei den Unruhen anläßlich des Besuchs des Schahs von Persien in West-Berlin wird der Student Benno Ohnesorg von einem Polizisten erschossen
		12. April 1968	Studentendemonstrationen infolge des Attentats auf Rudi Dutschke am Vortag
1987	750th anniversary of the City of Berlin. East and West compete for the grandest celebrations.	14. Mai 1970	Ulrike Meinhof befreit Andreas Baader. Sie gründen die Rote Armee Fraktion (RAF), die durch Terroranschläge das Gesellschaftssystem der Bundesrepublik beseitigen will

3. September 1971 Unterzeichnung des Vier-Mächte-Abkommens: offizielle Anerkennung des Status Quo.

1987 750-Jahr-Feier Berlins. Ost und West wollen sich mit ähnlichen, aber getrennten Aktivitäten gegenseitig übertreffen

1989–2000 The New Capital

July 1989	The first annual Love Parade, now one of the biggest street parties in Europe, is held in West Berlin with financial backing from the CDU.
September 9, 1989	New Forum, first official anti-SED protest group, is formed.
September 10, 1989	Announcement on Hungarian television that the border with Austria is open. East Germans travel through Hungary to the West.
October 7, 1989	40 years of the GDR are celebrated in East Berlin.
October 9, 1989	Mass demonstration for democracy in Leipzig.
November 4, 1989	Mass demonstrations for democracy throughout East German cities.
November 7, 1989	East German government and Prime Minister resign.
November 9/10, 1989	18.57, the SED Party Chief Schabowski announces that passports and travel permits will be issued on demand. East Germans no longer need to go through other countries to get to the West. Thousands of Berliners gather at the Wall. At 20.30 the first barrier is raised and East Berliners surge through to the West.
November 10, 1989	Bulgarian leader, Zhikow, is ousted.
November 17, 1989	New cabinet elected in East Berlin. New Prime Minister Hans Modrow promises substantial reforms. Mass demonstrations for democracy in Czechoslovakia.
November 24, 1989	Resignation of Czech Presidium and Secretariat.
December 22, 1989	The Brandenburg Gate is opened in the presence of Helmut Kohl and Hans Modrow.
December 23, 1989	Nicolae Ceauşcescu toppled from power in Romania.
January 27 and 28, 1990	Opening conference of New Forum.
March 18, 1990	East German elections held: the first free vote since 1949. The referendum on German unification and the unification of Berlin yields a result overwhelmingly in favour of unification, though a high proportion of East Berliners actually vote to stay separate.
June 1990	Cranes begin the official dismantling of the Wall.
June 22, 1990	Checkpoint Charlie dismantled.

1989–2000 Die neue Hauptstadt

Juli 1989	Die erste Love Parade findet mit finanzieller Unterstützung der Berliner CDU zum ersten Mal auf dem Kurfürstendamm statt
10. September 1989	Im ungarischen Staatsfernsehen wird bekanntgegeben, daß die Grenze zu Österreich geöffnet wurde. Ostdeutsche nutzen Ungarn als Transitland in den Westen
11. September 1989	Gründungsaufruf des »Neuen Forum«, der ersten republikanischen Oppositionsgruppe
7. Oktober 1989	Feiern zum 40. Jahrestag der Gründung der DDR in Ost-Berlin
9. Oktober 1989	Leipziger Montagsdemonstration mit Forderungen nach freien Wahlen
4. November 1989	Massendemonstrationen in zahlreichen Städten der DDR
7. November 1989	Die Regierung der DDR tritt zurück, am nächsten Tag auch das Politbüro der SED
9./10. November 1989	18 Uhr 57: Der Berliner SED-Bezirkschef Günter Schabowski verkündet in einer im Fernsehen übertragenen Pressekonferenz den Beschluß, die Mauer zu öffnen, und das neue angekündigte Reisegesetz, demzufolge Bürger der DDR »Privatreisen nach dem Ausland ... ohne Vorliegen von Voraussetzungen, Reiseanlässen oder Verwandtschaftsverhältnissen« beantragen können. Tausende Berliner versammeln sich an der Mauer. Um 20 Uhr 30 wird der erste Grenzübergang geöffnet, und Ost-Berliner strömen in den Westteil der Stadt
10. November 1989	Todor Schiwkow, Generalsekretär der bulgarischen KP und Staatsratsvorsitzender, wird zum Rücktritt gezwungen
17. November 1989	Die Volkskammer wählt den Dresdener SED-Bezirkschef Hans Modrow zum Ministerpräsidenten, er verspricht substantielle Reformen. Beginn der »Samtenen Revolution« in der Tschechoslowakei
24. November 1989	Politbüro und Zentralkomitee der tschechoslowakischen KP treten zurück
22. Dezember 1989	Am Brandenburger Tor wird in Anwesenheit von Helmut Kohl und Hans Modrow ein Übergang geöffnet

July 1, 1990	Currency reform: One Deutschmark = one Ostmark.
September 12, 1990	Formal Unification of the two Germanys agreed at a conference in Moscow. East and West Berlin revert to German control. Allied armies start to withdraw.
October 3, 1990	Formal Unification ceremony held in Berlin.
June 20, 1991	Berlin voted the capital of the new Germany by 338 votes to 320.
October 1, 1991	Mayor of Berlin moves to the Rotes Rathaus (formerly in East Berlin).
September 8, 1994	Formal departure of the Western Allied powers.
May 7, 1995	Jewish community celebrates the official opening of the newly restored Oranienburger Straße synagogue.
Summer 1995	Christo wraps the Berlin Reichstag in silver sheeting.
1996	Norman Foster starts work on the glass dome of the Reichstag.
January 1997	The new Velodrom plays host to the traditional six-day cycle race for the first time.
April 19, 1999	Reichstag is inaugurated as the plenary building of the German Bundestag. Berlin Jews commemorate the anniversary of the uprising in the Warsaw ghetto.
May 1999	German parliament meets for the first time in the restored and modernized Reichstag. Daniel Libeskind's Jewish Museum is completed.
November 9, 1999	10-year anniversary of the fall of the Berlin Wall.

23. Dezember 1989	Sturz Nicolae Ceauşescus, Generalsekretär der rumänischen KP und Vorsitzender des Staatsrates
27. und 28. Januar 1990	Konstituierende Sitzung des »Neuen Forum«
18. März 1990	Volkskammerwahlen, die ersten freien Wahlen in der DDR seit 1949. Das Wahlergebnis spiegelt den Wunsch nach einer Wiedervereinigung Deutschlands und Berlins, obwohl ein großer Teil der Wahlberechtigten im Ostteil der Stadt für Parteien stimmen, die für eine Koexistenz zweier deutscher Staaten eintreten
Juni 1990	Mit dem offiziellen Abriß der Mauer wird begonnen
22. Juni 1990	Ein Kran entfernt das Wachhäuschen des alliierten »Checkpoint Charlie« von der Mitte der Friedrichstraße
1. Juli 1990	Währungs-, Wirtschafts- und Sozialunion. Der Umtauschkurs von D-Mark und DDR-Mark beträgt 1:1
12. September 1990	»Zwei-plus-vier-Vertrag« über »die abschließende Regelung in bezug auf Deutschland«, in dem die Vier Mächte auf ihre Sonderrechte verzichten
3. Oktober 1990	Festakt in Berlin zur Wiedervereinigung Deutschlands
20. Juni 1991	Der Deutsche Bundestag beschließt mit 338 gegen 320 Stimmen, daß die Hauptstadt Berlin auch Sitz von Bundestag und Bundesregierung werden soll
1. Oktober 1991	Sitz des Regierenden Bürgermeisters von Berlin wird wieder das Rote Rathaus am Alexanderplatz
8. September 1994	Feierlicher Abzug der westlichen Alliierten aus Berlin
7. Mai 1995	Festakt zur Wiedereröffnung der Großen Synagoge in der Oranienburger Straße in Berlin-Mitte nach siebenjähriger Restaurierung
Sommer 1995	Verhüllung des Reichstags durch Christo und Jeanne-Claude
1996	Der Umbau des Reichstagsgebäudes zum Sitz des Deutschen Bundestages nach Plänen des Architekten Sir Norman Foster beginnt
Januar 1997	Das neue Velodrom (Architekt: Dominique Perrault) in Berlin-Prenzlauer Berg ist erstmals Austragungsort des traditionsreichen Berliner Sechstagerennens
19. April 1999	Das Reichstagsgebäude wird als Sitz des Deutschen Bundestages eingeweiht. Die Jüdische Gemeinde Berlins begeht den Jahrestag des Warschauer Aufstands
Mai 1999	Das Plenum des Deutschen Bundestages tritt zum ersten Mal im umgebauten Reichstagsgebäude zusammen. Das Jüdische Museum (Architekt: Daniel Libeskind) ist fertiggestellt
9. November 1999	Feierlichkeiten zum 10. Jahrestag des Mauerfalls

PICTURE CREDITS
BILDNACHWEIS

Paul Almasy
Ludwig Binder
Erik Bohr
Yevgeny/Jewgeni Chaldej
Stefan Drechsel
Justus Göpel
Gardi
Henschel
Gebr. Haeckel
Udo Hesse
Dieter Hoppe
Vincent Kluwe
Herbert Kraft
P. A. Lebrun
Lucien Lévy

Horst Maack
Bruni Meya
Doris Poklekowski
Florian Profitlich
Nelly Rau-Häring
Jost Schilgen
Gert Schütz
Hans-Martin Sewcz
Tony Vaccaro
Irmgard Wagner
Reimer Wulf
and/und Associated Press
 (Dieter Endlicher, Jockel Finck,
 Rainer Klostermeier, Schüler,
 Udo Weitz)